# BALTHUS

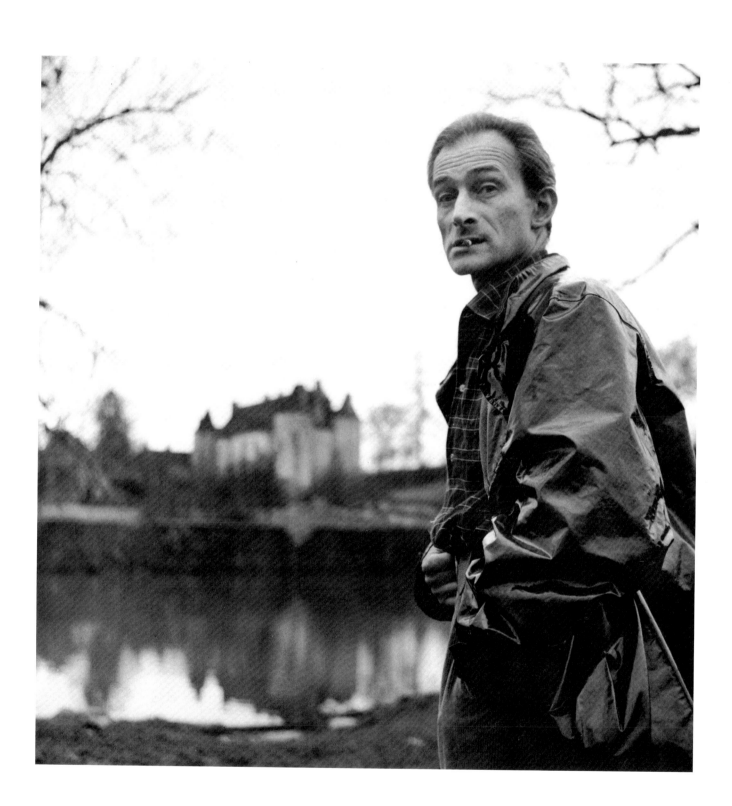

# BALTHUS

SABINE REWALD

THE METROPOLITAN MUSEUM OF ART, NEW YORK

HARRY N. ABRAMS, INC., PUBLISHERS, NEW YORK

CENTRE GEORGES POMPIDOU,
MUSÉE NATIONAL D'ART MODERNE, PARIS
November 5, 1983–January 23, 1984

THE METROPOLITAN MUSEUM OF ART, NEW YORK
February 29, 1984–May 13, 1984

The exhibition at The Metropolitan Museum of Art
was made possible in part by the Edith C.
Blum Foundation and the National Endowment for
the Arts in Washington, D.C., a federal agency.

---

THE METROPOLITAN MUSEUM OF ART

Philippe de Montebello, *Director*
William S. Lieberman, *Chairman of the Department
    of Twentieth Century Art*
Sabine Rewald, *Special Consultant*
Anne M. Lantzius, *Research Assistant, Department of
    Twentieth Century Art*

MUSÉE NATIONAL D'ART MODERNE,
CENTRE GEORGES POMPIDOU, PARIS

Dominique Bozo, Directeur
Gérard Régnier, Conservateur
Jean-Jacques Aillagon, Administrateur
Marie-Odile Peynet, Assistante de l'exposition
Florence Chauveau, Documentaliste
Sylvia Colle-Lorant, Documentaliste

---

Published by The Metropolitan Museum of Art, New York
Bradford D. Kelleher, *Publisher*
John P. O'Neill, *Editor in Chief*
Kathleen Howard, *Editor*
Dale Cotton, *Production Associate*

Patrick Cunningham, Designer

Composition by U.S. Lithograph
Printing by Lebanon Valley Offset
Cloth binding by Publishers Book Bindery, Inc.
Paperback binding by Sendor Bindery, Inc.

Library of Congress Cataloging in Publication Data

Rewald, Sabine
    Balthus.

    Catalog of an exhibition at the Metropolitan Museum
of Art, Feb. 29, 1984 to May 13, 1984.
    Bibliography
    1. Balthus, 1908–   —Exhibitions. I. Balthus,
1908–        II. Metropolitan Museum of Art (New York,
N.Y.) III. Title.
ND553.B23A4 1984      759.4      83-26560
ISBN 0-8109-0738-0
ISBN 0-87099-366-6 (pbk.)

*Front cover:* Detail from Balthus, The Mountain (pl. 14)

*Back cover:* Balthus, *Self-Portrait*, 1943. Pencil on paper,
24¾ × 18¾ in. (63 × 48 cm.). Pierre Matisse Gallery,
New York. Photograph: Eric Pollitzer

*Frontispiece:* Balthus at Chassy, 1956. Photograph: Loomis Dean.
Life Magazine © Time Inc.

# CONTENTS

# FOREWORD

The paintings of Balthus abound in paradoxes and are likely to challenge any effort to situate his style and interpret his work. In the retrospective exhibition that accompanies this publication we find that these paradoxes are not illusory—they are an integral part of the artist's expressive, often disquieting power.

To an uncommon degree Balthus is a painter both of our time and of eras past. He has used traditional compositions to enter a haunted realm. His pictorial language is highly disciplined, evocative of Piero della Francesca and of Poussin, and there is a profound poetry in the *matière*. But there often is in addition a quality of fierceness that jolts us from tradition and into a chimerical world. No other figurative artist of our century has expressed himself at such an intense level of consciousness, and few have plumbed so deeply the mysteries of the subconscious imagination.

Somewhat like Sassetta in his own time, Balthus stands apart from contemporaneous artistic movements. This deliberate aloofness contributes to the poignancy of his still interiors, solitary figures, and strictly ordered street scenes and landscapes. He is very much an enigma. His oeuvre is a quintessential expression of our age, yet it resists categorization. Indeed, the achievement of Balthus commands its own chapter in the history of twentieth-century art.

It is entirely appropriate that The Metropolitan Museum of Art present a Balthus retrospective. Two of his most important works reside here—*Nude in Front of a Mantel*, painted in 1955, and *The Mountain*, the recently acquired monumental landscape of 1937. Balthus's paint-ings are especially suited to an environment that evokes a vital component in their parturition: the contemplation of the Old Masters. During his youth Balthus studied the art of the past in the Louvre and in Italy and later the work of more recent masters such as Courbet; had he lived in New York, one would like to imagine that the Metropolitan would have been his world.

The exhibition has been the joint effort of The Metropolitan Museum of Art and the Musée national d'art moderne, Centre Georges Pompidou, in Paris where this retrospective opened. I wish to thank our colleagues in Paris, most notably Dominique Bozo, Directeur, Gérard Régnier, Conservateur, and Jean-Jacques Aillagon, Administrateur. The lenders to the exhibition have been patient; indeed in every sense they have been collaborators in our project.

For her biographic account and presentation of Balthus's work, I wish to thank Sabine Rewald, the author of this book. I wish also to acknowledge William S. Lieberman, Chairman of the Museum's Department of Twentieth Century Art, who conceived the exhibition and accompanied it through its installation here. As early as 1978, Mr. Lieberman discussed such a retrospective with Thomas B. Hess, the Museum's former Curator of Twentieth Century Art. Mr. Lieberman has been admirably assisted by Anne M. Lantzius. Lucy Belloli, Associate Conservator, has given knowledgeable and painstaking care to certain paintings included in the exhibition. Last, for his essential contribution to the exhibition, I wish to thank Pierre Matisse who, in 1938, first introduced Balthus to an American audience.

Philippe de Montebello
*Director*
*The Metropolitan*
*Museum of Art*

7

# ACKNOWLEDGMENTS

In June 1977 I visited Balthus at the Villa Medici in Rome and asked him if he would mind my writing a doctoral dissertation on his work. His only response was a smile. I thank him for receiving me several times since then, always with kindness.

This publication is based on the dissertation that I will submit to the Institute of Fine Arts, New York University. Professor Alexander C. Soper advised on things oriental, while Professor Gert Schiff read the manuscript, made suggestions, and supported my work with enthusiasm.

I am deeply indebted to the many who generously provided information and photographs, shared their memories with me, and otherwise gave assistance. I owe much to Lady Iya Abdy, the late Carmen Baron, Pierre Berès, Yves Bonnefoy, Vivian Campbell-Stoll, Alice Charmasson, Miriam da Costa, George Gaines, Pierre Granville, Else Henriquez, Jacques Hourrières, the Honorable Hubert Howard, Michel Kellermann, Pierre Klossowski, Boris Kocho, Jean Leyris, Mme Pierre Loeb, Francis Naumann, Mike Nichols, Nathalie de Noailles, Geneviève Picon, John Rewald, John Russell, Beatrice Saalburg, Rosabianca Skira, Mme Eugen Spiro, Jean Starobinski, Hans Thomann, Frédérique Tison, Antoinette de Watteville, Lady Weir, Pierre Zuccha, and those who wish to remain unnamed.

I received photographs, or assistance, from the Galerie Arts Anciens, Bevaix; the Galerie Claude Bernard, Paris; Galleria Il Gabbiano, Rome; Galerie Henriette Gomès, Paris; the B.C. Holland Gallery, Chicago; the Galerie Albert Loeb, Paris; the Gertrude Stein Gallery, New York; and E.V. Thaw & Co., New York.

I am very grateful to the Galerie Jan Krugier, Geneva. I also want to thank Maria Gaetana Matisse and Pierre Matisse of New York, who answered my many queries with great patience.

The Department of Painting and Sculpture of the Museum of Modern Art, New York, allowed me access to a number of their files on Balthus.

Christian Derouet, curator at the Musée national d'art moderne, Centre Georges Pompidou, Paris, kindly provided me with information about Balthus's 1934 exhibition at the Galerie Pierre. Marcel Schneider shared his knowledge of Marie-Laure de Noailles.

Ed Spiro duplicated many photographs, and Daniel D. Wheeler proved a selfless friend and adviser. Leo Steinberg offered an illuminating insight.

The staff of the Metropolitan Museum was very helpful. In particular I want to thank Kathleen Howard for her fine editorial suggestions and Anne M. Lantzius for her always gracious assistance.

I am most grateful to William S. Lieberman, chairman of the Department of Twentieth Century Art. He sponsored the two-year Andrew Mellon Fellowship that permitted me to complete my research here and abroad. He consulted me about an initial selection for the Paris and New York exhibitions, and he suggested that I write this catalogue. His seasoned counsel and encouragement have been invaluable.

Sabine Rewald

# BALTHUS

Fig. 1. Erich Klossowski, *Still Life with Fruit*, ca. 1930. Oil on canvas. Location unknown

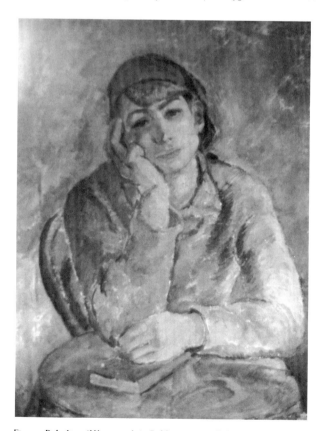

Fig. 2. Baladine (Klossowski), *Balthus*, 1924. Oil on canvas.
Private collection

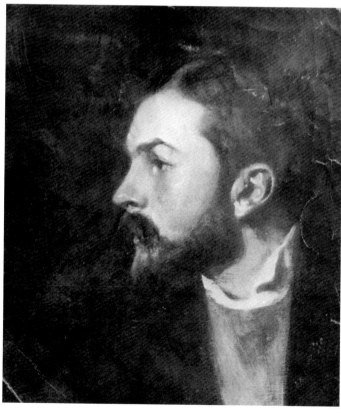

Fig. 3. Eugen Spiro, *Erich Klossowski*, ca. 1900. Oil on canvas.
Location unknown

I N 1922, WHEN HE WAS FOURTEEN, Balthus told a friend that he wanted to remain a child forever. In an important sense he made this wish come true—the thoughts, feelings, and impressions from his own adolescence would serve him for a lifetime of painting. In 1921 the poet Rainer Maria Rilke had already observed that Balthus "will remain in his dream and he will transform all reality to suit his creative needs."[1] This capacity to project his vision of reality precisely as he wished has contributed to the web of legend that, encouraged by Balthus, has wound itself around his life.

Balthus (Balthasar Klossowski) was born in Paris on February 29, 1908. In 1903 his parents had left Breslau in Silesia, then part of East Prussia, to live in Paris. His father, Erich Klossowski (1875–1946), held a doctorate in the fine arts. He was a painter (fig. 1) and art historian and wrote a study on Honoré Daumier that is still valued today. Balthus's mother, Elisabeth Dorothea (née Spiro; 1886–1969), also painted, exhibiting her works under the name Baladine (fig. 2). His older brother is the writer and artist Pierre Klossowski (b. 1905).

Like many Eastern Europeans, Balthus's forebears had been dislocated by the political and economic turmoil of the nineteenth century. In 1830, the year of Poland's War of Independence, an ill-fated revolt against Russian rule, the Klossowskis, an old Polish family entitled to the Rola coat of arms, left Warsaw. They took refuge in West Prussia, where they joined the ranks of Prussian nobility. Balthus's paternal grandfather, Leonard Klossowski, was a lawyer in Ragnit, East Prussia. In 1873 Balthus's maternal grandfather, Abraham Beer Spiro, and his family moved from their native Kovelitz in Novgorod near Minsk to Breslau in East Prussia where they acquired German citizenship. Spiro later became a cantor in Breslau and composed a great deal of music for religious services. One of his thirteen children was the painter Eugen Spiro (1874–1972), the best friend and, later, the brother-in-law of Erich Klossowski (fig. 3).

Thus Balthus grew up in an artistic and intellectual milieu. While his mother copied the works of Poussin in the Louvre, his father divided his time between writing and painting. Erich Klossowski was acquainted with Pierre Bonnard's circle of friends. He also belonged to

Fig. 4. Balthus, illustration for *Mitsou*, 1921. Published by
Rotapfel-Verlag, Zurich and Leipzig. The Metropolitan
Museum of Art, Gift of Mr. and Mrs. Pierre Matisse, 1983

Fig. 5. Balthus, illustration for *Mitsou*, 1921. Published by
Rotapfel-Verlag, Zurich and Leipzig. The Metropolitan
Museum of Art, Gift of Mr. and Mrs. Pierre Matisse, 1983

the group of German writers and artists who, like himself,
had left Breslau; among those who met at Le Dôme, a café
in Montparnasse, were Julius Meier-Graefe, Wilhelm
Uhde, and Eugen Spiro. Uhde had been a friend in Breslau,
where both studied with Richard Muther, a professor of
art history and editor of *Die Kunst*, the important series of
monographs on art to which Klossowski, Uhde, Meier-
Graefe, and Rilke had all contributed. Klossowski and
Meier-Graefe, a lifelong friend, wrote the catalogue
raisonné (published in Munich in 1908) of La Collection
Cheramy, a Parisian collection of paintings; in 1912 they
published *Orlando und Angelica*, a puppet play written by
Meier-Graefe with illustrations by Klossowski.

At the outbreak of World War I, the Klossowskis,
being German citizens, had to abandon Paris. They went
to Berlin, beginning a ten-year period of privation,
financial dependence on family and friends, and constant
relocation. During the war and postwar years, Erich
Klossowski became a successful stage designer for Berlin's
Lessing Theater whose director, Victor Barnowski, had
also come from Breslau. Nearly twenty years later, in
1934, Balthus would create his first stage designs for
Barnowski, when the latter directed Shakespeare's *As You
Like It* (*Comme il vous plaira*) at the Théâtre des Champs-
Elysées in Paris.

Beginning in early 1917, Erich and Baladine
Klossowski led separate lives in different cities. Baladine
moved with her two sons, first to Bern and then, only
months later, to Geneva. There they stayed with friends
before moving into a small furnished apartment. Part of
this period has been captured in the forty ink drawings
that illustrate *Mitsou*, a book in which the eleven-year-old
Balthus evokes his adventures with a stray tomcat. (Balthus
took some liberties with his surroundings; his illustra-
tions give the impression that he lived as an only child
with both his parents in a large country house, complete
with servants and garden.) These images are remarkable
for their draftsmanship, and their innate sense of
perspective, form, and drama makes captions superfluous
to the visual narrative (figs. 4 and 5). Albeit as austere as
woodcuts, they reveal a fine eye for detail. These works
are reminiscent of those of Frans Masereel, a Belgian
illustrator and engraver who lived in Geneva from 1916

to 1921. Baladine knew Masereel, and Balthus might have seen his woodcut illustrations for Pierre Jean Jouve's *Hôtel-Dieu*, a small book published in 1919.

The *Mitsou* illustrations with their inherent naiveté were admired by Emil Orlik, a well-known draftsman and printmaker who was a professor at the State Academy of the Berlin Museum of Fine Arts. One critic commented that "out of the childlike innocence of his picture book beckons something that is imponderable and strangely moving."[2] In a letter to Rilke in 1922, the publisher Kurt Wolff wrote that "the boy's ability to translate his feelings into graphic expression is astounding and almost frightening."[3]

In the autumn of 1920, during a visit to Baladine Klossowski, Rilke had been so enchanted by these drawings that he contributed a foreword in French and was instrumental in having them published by Rotapfel-Verlag, a Swiss-German firm, in 1921. The cover of *Mitsou* gave the artist's name as "Baltusz," as the young Klossowski then spelt his nickname; thereafter, on Rilke's suggestion, he signed his works with this childhood name.

Rilke had entered the life of the Klossowski family during the summer of 1919, and the loving friendship between the poet and Baladine is evident in their correspondence, which lasted until the poet's death in 1926 (fig. 6).[4] Baladine turned her apartment in Geneva, and later in Berlin, into a shrine dedicated to Rilke. She spent many hours absorbed by the poet, reading his works and writing to him. This correspondence sometimes assumed outlandish proportions. One day, for example, she began at 10 in the morning and at 6:30 in the evening she was still writing. She had a small table on which she kept the poet's own books and those by others that he sent her. In an unpublished letter she wrote to Rilke, "Your little altar is always decorated."

For Baladine this period was one in which "my sons were my schooling and my pleasure, and I was their playmate."[5] The Klossowski apartment existed in a world cut off from the watchful gaze of adults. In its complete remove from the conventions of ordinary life, its atmosphere seems to have anticipated that described by Jean Cocteau at the opening of his 1929 novel *Les Enfants terribles*. We know that mood well, for Balthus recreated it

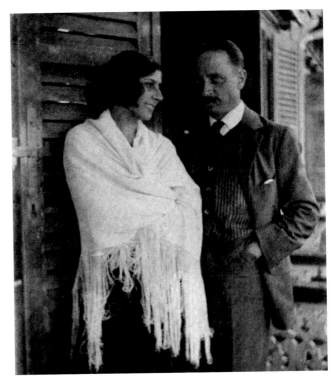

Fig. 6. Baladine Klossowski and Rainer Maria Rilke at Muzot, near Sierre (Valais), Switzerland, 1924

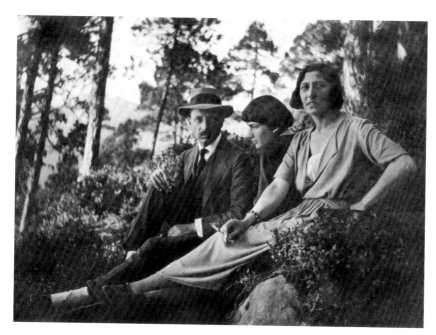

Fig. 7. Baladine Klossowski, Balthus, and Rainer Maria Rilke in Beatenberg, summer 1922. Courtesy of Mrs. Ilse Blumenthal-Weiss

many times in his later paintings of adolescents reading, sleeping, or dreaming in closed rooms. Just like Cocteau's little monsters, they spend much time in that "state of semiconsciousness in which children float immersed."[6] It seems unlikely that Balthus, always so busy, existed in this dreamy state; his mother did, however, and so do the models in his paintings.

Rilke became a guardian angel to the little family who, prey to the disorders then occurring in Germany, often hovered on the brink of poverty. As surrogate father and admired friend, Rilke fostered Balthus's "unique talent." Unfaltering in his support, he took charge of settling matters at Geneva's Lycée Calvin when Balthus failed an examination in geography.

In the spring of 1921 financial difficulties obliged Baladine to leave Geneva and move with her sons to Berlin, where they first lived with her brother Eugen Spiro and his family and later in their own apartment. Except for most of the summer and autumn months, the Klossowskis remained there until July 1923. In letters to friends, Rilke described their situation as "Russian pathos," because nothing could shield them from the nightmare of Berlin, a city troubled by political unrest, soaring inflation, labor strikes, and shortages of electricity, gas, and water. Baladine had no money to pay for private schooling for her sons. In the autumn of 1922, Balthus hoped to gain admission to the State Academy of the Museum of Applied Arts in Berlin, where Orlik was a professor, but nothing came of it. And so, unencumbered by school, Balthus was free to immerse himself completely in pursuits at which he excelled. He illustrated several Chinese novels and designed maquettes of stage sets for a Chinese play, offering them to the

Munich Staatstheater in 1922 for a proposed production that was never mounted. From about 1918 on, Balthus spent the summer months in Beatenberg, a picturesque village above the Lake of Thun in Switzerland. He worked there as the resident pupil and assistant to Margrit Bay, a sculptor who was part of a small arts-and-crafts group of anthroposophical spirit. Balthus joined in their artistic activities, their performances of medieval German plays, and their hikes into the nearby mountains, which in 1937 would become the setting for his large painting *The Mountain* (pl. 14). Rilke visited his protégé at Beatenberg in the summer of 1922 (fig. 7).

While Balthus and his brother Pierre lived in Berlin, Rilke's concern over their lack of schooling grew. As for Erich Klossowski, he visited Paris in the spring of 1922 to arrange Pierre's admission to the École Dramatique of the Théâtre du Vieux-Colombier. Rilke asked André Gide, who was a friend of Jacques Copeau, the director of the theater, to assist Klossowski. Gide and Klossowski liked each other, and Gide promised his help. This plan was not realized, however, because Pierre could not get a visa. Later, in November 1923, Pierre finally obtained the necessary documents and came to Paris. He stayed first at Gide's Villa Montmorency, then at his country house at Cuverville, and afterward at the apartment of a friend of Gide's. He did not attend the school of the Vieux-Colombier, but the Lycée Janson de Sailly, where he met Pierre Leyris, who later became a friend of Balthus's. Balthus, in the meantime, wrote such a persuasive letter to Gide that the writer invited him as well.

When Balthus came to Paris in March 1924, his interests were focused on film and theater. Soon after his arrival, he joined the team constructing the sets for *Les*

Fig. 8. Balthus, *Study of a Nude*, ca. 1923.
Pencil on kraft paper, 12 × 15 in. (31 ×
38 cm.). Private collection

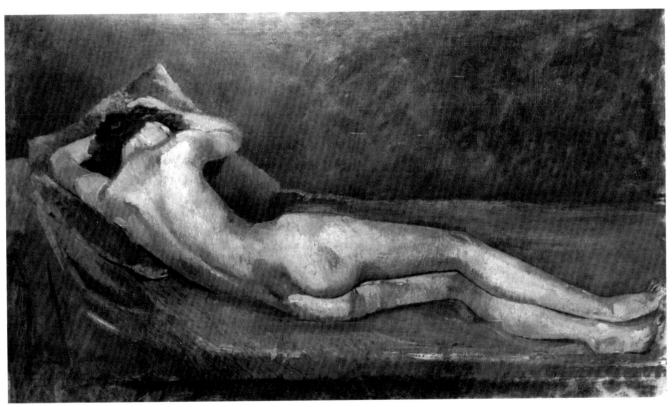

Fig. 9. Balthus, *Reclining Nude*, ca. 1924. Oil on canvas, 18⅞ × 31½ in. (48 × 80 cm.). Private collection

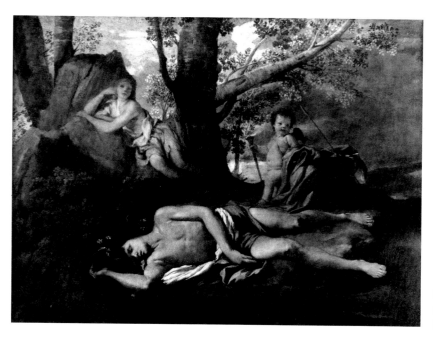

Fig. 10. Nicolas Poussin, *Echo and Narcissus*,
ca. 1627. Oil on canvas, 29⅛ × 39⅛ in.
(74 × 100 cm.). Musée du Louvre, Paris

*Soirées de Paris*, a series of avant-garde programs produced by Count Étienne de Beaumont at the Théâtre de la Cigale in May and June 1924. (Pablo Picasso, André Derain, and Georges Braque had been commissioned to design sets and costumes.)

For his training as a painter, Balthus proceeded for a while along a path of self-education that excluded art schools or painting lessons. Instead, he adopted an age-old method and concentrated on studying the Old Masters in the Louvre; he later continued this process in Italy. In 1924, however, Balthus frequently visited the informal sketching classes at the Grande Chaumière, where, in the evenings, Pierre Bonnard and Maurice Vlaminck offered advice to any who sought it. At these classes Balthus met other young artists and drew after a model, as he had done in Beatenberg (fig. 8).

Bonnard had seen Balthus's work during a visit to Baladine, and in October 1924 he, Maurice Denis, and Albert Marquet met with the young painter to look at a group of his recent pictures. *Reclining Nude* (ca. 1924; fig. 9), one of Balthus's earliest surviving paintings, may have been among this selection. Inspired by the Louvre's antique *Sleeping Hermaphrodite*, it evinces the fine technical mastery and subtle ambiguity that remained so characteristic of Balthus. The older painters liked what they saw and suggested that Balthus copy the works of Poussin, which he did during the autumn of 1925, setting his easel before *Echo and Narcissus* in the Louvre (fig. 10). His choice may have been determined by the small size of this exquisite composition as well as by Rilke's poem *Narcisse*, a work written in French in January 1925 and dedicated to Balthus. In it Rilke compares the figure of Narcissus, whose sleep and self-absorption symbolize

rebirth and recreation, to that of an artist. Balthus, in turn, dedicated his painting, now lost, to the poet with the inscription "À René" written on a rock. Thus was initiated the theme of narcissism whose symbols would appear throughout the painter's oeuvre.

Erich Klossowski had instilled in the young Balthus a deep admiration for the works of Piero della Francesca whom he described as the Cézanne of his time. Hence the decision of Balthus, unusual among French painters of his generation, to study *The Legend of the True Cross*, Piero's fresco cycle in the church of San Francesco in Arezzo. In August 1926, during his stay in Arezzo, Balthus wrote to a friend of his great admiration for Piero's art. Saying that the frescoes were the most beautiful he had ever seen, he praised the extraordinary colors and mathematical precision of the compositions. Feeling that words could not capture the reality of these frescoes, he made several small copies of them. His copy of the two-episode composition known as *The Invention and Recognition of the True Cross* (1926; figs. 11 and 12) discloses an overriding interest in formal order. Thus, once Balthus eliminated the damaged left-hand portion of the fresco, the demands of symmetry required that he also delete a section on the right-hand side. He chose the Renaissance church facade for his picture's edge. In his composition the pensive figure leaning on a spade finds itself in the picture's center and thus receives greater prominence. During his stay in Italy Balthus also studied and copied Piero's *Resurrection* (fig. 13) in the Pinacoteca at Borgo Sansepolcro as well as frescoes by Masolino and Masaccio in the Brancacci Chapel in Florence's Santa Maria del Carmine.

In the spring of 1927 Balthus applied the experience

16

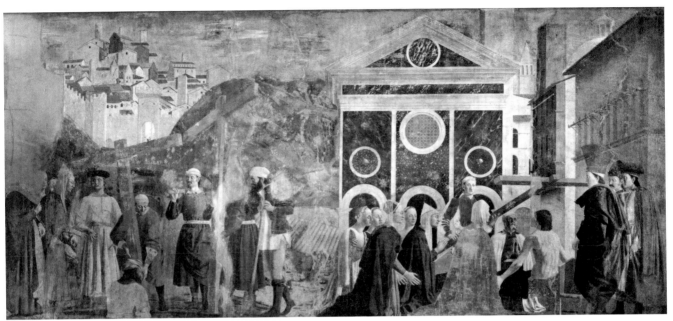

Fig. 11. Piero della Francesca, *The Invention and Recognition of the True Cross* from *The Legend of the True Cross*, probably 1453–54. Fresco. San Francesco, Arezzo

Fig. 12. Balthus, *Copy after Piero della Francesca's "The Invention and Recognition of the True Cross,"* 1926. Oil on cardboard, 17½ × 26¼ in. (45 × 67 cm.). Galerie Jan Krugier, Geneva

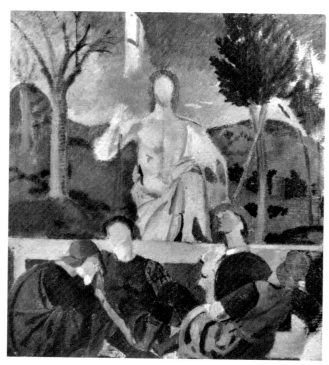

Fig. 13. Balthus, *Copy after Piero della Francesca's "Resurrection,"* 1926.
Oil on wood. 11⅛ × 12¼ in. (29 × 31 cm.). Galerie Jan
Krugier, Geneva.

and inspiration he had gained from his Italian studies to
the wall paintings he executed in tempera on the east
wall of the small Protestant church in Beatenberg. (On
his return from Italy in the fall of 1926, Balthus offered to
decorate the church interiors of the parishes of Beatenberg
and Einingen, but only the former accepted his offer.) In
the Beatenberg paintings Balthus depicted the Good
Shepherd flanked by the Evangelists—Luke and Mat-
thew on one side, and Mark and John on the other. A
local youth, slim and graceful, posed for the main figure
(fig. 14). He sported a straw hat and ankle rings and had
a fruit basket strapped to his hip. How much more man-
nered must have been the two earlier cartoon sketches,
which had been rejected by a shocked parish determined
to have an "earthier" shepherd? This "popular" interpreta-
tion of biblical figures, whose vivid coloring is still
remembered by the older residents of Beatenberg, led to
the removal of the frescoes during the church's restora-
tion in 1934.

Balthus was strongly influenced by Piero's "insistence
on representing Scripture in terms of daily experience."[7]
On a stormy day late in 1926, as he was crossing the Lake
of Thun, Balthus saw a young peasant woman's basket,
filled with apples, knocked over by a swell. As she bent
to pick up the apples, thunder sounded, and she held on
to her hat, which the wind was about to carry away. Her
frightened gesture captivated Balthus, who saw eternal
and biblical elements in it. At that time he was planning
a large painting of a scene from the Legend of Tobias.
This incident inspired him to cast the young woman as
Sarah and to use a contemporary setting. The episode
—Sarah recoiling in fright as the Angel Raphael flies
away—would be set in a Swiss household, and the Angel
Raphael would wear a peasant's hat. Only sketches
survive for this painting (figs. 15, 16, and 98), which
seems never to have materialized. Few, no doubt, would
have recognized a biblical scene in the finished work.
This notion of transposing a biblical theme into a
contemporary setting (and thus of concealing the identi-
ties of the figures) has a sly, even wicked whimsy about
it, an ambivalence that gives so much of Balthus's art its
unique quality.

Several years later, after he had assimilated some of

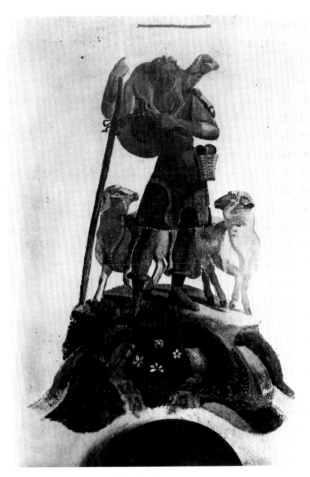

Fig. 14. Balthus, *The Good Shepherd*, 1927 (destroyed 1934).
Tempera wall painting. Protestant church, Beatenberg

Fig. 15. Balthus, *Study for "The Angel Raphael Leaving
Tobias and His Family,"* 1927. Ink on paper, 8⅝ × 5⅞ in.
(22 × 15 cm.). Private collection.

Fig. 16. Balthus, *Study for "The Angel Raphael Leaving
Tobias and His Family,"* 1927. Ink on paper, 10 × 7⅞ in.
(25 × 20 cm.). Private collection

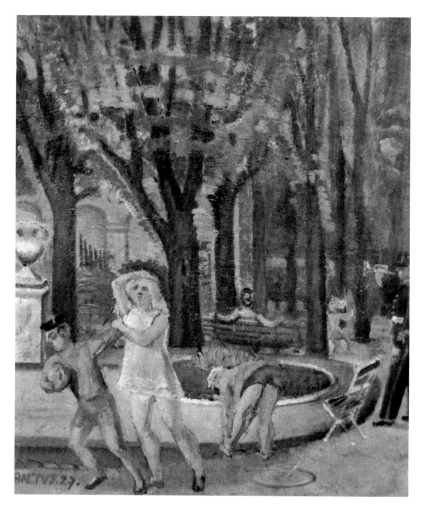

Fig. 17. Balthus, *The Luxembourg Gardens*, 1927.
Oil on canvas, 24¼ × 20 in. (63 × 51 cm.).
Donald Morris Gallery, Inc., Birmingham, Mich.
Photograph: Eric Pollitzer

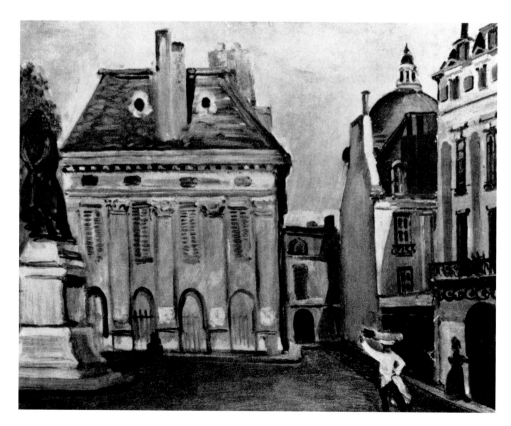

Fig. 18. Balthus, *Place de l'Institut*, 1929.
Oil on canvas, 25½ × 17 in. (65 × 43 cm.).
Private collection

the formalism characteristic of Piero, Balthus applied it to secular subjects. These subjects appear, from time to time, cast in the mold of known motifs, religious and other, that are taken from famous earlier paintings.

Balthus returned to Paris in the fall of 1927. Critics and writers were then deploring the lack of originality in the works of a new generation of artists who seemed lost between Cubism, Abstraction, Surrealism, and a conventional kind of figurative art. Balthus, however, appears to have suffered no such conflict, and for the next three years he worked in a deliberately naive and somewhat anachronistic manner, painting a series of small pictures devoted to his observations of the Parisian scene. The loose brushstrokes and modulated colors of these paintings are rather impressionistic and are reminiscent of Bonnard. In one group of works, which depict children in the Luxembourg Gardens, his interest was captured by the postures children exhibit at play while unobserved. *The Luxembourg Gardens* (1927; fig. 17) demonstrates Balthus's tendency to incorporate slyly humorous allusions in his paintings. Here the two children on the left are a mirror image of Adam and Eve in Masaccio's Expulsion fresco in the Brancacci Chapel. And we have seen the trumpet player on the right in Seurat's *Sunday Afternoon on the Island of La Grande Jatte.*

Another series of paintings portrays life in the squares of the fifth and sixth arrondissements, as in *Place de l'Institut* (1929; fig. 18), and along the quays of the Seine, as in *The Quay* (ca. 1928; fig. 19). By focusing on Le Vieux Paris, Balthus shared with the photographer Eugène Atget a love of scenes left untouched by time and progress. But unlike Atget, Balthus did not exclude people from his compositions. In fact, his figures, strategically placed against similar backgrounds, gradually grew larger and more prominent.

At the end of 1930 Balthus left Paris to do his fifteen-month military service in North Africa. In 1932 he returned briefly to Paris and then went to Switzerland. Working at the Bernisches Historisches Museum in Bern during the summer of 1932, he copied several paintings in Joseph Reinhardt's Swiss Peasant Costume Cycle (1787–97). Among the pictures he copied were *Kanton Zug,* with its portraits of Frantz Ludiger Kilchmeier and

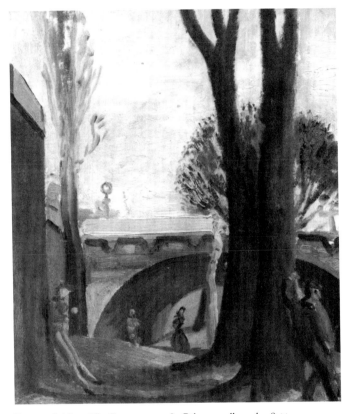

Fig. 19. Balthus, *The Quay*, ca. 1928. Oil on cardboard, 18 × 15 in. (46 × 38 cm.). Private collection

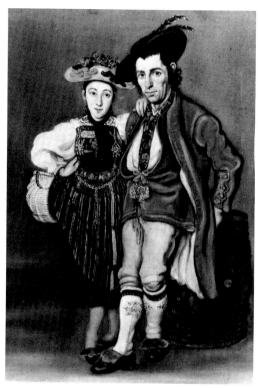

Fig. 20. Joseph Reinhardt, *Kanton Zug: Frantz Ludiger Kilchmeier and His Young Daughter*, 1794. Oil on canvas, 27½ × 19¾ in. (70 × 50 cm.). Historisches Museum, Bern

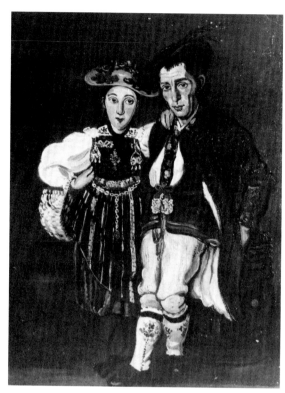

Fig. 21. Balthus, *Copy after Joseph Reinhardt's "Kanton Zug,"* 1932. Oil on canvas, 27½ × 19¾ in. (70 × 50 cm.). Location unknown

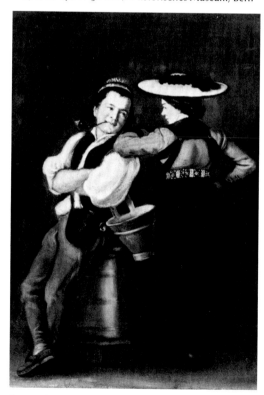

Fig. 22. Joseph Reinhardt, *Kanton Freiburg: Christen Heumann and His Young Sister*, 1795. Oil on canvas, 27½ × 19¾ in. (70 × 50 cm.). Historisches Museum, Bern

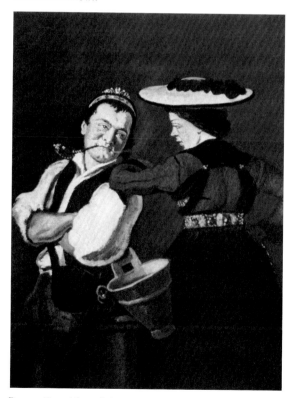

Fig. 23. Detail from Balthus, *Copy after Joseph Reinhardt's "Kanton Freiburg,"* 1932. Oil on canvas, 27½ × 19¾ in. (70 × 50 cm.). Location unknown

his young daughter (figs. 20 and 21), and *Kanton Freiburg*, which includes portraits of Christen Heumann and his young sister (figs. 22 and 23). In 1937 Balthus would incorporate Christen Heumann's pensive face in *The Mountain* (fig. 25; pl. 14). Balthus perceived a truth and liveliness in Reinhardt's pictures that appealed to him, and he was impressed by his skill at composing groups of two or three figures.

    *Kanton Bern: Emmentaler Bauernfamilie* (fig. 24) epitomizes Reinhardt's art. Here the artist combined archaizing mannerisms with close, candid observation and considerable economy of means. The clearly defined forms were demanded by the genre, whose purpose was to provide faithful documentation of Swiss costumes, down to the smallest details, including patterns, accessories, and buttons. On a practical level Balthus adopted this style because he wanted to sell his copies, but on a personal level he was sympathetic to Reinhardt's approach. This immersion in Reinhardt's work had far-reaching effects. At this time Balthus was experiencing grave doubts about his future as a painter; his letters disclose frustration, bitterness, and feelings of abandonment. But, as he later wrote to Margrit Bay, the copies that he made of Reinhardt's pictures taught him anew the métier of painting. Unfortunately these copies do not seem to have solved his grim financial problems. He sent the paintings to Margrit Bay in Beatenberg; although she did not have great success in selling them, she did pay him for them.

    In the autumn of 1932 Balthus applied the "Reinhardt manner" to two small portraits. *Antoinette de Watteville* (1932; fig. 26) depicts Balthus's future wife, a young Swiss woman whom he had earlier painted in his somewhat impressionistic period (fig. 27). The other portrait, *Pierre and Betty Leyris* (fig. 28), was painted during the winter of 1932–33, while he was living with these friends in Paris. A small work, it reveals formal qualities —the stark and shallow setting, the naive mannerism of the close-up presentation of the figures, the well-defined forms, and the flat, somber colors—that characterize much of Balthus's subsequent work. Like many of his paintings, it gives the impression of having frozen a moment in time; the ball of the toy, known as a "bilboquet" (cup and ball), seems suspended in midair. In

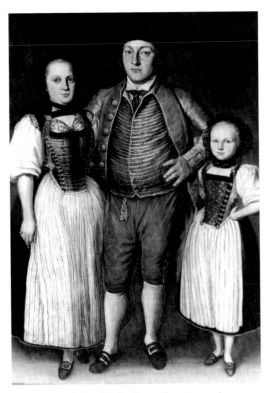

Fig. 24. Joseph Reinhardt, *Kanton Bern: Emmentaler Bauernfamilie*, 1791. Oil on canvas, 27½ × 19¾ in. (70 × 50 cm.). Historisches Museum, Bern

Fig. 25. Detail from Balthus, *The Mountain*, 1937. See pl. 14.

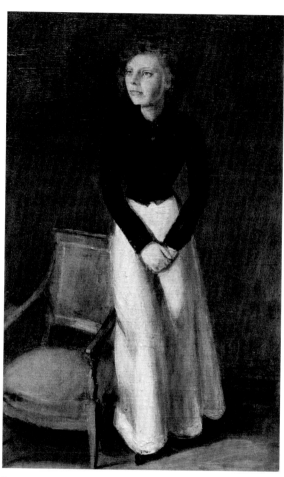

Fig. 26. Balthus, *Antoinette de Watteville*, 1932. Oil on canvas, 27½ × 19¾ in. (70 × 50 cm.). Pierre Matisse Gallery, New York

Fig. 27. Balthus, *Reclining Girl (Antoinette de Watteville)*, 1930. Oil on canvas, 37 × 29 in. (94 × 74 cm.). Collection Mrs. Vivian Newbury. Photograph: Michael Tropea

addition, the double portrait bears the hallmark of Balthus's oeuvre: the complete self-absorption in which the figures appear to be lost.

In 1933 Balthus became reinterested in Parisian street scenes, and in *The Street* (fig. 29; pl. 3) he treated the theme on a much larger scale. The painter represents the Rue Bourbon-le-Château, a little street just a few steps from the Rue de Furstenberg, where, at number 4, he had taken his first studio that spring. Real as the urban setting may be, it is peopled with imaginary and symbolic figures. *The Street* is an astonishing picture not only for its scale and haunting equivocality but also for its style, marked by sharp contours and flat, unmodulated colors (Balthus prepared his canvas with red underpaint to bring out the colors). Its overall unity is based on a rigorous structure that is determined by an underlying geometrical construction of lines, diagonals, and circles and by a coherent tonal value system. When a friend asked Balthus why he emphasized these geometrical elements in his works, the artist replied that they helped him find the forms of reality. The willful archaism of the handling recalls the *Images d'Épinal*, the popular nineteenth-century colored prints that were published in the town of Épinal, the capital of the Vosges department, and especially those sheets narrating the adventures of naughty boys (fig. 30). *The Street* also evokes illustrations made for tales of moral instruction by Heinrich Hoffmann-Donner, the author of *Der Struwwelpeter, König Nussknacker und der Arme Reinhold* (fig. 31), and other books.

What caused the change from Balthus's loosely impressionist manner to a style of clearly defined forms? Could it have been his response to the limpid light of Morocco, which he knew during his military service? Two writers have answered in the affirmative: John Russell, in an illuminating essay published by the Tate Gallery in 1968, and Jean Leymarie, whose poetic monograph on Balthus appeared in 1978.[8] But ironically the stylistic change could also have been the consequence of a totally different kind of experience—the artist's solitary work in that museum room in Bern.

In *The Street* the physical proximity of the figures merely accentuates their remoteness from one another. Those facing us, according to one interpretation, repre-

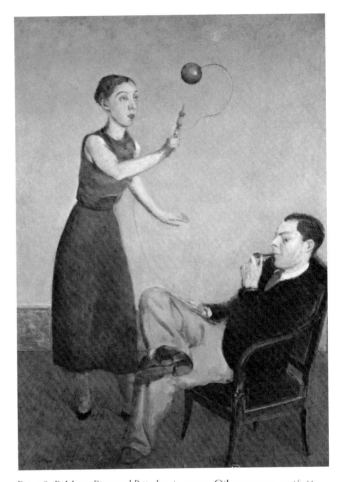

Fig. 28. Balthus, *Pierre and Betty Leyris*, 1933. Oil on canvas, 27½ × 19¾ in. (70 × 50 cm.). Gertrude Stein Gallery, New York

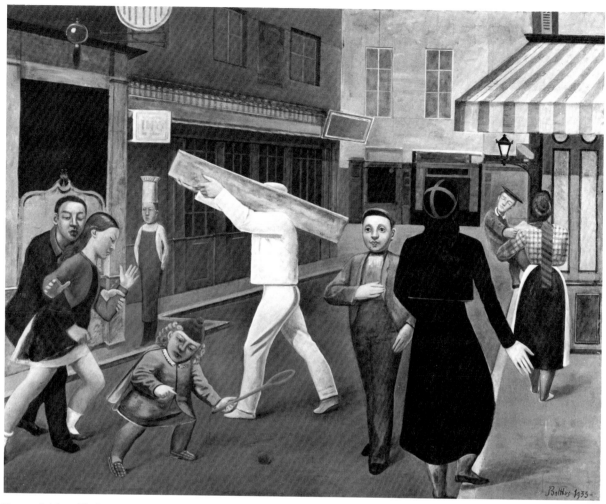

Fig. 29. Balthus, *The Street*, 1933. Oil on canvas, 76¾ × 94½ in. (195 × 240 cm.). The Museum of Modern Art, James Thrall Soby Bequest, 1979. See pl. 3.

Fig. 30. Detail from *Le Petit Vaurien*, *Images d'Épinal* no. 1158, Garçons no. 4, mid-nineteenth century

Fig. 31. Illustration from Heinrich Hoffmann-Donner, *König Nussknacker und der Arme Reinhold* (Frankfurt am Main, 1851)

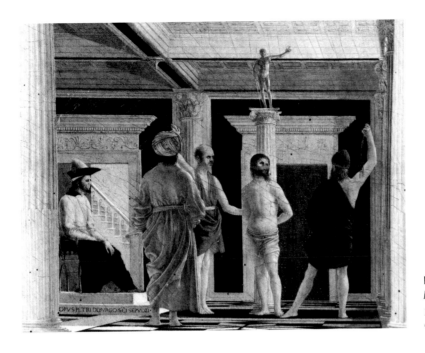

Fig. 32. Detail from Piero della Francesca, *Flagellation*, probably 1450s. Panel, 23¼ × 32 in. (59 × 81 cm.). Galleria Nazionale delle Marche, Palazzo Ducale, Urbino

sent characters from Lewis Carroll's *Through the Looking Glass*, with Tweedledee coming toward us. They mingle with others clearly inspired by Piero, such as the woman in black who, in a reversal typical of Balthus, appears as the figure in white in Piero's *Flagellation* (fig. 32). (John Russell, with remarkable insight, recognized in *The Street* the influence of Piero's *The Invention and Recognition of the True Cross*, even though Balthus's copy of it was then unknown.) The central position that the pensive peasant took in Balthus's copy (fig. 12) is now taken by the figure of the mason who forms the axis of *The Street*. These borrowings —the figures from Carroll and Piero who walk on a Parisian street—contribute to the sense of enchantment and wonder so often evoked by Balthus's work. The artist himself was pleased with this work, which he regarded as his first important painting. In June 1933, shortly after its completion, he told Margrit Bay that he had succeeded in expressing exactly what he wanted to say.

Balthus's friendship with André Derain dates from this period. He often visited the older painter whose advice and great experience were surely not without consequence. Certainly the restricted palette of *The Street* is similar to that recommended by Derain in his notes for a planned, but never published, treatise to be called *De l'art de peindre*.[9]

Pierre Loeb owned the Galerie Pierre in Paris, where he exhibited the works of the Surrealists and the avant-garde. Taken to Balthus's studio by Wilhelm Uhde, Loeb was especially impressed by *The Street*. The dealer saw the original state of this picture; around 1954, at the request of James Thrall Soby, the owner of the painting, Balthus altered the "naughty" passage on the left (fig. 33).

Fig. 33. Detail from Balthus, *The Street*, 1933. Before alteration by the artist in ca. 1954. See fig. 29 and pl. 3.

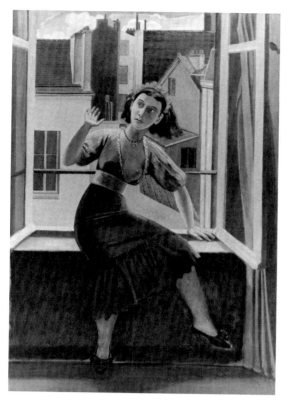

Fig. 34. Balthus, *The Window*, 1933. Oil on canvas, 63¼ × 44⅛ in. (161 × 112 cm.). Courtesy of the Indiana University Art Museum, Bloomington. See pl. 6.

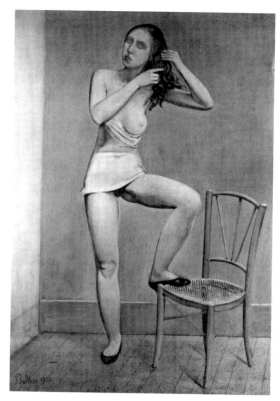

Fig. 35. Balthus, *Alice*, 1933. Oil on canvas, 67 × 51 in. (170 × 130 cm.). Private collection

In April 1934 the Galerie Pierre gave Balthus his first exhibition; it caused what the period loved to call a "scandal." The Galerie Pierre showed, besides two small portraits, *The Street* and four other large paintings that Balthus had prepared for his first exhibition: *The Window* (fig. 34; pl. 6), *Alice* (fig. 35), *Cathy Dressing* (fig. 36; pl. 5), and *The Guitar Lesson* (fig. 37). Although uniformly endowed with provocative situations and obvious eroticism, the pictures seemed all the more sensational for the commonplaceness and familiarity of their subjects and their muted tonality. Balthus defined his forms with sharp contours, and the resulting hardness and angularity suggested that the erotic content was not without a touch of sadomasochism.

Balthus has always maintained a continuous dialogue with his oeuvre, often returning years later to favorite motifs and subjects. Thus, the gesture of the young model in *The Window* evokes that of the frightened Sarah, albeit in different circumstances.

Since his return from Bern at the end of 1932, Balthus had worked on illustrations for Emily Brontë's novel *Wuthering Heights* (1848). *Cathy Dressing* is inspired by an episode from the novel. Balthus, however, transformed a relatively innocent encounter into a prelude for an erotic ritual, with Cathy and Heathcliff portrayed with the features of Antoinette de Watteville and the artist himself.

*Alice* surprises by its matter-of-fact representation of

a young woman, who stands, provocatively semi-naked, combing her hair in a bare corner of the painter's studio. If the painting's surface is thought of as a mirror in front of which Alice stands and looks at herself, the viewer becomes a voyeur. The title might be an allusion to *Through the Looking Glass* by Lewis Carroll, whose works Balthus treasured. Suggestive, sensual warmth radiates from the picture, which is painted almost entirely in tones of amber and honey. The figure's sexual accessibility is, however, contradicted by the remote expression of her clouded eyes. The writer Antonin Artaud, a friend of the painter's, described this ambiguity in his review of the exhibition: "Balthus paints, primarily, light and form. By the light of a wall, a polished floor, a chair, or an epidermis he invites us to enter into the mystery of a human body. That body has a sex, and that sex makes itself clear to us, with all the asperities that go with it. The nude I have in mind has about it something harsh, something tough, something unyielding, and—there is no gainsaying the fact—something cruel. It is an invitation to lovemaking, but one that does not dissimulate the dangers involved."[10]

*Alice* and *The Window*, which were both painted after a model, are marked by a realism that is absent from the other large works exhibited at the Galerie Pierre. In this second group imaginary themes are represented in a strongly stylized manner, which is most pronounced in *The Guitar Lesson*. Here the lesson has turned into a sexual

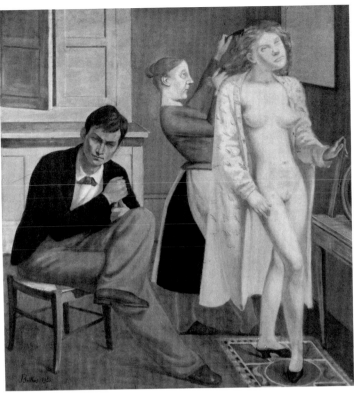

Fig. 36. Balthus, *Cathy Dressing*, 1933. Oil on canvas, 65 × 59 in. (165 × 150 cm.). Musée national d'art moderne, Centre Georges Pompidou, Paris. See fig. 47 and pl. 5.

initiation rite, but Balthus presents the shocking imaginary incident with the simplicity of a children's book image. His palette is somber; only the red of the girl's jacket and the white of her exposed skin stand out. This work parodies the traditional theme of the music lesson, which often contains an allusion to erotic play. Parody becomes blasphemy when we realize that the composition may be based upon that of a Pietà (fig. 38). Themes of this character have usually been handled in more intimate formats and kept in portfolios or indeed have remained restricted to the realms of popular and ribald pornography (fig. 39). In fact, during the two-week exhibition at the Galerie Pierre, *The Guitar Lesson* remained in a back room, accessible only to selected viewers.

When Balthus painted *The Guitar Lesson* in early 1934, he was bitterly disappointed over the Beatenberg parish's decision to remove his wall paintings. Could it be that he intended the blasphemous note in this picture as a symbolic act of revenge? Whatever else he may have had in mind, the artist deliberated the painting in several existing preparatory studies. One representing both figures (fig. 40) compares in style to the artist's sketches for the *Wuthering Heights* illustrations (pls. 52–65). Firmer contours define the image in the various drawings for the single figure of the girl (figs. 41 and 42). This motif would reappear in *The Victim* (fig. 43; pl. 20), a large canvas from 1939–46, as well as in *The Week with Four "Thursdays"* (pl. 30), a series of 1949. (In 1949 Balthus also recast

the two-figure theme of *The Guitar Lesson* in a drawing [fig. 44], but this time he made the music teacher a man.)

Even today those who visited the Galerie Pierre in April 1934 use words like "surprise," "shock," and "amazement" to define their reactions. In a letter to Margrit Bay written while the pictures still hung in the Galerie Pierre, Balthus remarked that he had wanted to disturb the viewer's conscience. He succeeded in shocking, but the result was that no one in Paris would buy his paintings. Only in 1937 did the Galerie Pierre sell *The Street* to the American collector James Thrall Soby who had fallen in love with it at first sight. It was the first of many of Balthus's paintings to enter an American collection. (In 1938 Pierre Matisse began showing Balthus's works in his gallery in New York where today he continues to be the sole representative of the artist.)

In 1934 some French critics reacted in a derisive manner, accusing the painter of "morbidity" and calling him a "fanatic of nymphomania" or simply the "Freud of painting."[11] The poets and writers who were the artist's friends did not share these opinions. Among the first in a long line of literati who admired the works of Balthus, Antonin Artaud and Pierre Jean Jouve discerned analogies to their own art in Balthus's paintings. Jouve's writing stems from a symbolist tradition that, while under the influence of Freudian theories during the mid-1920s, drew inspiration from dreams and the unconscious. Often mystical, his themes evolve around

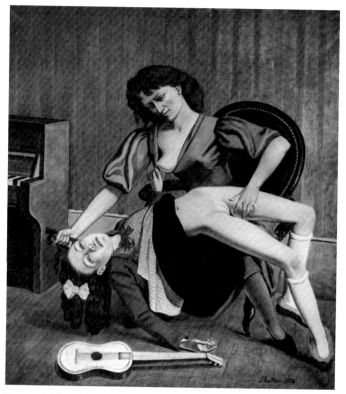

Fig. 37. Balthus, *The Guitar Lesson*, 1934. Oil on canvas, 63½ × 54½ in. (161 × 139 cm.). Private collection

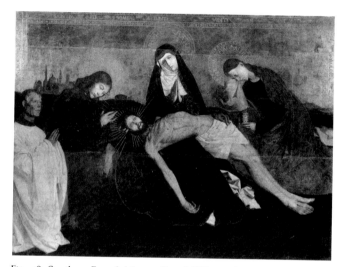

Fig. 38. Southern French Master, *Pietà de Villeneuve-les-Avignons*, ca. 1470. Panel, 64 × 86 in. (163 × 218 cm.). Musée du Louvre, Paris

Fig. 39. G. Topfer, *Spanking for Laughter*. Book illustration. Institute for Sex Research, Indiana University, Bloomington

Fig. 40. Balthus, *Study for "The Guitar Lesson,"* ca. 1934. Ink on paper. Location unknown

Fig. 41. Balthus, *Study for "The Guitar Lesson,"* ca. 1934. Ink on paper, 7⅝ × 11¾ in. (19 × 30 cm.). Collection John Rewald

Fig. 44. Balthus, *Study after "The Guitar Lesson,"* 1949. Pencil on paper, 11⅜ × 7½ in. (29 × 19 cm.). Private collection

Fig. 42. Balthus, *Study for "The Guitar Lesson,"* ca. 1934. Pencil on paper, 7½ × 12 in. (19 × 31 cm.). Collection Arnold H. Crane

Fig. 43. Balthus, *The Victim,* 1939–46. Oil on canvas, 52¼ × 86½ in. (133 × 220 cm.) Private collection. See pl. 20

Fig. 45. Balthus, *Antonin Artaud*, 1935. Ink on paper, 9½ × 8⅛ in. (24 × 21 cm.). Collection Pierre Matisse, New York

sin and salvation, Eros and death. Then, during World War II, his voice turned prophetic and his vision apocalyptic. The relationship between the poet and the painter might be described as one of correspondence. Thus, the entranced, magical sense of equivocality, shifting between dream and reality, that characterizes Jouve's *Histoires sanglantes* (1932) can also be found in *The Street* and in the other paintings in the Galerie Pierre exhibition. Similarly, in his novel *Dans les années profondes* (1935), set in Switzerland's mountainous Engadine, Jouve created literary images that, in their magical clarity, evoke the sharp definition that forms assume in the crystalline atmosphere of great heights, a clarity that Balthus captured in *The Mountain*. Jouve discovered secret and stirring symbols in Balthus's paintings. They can also be found in his own works, such as the number seven, which symbolizes woman in his writings, in the novel *La Victime* (1935), which he dedicated to Balthus, and in *Dans les années profondes*. Perhaps the latter inspired Balthus to put seven figures in *The Mountain*.

In 1924 Jouve had collaborated with his wife, the psychoanalyst Dr. Blanche Reverchon-Jouve, on the French translation of Freud's *Three Essays on the Theory of Sexuality*, the fundamental study of the Oedipus complex and of the development of sexuality in childhood. Balthus was an intimate of the Jouve household, and had he wanted to familiarize himself with Freudian theories, of which his works betray some knowledge, this would have posed no problem.

Balthus first met Artaud in the early 1930s at Aux Deux Magots, the café favored by Parisian artists. The two men bore a striking resemblance to one another, a phenomenon that gives Balthus's portrait of Artaud, executed on the back of Le Dôme notepaper (fig. 45), the aspect of a self-portrait. Artaud (fig. 46), in turn, could have identified with Balthus's self-portrait in *Cathy Dressing* (fig. 47).

Artaud, in writings and manifestos alike, called for a theater that would neither entertain nor present ordinary plays, but would involve famous historical and mythical figures performing extraordinary deeds. He was contemptuous of art dealing with any aspect of daily life. In 1924 he praised those young artists who could paint cardplayers

so that they "looked like gods."[12] Artaud especially admired those of Balthus's pictures in which the figures looked like persons from "smoldering dramas, surprised in a moment of daily routine."[13] In 1936 Artaud became the first writer to publish a penetrating analysis of Balthus's work, in which he too perceived a symbolism not evident at first glance. While criticizing the Surrealist rearrangement of forms, he praised Balthus for reconstructing the world from appearances, in a style Artaud had earlier characterized as Organic Realism.

In 1934 Artaud had admired the somber fairy-tale forest designed by Balthus for Victor Barnowski's production of Shakespeare's *As You Like It* (*Comme il vous plaira*) (fig. 48). In his review Artaud wrote, "In this play all of Balthus's forests are deep, mysterious, and full of somber grandeur. Unlike the usual forests on stage, they contain darkness and rhythm that speak to the soul."[14] Artaud then commissioned Balthus to prepare the sets and costumes for his production of *Les Cenci*, which opened at the Théâtre aux Folies Wagram in Paris in May 1935 (fig. 50). The play is based on a verse drama by Shelley; he had in turn derived the theme from Stendhal's translation of Renaissance court papers, which told a tale of rape, incest, and murder in a noble Roman family. *Les Cenci* was supposed to initiate, or "prepare" as Artaud put it, the Theater of Cruelty that he envisaged, but which never, in fact, came into existence. Artaud's ideas, however, had a great influence on the postwar theater. A commercial failure, *Les Cenci* ran for only fifteen performances, the final one attended by only ten or fifteen people. Balthus's contribution, however, was successful as far as the critics were concerned. The ink drawings for the set (fig. 49) represented the Cenci palace in Rome and were inspired by Piranesi's *Imaginary Prisons* (1760–61). The set's main elements were wooden screens covered with painted canvas (figs. 51 and 52).

Artaud's notoriety and the social position of Lady Iya Abdy, who played a leading role, turned the premiere into an event attended by reporters from every Parisian newspaper and from the American paper *Women's Wear Daily* (the latter commented only on Lady Abdy's costumes, on- and off-stage). Balthus painted a portrait of Lady Abdy in 1935 (pl. 8). In the artist's studio on the

Fig. 46. Antonin Artaud, ca. 1930. Photograph: Roger-Viollet

Fig. 47. Detail from Balthus, *Cathy Dressing*, 1933. Self-portrait of the artist as Heathcliff. See fig. 36 and pl. 5.

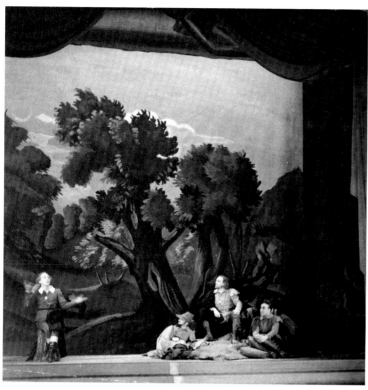

Fig. 48. Set by Balthus for *As You Like It*, Paris, 1934.
Photograph: Lipnitzki Viollet

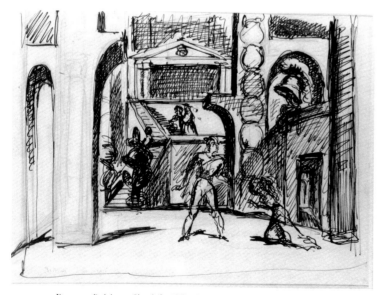

Fig. 49. Balthus, *Sketch for "The Cenci,"* 1935. Ink on paper, 12 ×
15 in. (31 × 28 cm.). Collection Pierre Matisse, New York

Rue de Furstenberg she still appears to play her role of
Beatrice Cenci. This picture is one of a group of nearly
twenty portraits dating from 1934–37; during this period
following the Galerie Pierre exhibition, Balthus worked
almost exclusively in this genre, and these works were his
only source of income.

In these portraits Balthus reduced his palette to a
narrow, almost monochromatic range of browns, ochers,
grays, and blacks, enlivened only by an occasional patch
of red in a blouse, a tie, or piping on a dress. His style
slowly moved away from Reinhardt's archaizing manner
in *Mme Pierre Loeb* (1934; fig. 53; pl. 7) to Courbet's
sensuous realism in *The White Skirt* (fig. 54; pl. 13 ), a
portrait of Antoinette de Watteville painted in 1937, the
year of their marriage. In his commissioned portraits,
which Balthus called his "monsters," he mingled
truthfulness, stylization, and elements of the bizarre. In
*Lelia Caetani* (1935; fig. 55), for example, Balthus accentu-
ated the subject's characteristic air of detachment and
pensiveness by placing her in surroundings found in
children's picture books. As Carroll's Alice would do
from time to time, she towers over trees and lamppost.
The site depicted is the Rond Point des Champs-Elysées
in Paris (the church is an invention); only a few steps
away is the Rue du Cirque, where Princess Marguerite of
Bassiano, who commissioned this portrait of her daugh-
ter, had an apartment.

Balthus probes his sitters' psyches; he perceives
aspects, perhaps unknown to his subjects until years
later, that he magnifies on the canvas. Never flattering,
these portraits are often disquieting, even sinister. They
bring to mind the remarks on identity made by the
American photographer Diane Arbus: "Our whole dis-
guise is like giving a sign to the world to think of us in a
certain way but there's a point between what you want
people to know about you and what you can't help
people knowing about you. And that has to do with what
I've always called the gap between intention and effect."[15]

Balthus's sitters, shorn of disguise and pretense,
appear caught in this "gap." Thus sitting for such a
portrait must have proved a challenge for strong person-
alities like Marie-Laure, vicomtesse de Noailles (fig. 56;
pl. 11). She was one of Paris's most celebrated hostesses,

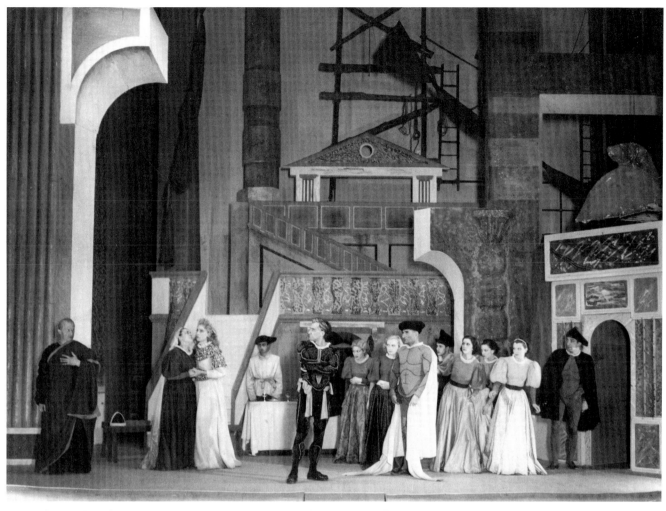

Fig. 50. Set by Balthus for Artaud's *Les Cenci*, Paris, 1935. Photograph: Lipnitzki-Viollet

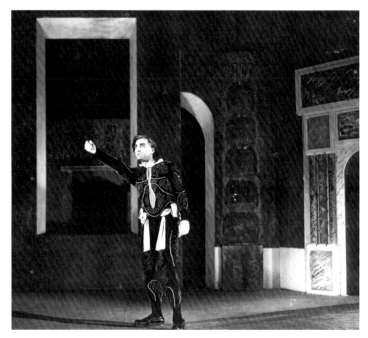

Fig. 51. Antonin Artaud in his production of *Les Cenci*, 1935. Photograph: Lipnitzki-Viollet

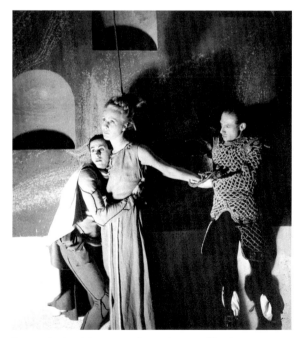

Fig. 52. Lady Abdy in Artaud's production of *Les Cenci*, 1935. Photograph: Lipnitzki-Viollet

Fig. 53. Balthus, *Mme Pierre Loeb*, 1934. Oil on canvas, 28¼ × 20½ in. (72 × 52 cm.). Collection Albert Loeb. See pl. 7.

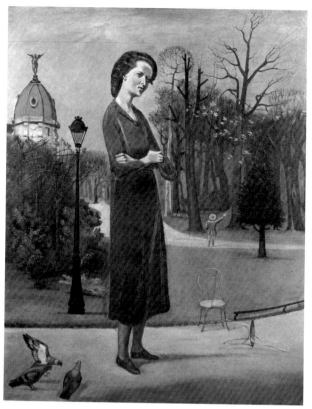

Fig. 55. Balthus, *Lelia Caetani*, 1935. Oil on canvas, 45½ × 34½ in. (116 × 88 cm.). Private collection

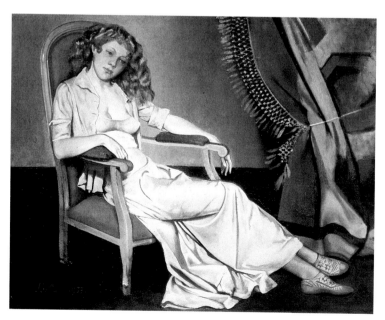

Fig. 54. Balthus, *The White Skirt*, 1937. Oil on canvas, 51¼ × 63¾ in. (130 × 162 cm.). Private collection. See pl. 13.

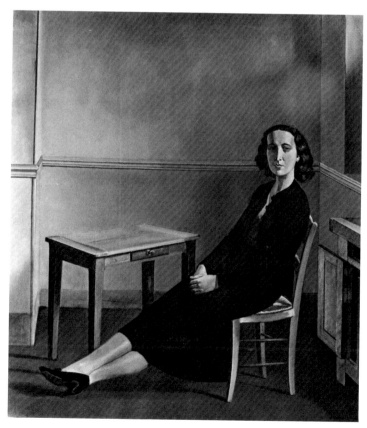

Fig. 56. Balthus, *The Vicomtesse de Noailles*, 1936. Oil on canvas, 62¼ × 53⅛ in. (158 × 135 cm.). Private collection. See pl. 11.

Fig. 57. Balthus, *Joan Miró and His Daughter Dolores*, 1937–38.
Oil on canvas, 51¼ × 35 in. (130 × 89 cm.). The Museum of
Modern Art, New York, Abby Aldrich Rockefeller Fund, 1938.
See pl. 12.

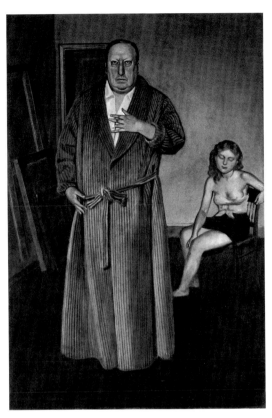

Fig. 58. Balthus, *André Derain*, 1936. Oil on wood,
44⅛ × 28½ in. (113 × 72 cm.). The Museum of
Modern Art, Acquired through the Lillie P. Bliss
Bequest, 1944. See pl. 10.

welcoming artists and society figures to her luxurious
house on the Place des États-Unis in Paris. Balthus,
however, portrays her in the cell-like setting of his studio
at the Cour de Rohan to which he had moved in 1936.

In *Joan Miró and His Daughter Dolores* (1937–38;
fig. 57; pl. 12) and *André Derain* (1936; fig. 58; pl. 10),
Balthus used the backgrounds of the pictures to comment
on the subjects' painting styles. In the Miró picture, with
its flattened space and strong horizon line, Balthus slyly
alluded to the Abstract Surrealist works the Spanish
painter was then producing. Derain, on the other hand,
embraced the world of appearances, and so Balthus set
him within the context of his own studio, flanked by a
nude model and stacked canvases. While wittily acknowl-
edging two such opposing tendencies as Abstract Surreal-
ism and Neo-Realism, Balthus continued to cultivate
what Artaud termed a "reaction against Surrealism."[16]
Consequently, Balthus has been grouped with the
Neo-Romantics Christian Bérard, Eugène Berman, and
Pavel Tchelitchew. In reality, however, he eludes cate-
gorization. Indeed it is by avoiding labels and concentrat-
ing on the differences between his art and that of his
contemporaries that we can best perceive and appreciate
Balthus's inimitable qualities.

A delegation of Surrealists—André Breton, Paul
Éluard, Georges Hugnet, and Alberto Giacometti—

visited Balthus before his exhibition at the Galerie
Pierre. This meeting ended in argument, but it marked
the beginning of his friendship with Giacometti. Balthus
did share with some of the Surrealists a preference for
clear forms capable of producing shock. But whereas the
Surrealists treated form and space irrationally and usually
cared little for structure, Balthus composed his pictures
with the skill of an architect and favored a Renaissance
conception of space. He did not mingle aspects of the
irrational with those of reality, though his reality is not
quite that of daily life.

The German painters of the Neue Sachlichkeit (New
Objectivity) were also Balthus's contemporaries. They
depicted their milieu with such clinical objectivity that
their works allow one to reconstruct the fashions, coiffures,
interiors, furnishings, and social life of Germany during
the 1920s and 1930s. But one could not recreate the Paris
of the 1930s from Balthus's paintings. In his striving for a
classical order, a refined aestheticism, and a sense of
timelessness, he tends to suppress references to the
contemporary. His interiors are usually bare or sparsely
furnished. Space and the position of each object are
clearly defined; objects form still lifes. The subdued and
somber hues of his palette reinforce the remoteness of his
figures. But within these austere and hushed interiors
often lurks something foreboding and disorienting; there

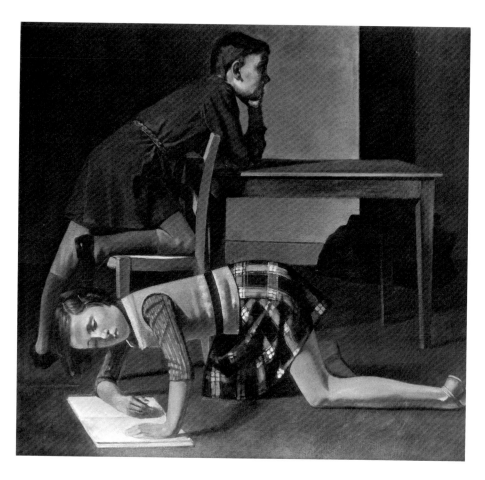

Fig. 59. Balthus, *The Children*, 1937.
Oil on canvas, 49¼ × 50¾ in. (125 ×
129 cm.). Musée du Louvre, Paris,
Donation Pablo Picasso. See pl. 16.

is a tension between "the commonplace and the disquieting, between innocence and blatant immodesty, privacy and public display."[17]

The German painter Georg Schrimpf does, however, show a certain affinity to Balthus. His pictures reflect study of the Italian masters, and in their simplified forms, in the stillness of their figures, and in their daydreaming or pensive girls, they are not unlike Balthus's later works.

In 1937, while continuing to paint portraits, Balthus returned to compositions similar to those of the Galerie Pierre works. His themes, however, were not markedly erotic or scandal-provoking; now they encompassed moods and settings as varied as anger in *Still Life* (pl. 15) and serenity in *The Mountain* (pl. 14), an allegory that was to form part of a never completed cycle of the seasons. He evoked moodiness in *The Children* (fig. 59; pl. 16), which has as a backdrop the forbidding austerity of his studio. The two young models, the sister and brother Thérèse and Hubert Blanchard, were neighbors. For this picture, Balthus cast them into the positions of Heathcliff and Cathy from one of his illustrations for *Wuthering Heights* (pl. 53), upon which the composition of this painting is based. Then, one year later in 1938, he executed pencil studies (figs. 60 and 61) after Thérèse's and Hubert's positions in *The Children*. These postures reappear in a series of paintings that continues today.

Like these studies, the few drawings that survive from this period are for the most part in a smudged condition, showing the artist's casual attitude toward them. For Balthus, one of the finest draftsmen of his day, they counted for little more than working sketches, to be tossed aside once they had served their immediate purpose. Balthus frequently left his drawings unfinished, abandoning them when he had solved specific formal problems. The medium may be pen and ink, crayon, or watercolor, and the handling varies from fluidity to staccato, from rawness to Ingresque refinement. These works often show a spontaneity and a gentleness that his paintings frequently lack. The drawings for *Wuthering Heights*, however, occupy a special place within the painter's oeuvre. He executed numerous preparatory studies until for the final fourteen illustrations (pls. 52–65) he adopted the stark style then characteristic of his paintings. No French artist had illustrated Emily Brontë's novel, a book that Balthus greatly admired.[18] It is set in the wild moors of Yorkshire and tells of the love between Cathy and Heathcliff. Formed during childhood, the fateful bond between them haunts and destroys them as adults.

Brontë's language is evocative, often describing the realm that exists between dream and reality. Balthus succeeded in translating the novel's foreboding and magical atmosphere into nervous black ink strokes. The thick

Fig. 60. Balthus, *Study after "The Children,"* 1937. Pencil on paper, 7¼ × 5¾ in. (18 × 15 cm.). Private collection

Fig. 61. Balthus, *Study after "The Children,"* 1938. Pencil on paper, 5¾ × 7⅜ in. (15 × 19 cm.). Private collection

contours that form his figures lift them relief-like from their surroundings.

The fourteen illustrations cover only the first part of the novel, focusing mainly on Cathy's and Heathcliff's adolescence. The first illustration (fig. 63; pl. 52) introduces the theme of the entire series—the separation between the world of adults and the world of Cathy and Heathcliff. At first cruel and active participants, these adults become mere onlookers when the world of childhood has been closed to them.

The figures of Heathcliff and Cathy—whose features are those of Balthus and Antoinette de Watteville—dominate the bare interiors and landscapes. Their movements appear unbalanced and stilted, and their bodies and hair are taut, almost electrified. The intentional stiffness of their gestures conveys the violence of a passion kept barely in check.

The many preparatory drawings for *Wuthering Heights* were begun at the end of 1932. Although usually dated 1933, the final illustrations appear more plausibly to have been done in 1934–35, for in June 1933, while preparing the Galerie Pierre exhibition, then planned for the following winter, Balthus told Margrit Bay that he was still far from completing the drawings.

Balthus had stopped painting after the exhibition, because, in Jouve's words, it "put him so much to the test

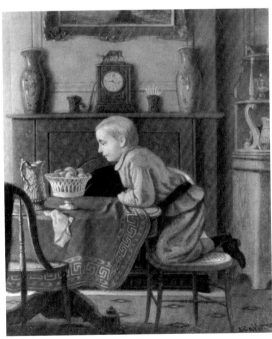

Fig. 62. John Carlin, *Forbidden Fruit*, 1874. Oil on canvas, 12 × 10 in. (31 × 25 cm.). Hirschl & Adler Galleries, New York. Photograph: Helga Photo Studio

Fig. 63. Balthus, *Illustration for Emily Bronte's "Wuthering Heights,"* ("Pull his hair when you go by . . ."), 1934–35. Ink on paper, 10 × 9½ in. (25 × 24 cm.). Private collection

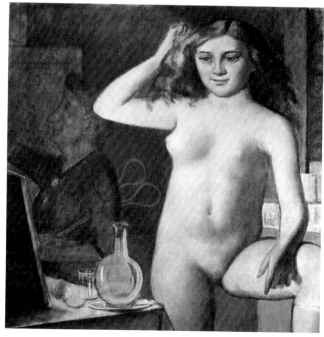

Fig. 64. Balthus, *Georgette Dressing*, 1948–49. Oil on canvas, 38 × 36½ in. (97 × 93 cm.). Private collection. Photograph: eeva-inkeri

and exposed him to such a degree that he suffered a severe crisis afterwards in spite of outer appearances of success."[19] It seems likely that during this period of withdrawal Balthus completed the *Wuthering Heights* illustrations, eight of which were published in late 1935 in the periodical *Minotaure.*

*Wuthering Heights* provided Balthus with an opportunity to work with his most personal theme—adolescents isolated in rooms closed to the outside world. When adults do appear, they serve to emphasize the remoteness of the adolescents. The figure of the elderly maid recurs in Balthus's paintings. She first appeared in *The Quays* (pl. 1), a work of 1929; we find her again as Nelly throughout the *Wuthering Heights* illustrations, and she combs Cathy's hair in *Cathy Dressing.* In the 1948–49 series *Georgette Dressing* (fig. 64), an elderly maid hovers in the background as a nude adolescent peers into a mirror. Very old and bent, she is seen for the last time in *The Passage du Commerce Saint-André* (1952–54; pl. 33).

In Balthus's world boys assume a rather passive role. They are subdued mates or losing partners in card games. Meanwhile girls and cats reign supreme. Analogies to this world removed from that of men can be found in the works of Rilke, dominated as they are by "children, and women, both young and old."[20] The poet always stressed the importance of childhood. His own, which in retrospect he regarded as unhappy, was his source of creation in both his poetry and prose. In Balthus's *The Children* (fig. 59; pl. 16), one finds a mood expressed in lines from Rilke's poem *Dauer der Kindheit* (Childhood) written on July 5, 1924:

> A child's long afternoon
> not yet fully alive, still maturing
> subject to growing pains
> helpless period of waiting. . .
> lonely afternoons
> gazing from one mirror to another. . .[21]

Balthus never casts his children as pretty objects, depicted with bowls of fruit, mantel clocks, and patterned table covers in an overstuffed Victorian interior, as did the American painter John Carlin in his *Forbidden Fruit* (1874; fig. 62). Instead, set against a harsh back-

ground, they appear all-important, as they would to someone their own age. The Balthusian children, when awake, rarely smile. They remain remote, pensive, lost in daydreams. These dreams sometimes produce languid abandon; at other times they induce the gangling postures that convey the sexual ambiguities that are part of puberty.

Between 1936 and 1938, Balthus executed a series of works for which the young Thérèse Blanchard served as a model. Among the earliest of these is *Thérèse* (fig. 65), executed in 1936. With tender intuition Balthus catches the girl's grave look and endows her with fragile dignity.

Balthus denies that his paintings of adolescents have an erotic content and insists that he cares only about structure. Many viewers, however, find these works poignant precisely because they do represent pubescent girls in suggestive postures severely disciplined by a pictorial order of architectural rigor. Cyril Connolly in his essay for the painter's 1952 exhibition at the Lefevre Gallery in London wrote of "the almost deliberate opposition between the choice of subject and the treatment, a kind of counterpoint between them."[22] Such a counterpoint certainly prevails in *Girl with a Cat* (1937; fig. 66; pl. 17) and *Thérèse Dreaming* (1938; fig. 67; pl. 19). In each picture the model's pose could be regarded as the flaunting, yet innocent exhibitionism of adolescence, but Balthus imbues it with a provocative and tantalizing suggestiveness. The cat, which echoes in both works the inscrutable or rapt expression of Thérèse's face, could be a further contribution to the erotic metaphor. On the other hand, it may merely be the emblem of the artist or, in the light of *Mitsou*, a talisman from his childhood. It seems possible that Thérèse's posture had its inspiration in the Man Ray photocollage (fig. 68) that appeared in the same issue of *Minotaure* as Balthus's *Wuthering Heights* illustrations. The precise source is the figure on the left in the photocollage for which Man Ray used a Pears Soap advertisement (fig. 69). Furthermore, the figure on the right in Man Ray's photocollage must also have appealed to Balthus, for he seems to have used her in a 1939 painting of a nude girl.[23]

The austere setting of *The Children* and of the series of works depicting Thérèse is replaced by a petit-

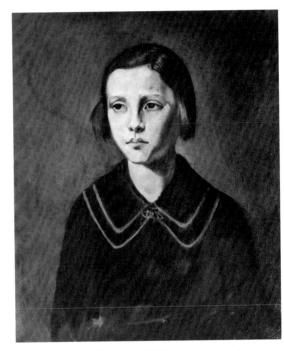

Fig. 65. Balthus, *Thérèse*, 1936. Oil on canvas, 23½ × 19¼ in. (60 × 49 cm.). Private collection

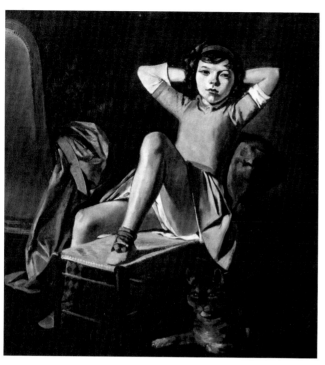

Fig. 66. Balthus, *Girl with a Cat*, 1937. Oil on wood, 34½ × 30¾ in. (88 × 78 cm.). Collection Mr. and Mrs. E. A. Bergman. See pl. 17.

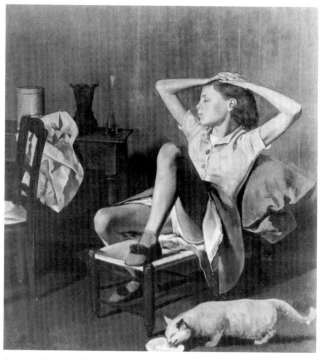

Fig. 67. Balthus, *Thérèse Dreaming*, 1938. Oil on canvas, 59 × 51 in. (150 × 130 cm.). Private collection. See pl. 19.

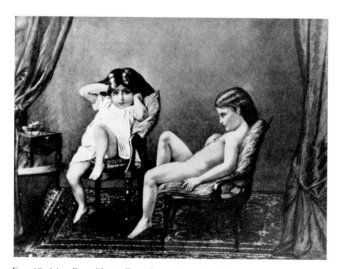

Fig. 68. Man Ray, *Photocollage*. Reproduced in *Minotaure*, no. 3 (1935)

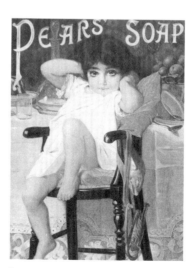

Fig. 69. Pears Soap advertisement, *Illustrated London News*, 1901

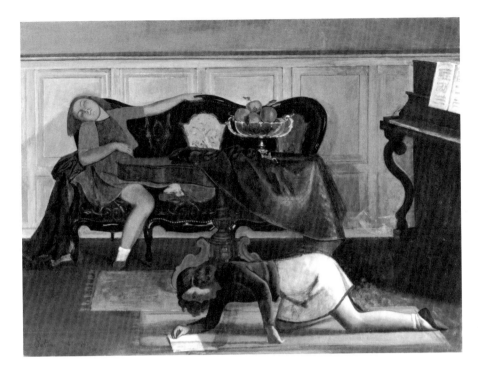

Fig. 70. Balthus, *The Living Room*, 1941–43. Oil on canvas, 44¼ × 57¼ in. (114 × 147 cm.). The Minneapolis Institute of Arts, The John R. Van Derlip and William Hood Dunwoody Funds. See pl. 24.

bourgeois interior in the two versions of *The Living Room*, one painted in 1941–43 (fig. 70; pl. 24) and the other in 1942 (fig. 111). Like Thérèse, the two adolescents read and daydream; they bring greater concentration to these activities than she did. In fact, however, to escape from boredom, the young model Georgette, who posed for both figures in these paintings, usually slept on the sofa while Balthus worked. Georgette was the thirteen-year-old daughter of the farmer who lived with his family on the farmstead of Champrovent in the French Savoy. Balthus had vacationed there in the late 1930s with his friends Pierre and Betty Leyris. (Pierre Leyris is a poet and translator of the works of Shakespeare, Dickens, Hawthorne, and Melville, among others. His wife Betty is English.)

After Balthus had been mobilized and seen battle near Saarbruck in Alsace, he returned with his wife to Champrovent, living and painting there from the summer of 1940 until the end of 1941. He used the farm's parlor as the setting for these paintings. Farmhouse parlors are used only on holidays, and since the painter's stay at Champrovent, few people have sat on the upholstered Napoleon III canapé, and few have played on the piano. The room has remained unchanged to this day (fig. 71).

Champrovent commands a fine view of the region that lies between the Rhone Valley and the Lake of Creuset. Balthus captured it in two landscapes: *Landscape of Champrovent* (1941–43; pl. 25) and *Vernatel* (*Landscape with Oxen*) (1941–42; pl. 26). Although painted in different seasons and styles, the two landscapes form a

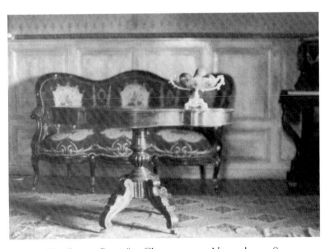

Fig. 71. The "Living Room" at Champrovent, November 1981. Photograph: Sabine Rewald

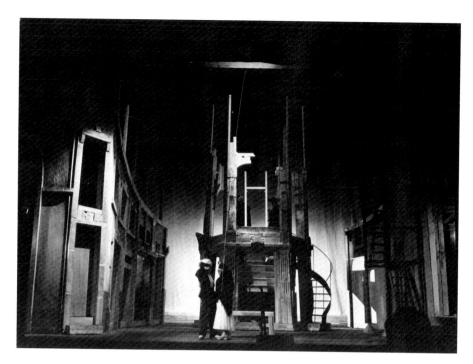

Fig. 72. Set by Balthus for *L'État de siège*, Paris, 1948. Photograph: Lipnitzki-Viollet

Fig. 73. Set by Balthus for *Le Peintre et son modèle*, Paris, 1949. Photograph: Collection Viollet

continuous panorama of the land viewed from a spot near the farmhouse doorstep. In *Landscape of Champrovent* the setting sun of an August afternoon casts long shadows and bathes every form in gentle, golden light. In *Vernatel (Landscape with Oxen)* we see the working life of the farm. The month is now November; the summer's tasks have been completed, and wood is being brought in for the winter. Balthus's pair of Savoy landscapes have their origins in the classical and naturalistic traditions of landscape painting of the previous centuries.

For the remainder of the war Balthus lived in Switzerland, in Bern, Fribourg, and Geneva. He has always used his surroundings, whatever they happen to be, as the setting of his interior scenes, and the setting has always had a direct influence on his painting style. When the war forced Balthus from his gloomy Parisian studio to the more comfortable environments of Champrovent and Switzerland, his paintings reflected this change. In *The Game of Patience* (pl. 27), painted in Fribourg in 1943, the elegant Louis XV furniture inspires a smooth and polished paint surface, reminiscent of that of the Old Masters. The interior of *The Golden Days* (1944–45; pl. 28) has a velvety quality. Begun in Fribourg, the painting was completed at the Villa Diodati in Geneva where Lord Byron had stayed in 1816 and where Balthus lived for over a year, beginning in September 1945. (In Byron, he admired the hero. One of the rumors circulated by Balthus, and repeated by Soby, is that "his grandmother was a Gordon from Scotland, somehow, but in any case, appropriately, related to Lord Byron."[24])

During these years in Switzerland the painter and his wife had two sons, Stanislas and Thaddeus. At some

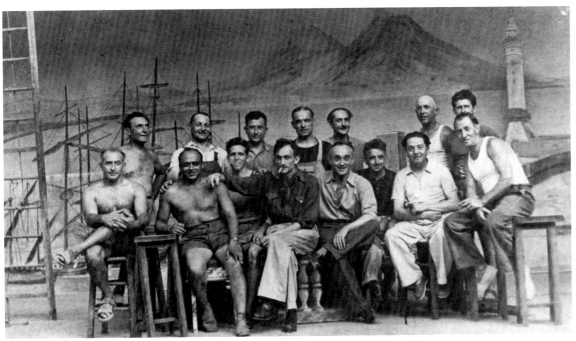

Fig. 74. Balthus (front row center, smoking cigarette) with his crew on the set for *Così fan tutte*, Aix-en-Provence, 1950.
Photograph: Alfio di Bella

point in 1946–47 Balthus left Geneva and returned to
Paris without his family. He and his wife separated but
did not divorce until 1966.

Between 1948 and 1960, once more and very suc-
cessfully, Balthus designed sets and costumes for five
quite different stage productions: three plays, an opera,
and a ballet. For Albert Camus's *L'État de siège*, a 1948 play
set in Cadix, a fictitious Spanish city under siege, he
created a single decor whose ruined Renaissance architec-
ture could suggest either a city or a cemetery (fig. 72).
Produced and directed by Jean-Louis Barrault, *L'État de
siège* opened at the Théâtre Marigny in October 1948.

Balthus then worked on the ballet *Le Peintre et son
modèle*, which Boris Kochno, Diaghilev's former assistant,
restaged in November 1949 at the Théâtre des Champs-
Elysées after the original choreography of Léonide Massine.
To evoke a painter's sparsely furnished studio, Balthus
combined invention with economy of means; he went to
the theater before each of the seven performances and
decorated the stage anew, using only a few objects
selected from the theater's stock of accessories (fig. 73).

In 1950 Balthus designed the costumes and sets for a
production of Mozart's *Così fan tutte* mounted in July at
the 3ième Festival International de Musique in Aix-en-
Provence (fig. 74). His decors captured the spirit of an
opera that has been described as "iridescent, like a
glorious soap-bubble, with the colors of buffoonery,
parody, and both genuine and simulated emotions."[25] In
preparation for this commission, Balthus immersed him-
self in Mozart's music for six months. The interior scenes
he designed conveyed the grace, elegance, and symme-
try of eighteenth-century Rococo classicism, while the

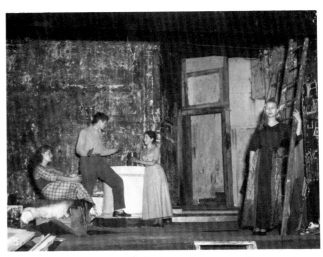

Fig. 75. Set by Balthus for *L'Île des chèvres*, Paris, 1953. Photograph:
Lipnitzki-Viollet

Fig. 76. Set by Balthus for *Jules César*, Paris, 1960. Photograph: Collection Viollet

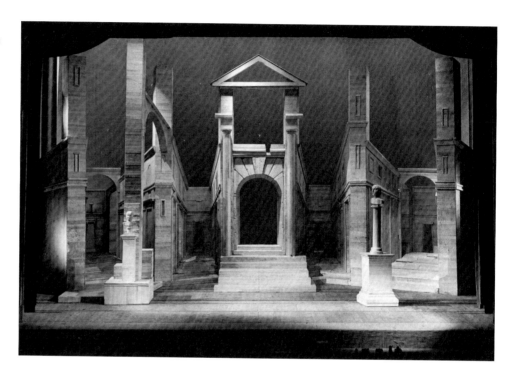

Fig. 77. Set by Balthus for *Jules César*, Paris, 1960. Photograph: Collection Viollet

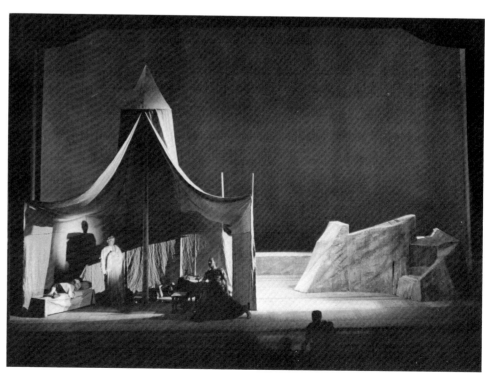

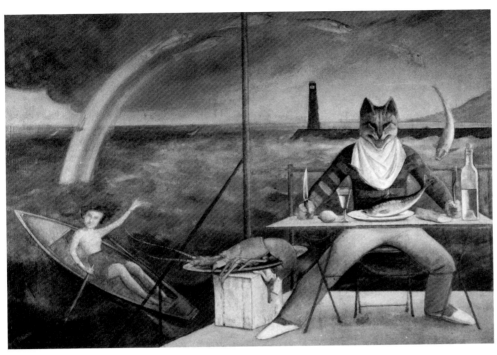

Fig. 78. Balthus, *The Méditerranée's Cat*, 1949. Oil on canvas, 50 × 72⅞ in. (127 × 185 cm.). Thomas Ammann Fine Art, Zurich

garden and harbor scenes offered effects of both magic and play, against a background inspired by early nineteenth-century Italian gouache views of the Bay of Naples, complete with a smoking Vesuvius in the distance. By slipping in occasional trompe-l'oeil papier-mâché figures he also emulated Mozart's love of *travesti* and irony.

For Ugo Betti's play *L'Île des chèvres*, which opened in April 1953 at the Théâtre des Noctambules, Balthus gave the single set, a large cavelike room in a farmhouse, a patina of age and dilapidation. He painted the walls, leaving the paper and glue that had remained when old posters were torn off and adding scumbles, scratches, and some graffiti (fig. 75).

Yves Bonnefoy's adaptation of Shakespeare's *Julius Caesar* (*Jules César*), directed by Barrault in 1960 for the Théâtre de France-Odéon, drew a totally different response from Balthus, who now delivered two very dissimilar stage sets. The first represented various locations in Rome and was a Palladian architectural decor, all harmony and near-symmetry (fig. 76). The second, showing Brutus's tent and the Plains of Philippi was unstructured and undefined (fig. 77). For each of these productions Balthus first prepared maquettes and then worked with the crews responsible for building and painting the sets. Moments before the curtain rose on *L'État de siège*, Balthus was seen crossing the set, hammer and saw in hand, intent on some last-minute carpentry.[26]

*The Méditerranée's Cat* (1949; fig. 78) also strikes one as a little theatrical. Balthus painted this signboard for the interior of the Restaurant La Méditerranée, located

on the Place de l'Odéon, across the street from the entrance to the theater. Just like the cat, Balthus and his friends dined there on fine seafood. His friends at the time included the poets and writers Paul Éluard, Albert Camus, and André Malraux.

In this signboard a cat's dream of paradise is a rainbow that turns into fish that land on its plate. Painted in unusually bright colors, *The Méditerranée's Cat* is the artist's only "seascape." His model, Laurence Bataille, salutes from her boat below, a reminiscence of Courbet's *La Dame au podoscaphe* (1865).

For two large canvases done at this time, Balthus once again used the bleak setting of his studio, still at the Cour de Rohan: *The Game of Cards* (1948–50; pl. 29) and *The Room* (1952–54; pl. 32). In *The Passage du Commerce Saint-André* (1952–54; pl. 33), Balthus returned again to the urban scene. Now his subject became the tiny passageway that runs between the Rue Saint-André-des-Arts and the Boulevard Saint-Germain at the Carrefour de l'Odéon, viewed from a third entrance to it, at 19 Rue de l'Ancienne Comédie. Balthus knew the site well; the passage led to his studio at the Cour de Rohan, just around the corner to the left. Although twenty years separate *The Passage du Commerce Saint-André* from *The Street*, the two pictures can be regarded as companion pieces, complementary views of Paris: *The Street* shows a workday and *The Passage du Commerce Saint-André* a Sunday, with its closed shopfronts and children at play.

*The Passage du Commerce Saint-André* could also be seen as the painter's farewell to his Parisian life, for in 1953

Balthus moved to the Château de Chassy, his new home in the Morvan, a mountainous region in central France. His work was not well known; only rarely had he been the subject of an exhibition. In Paris twelve years passed between his first exhibition at the Galerie Pierre and his second, which was mounted late in 1946 at the Galerie "Beaux-Arts" (space that Henriette Gomès, formerly associated with the Galerie Pierre, had rented from Wildenstein). It caused no stir, and there was only one review. Balthus was better known in New York, where Pierre Matisse had organized exhibitions for him in 1938, 1939, and 1949 and where, in 1956, the Museum of Modern Art mounted the painter's first museum exhibition.

Beginning in the 1930s, poets, writers, and fellow artists, among them Jouve, Camus, Cassandre, Giacometti, Roman, Masson, and Picasso, had admired and bought the works of Balthus. In the early 1950s a small group of French collectors and dealers formed a syndicate to buy his paintings, and this permitted the artist first to rent and then to buy the Château de Chassy. With its thick walls and heavy round towers, the three-story stone house dates from the fourteenth century, was remodeled during the seventeenth century, and was once used as a hunting lodge. Looking like a fairy-tale castle (or perhaps Wuthering Heights), it can be seen in the background of the pictures that the American photographer Loomis Dean took of Balthus in 1956 (frontispiece and fig. 79). Surrounded by fine old trees, the château stands grandly isolated in a somewhat bleak countryside. As in the past, his environment influenced Balthus, and landscape began to take a more important place in his work. In fact, of the seventy-odd paintings that left his studio at Chassy between 1954 and 1960, more than twenty were landscapes, all but two painted from the château's various windows. With them came light and air.

For *Landscape with Trees* (pl. 38), painted in the early spring of 1955, Balthus set up his canvas in front of a window in the north tower and captured the gently ascending hillside with its ancient gnarled trees. The western view from his studio windows yielded another series of landscapes, among them *Landscape with a Cow*

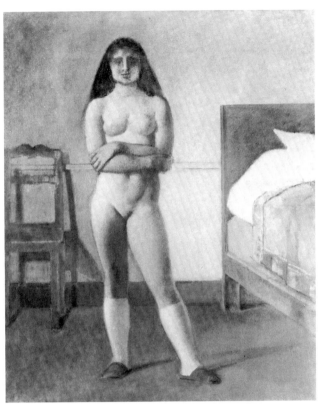

Fig. 81. Balthus, *Girl in Red Slippers*, 1957. Oil on canvas, 63¾ × 51¼ in. (162 × 130 cm.). Private collection

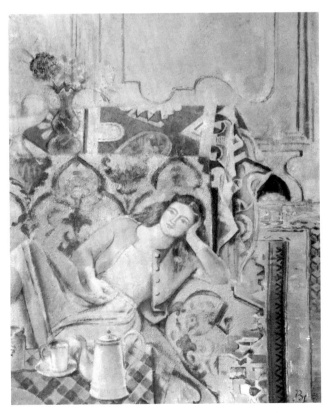

Fig. 82. Balthus, *The Cup of Coffee*, 1959–60. Oil on canvas, 64 × 51¼ in. (163 × 130 cm.). Collection Sheldon H. Solow. Photograph: Eric Pollitzer

Fig. 83. Balthus, *The Dream I*, 1955. Oil on canvas, 51 × 64 in. (130 × 163 cm.). Private collection. See pl. 35.

Fig. 84. Gustave Courbet, *The Awakening*, 1966. Oil on canvas, 30⅛ × 39⅛ in. (77 × 100 cm.). Kunstmuseum, Bern

(1959–60; pl. 43). Such views were possible only when winter and early spring kept the trees bare of foliage. The winter pictures show farmers at work, crossing the fields, or walking through the muddy courtyard. Six works from 1954–60 are views from the eastern windows of Chassy looking toward the courtyard of the farmhouse, with its outbuildings, sheds, and inner and outer gates. These gates were photographed by Loomis Dean (fig. 80) during his visit to Chassy. The tree in *Landscape with a Tree* (1958–60; pl. 45) stands in the garden in front of the château. Balthus had painted it in *Girl at a Window* (1957; pl. 40), this time in early summer and from a window on the ground floor. The girl contemplating this summer morning is Frédérique, the painter's niece by marriage and his favorite model at Chassy. Her young beauty graces most of the interior views that Balthus painted at Chassy. We see her nude in *Girl in Red Slippers* (1957; fig. 81), playing cards in *The Fortune Teller* (1956; pl. 39), and daydreaming in *The Cup of Coffee* (1959–60; fig. 82).

During the Chassy period Balthus addressed problems of form more than those of a psychological nature. The pictorial space gradually became more shallow, and decoration replaced drama. In earlier paintings the pres-

ence of two figures within an interior created a sense of foreboding. Now in *The Dream I* (1955; fig. 83; pl. 35), nothing threatens to disturb the girl slumbering on her red pillow, in a composition clearly inspired by Courbet's *The Awakening* (1864; fig. 84). The figure approaching on tiptoe, like a good fairy or like an angel in an Annunciation, holds a red flower in the axis of the composition. Similarly, in *The Golden Fruit* (ca. 1959; pl. 41), the "bad" fairy does not harm or disturb the dozing child.

The painter's eroticism, which was never free of ambiguity, adopts a more placid character in the Chassy period. In *Nude in Front of a Mantel* (1955; pl. 37), which was inspired by a magazine illustration, the figure is as static as those on an Egyptian frieze. In *The Moth* (1959; pl. 42), the girl looks ephemeral and idealized. Her form seems almost relief-like, as though it had been carved from the painting's surface, which has the texture of a rough stuccoed wall. To achieve the fresco effect of *The Moth*, Balthus applied many layers of casein tempera, a technique that points toward the new direction his art would take in Rome.

From 1961 to 1977 Balthus served as director of the French Academy at the Villa Medici in Rome, which brought him into renewed contact with Renaissance art and the country he had loved in his youth. André Malraux, France's minister of cultural affairs, appointed Balthus to this post. Malraux wanted to revive the Villa Medici as a center of French culture, and he believed that Balthus would help restore the prestige the academy had enjoyed under Ingres's directorship in 1835–42.

The historic villa had been allowed to deteriorate; it reminded Balthus of a shabby provincial museum. The designer in Balthus found a challenging project in the rehabilitation of the villa and its garden to their original Renaissance character. Slowly the new director and his restoration crew stripped the interior of its sumptuous clutter and made it as monumentally stark and austere as that in Uccello's *The Profanation of the Host* (figs. 85 and 86). The vast bare walls, their colors ranging from a luminous "Piero green" to muted browns, appear in the backgrounds of the paintings that Balthus produced during this period.

Balthus produced relatively few pictures during his

Fig. 85. Room in the Villa Medici, Rome, before Balthus's restoration, which began in 1961. Photograph: E. C. P. Armées

Fig. 86. Room in the Villa Medici, Rome, after Balthus's restoration. This room is not that shown in fig. 85.

Fig. 87. Balthus, *Japanese Figure with a Red Table*, 1967–76. Oil on canvas, 57 × 75½ in. (145 × 192 cm.). Private collection. Photograph: Eric Pollitzer

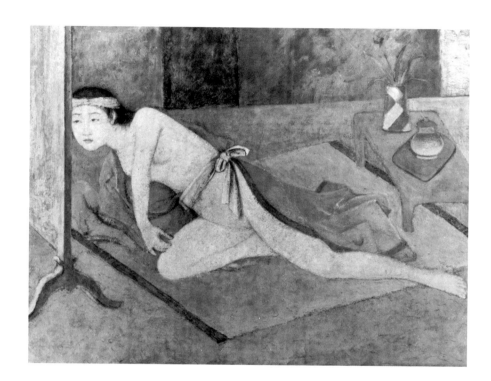

Fig. 88. Balthus. *Japanese Figure with a Black Mirror*, 1967–76. Oil on canvas, 59 × 77 in. (150 × 196 cm.). Private collection. Photograph: Eric Pollitzer. See pl. 48.

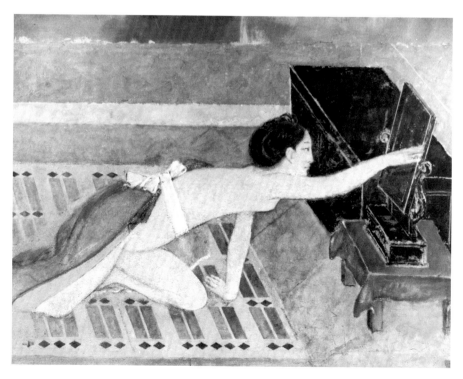

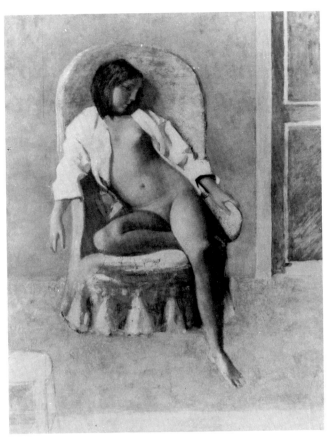

Fig. 89. Balthus, *Nude Resting*, 1977. Oil on canvas, 79 × 59 in. (201 × 150 cm.). Collection Jerold and Dolores Solovy

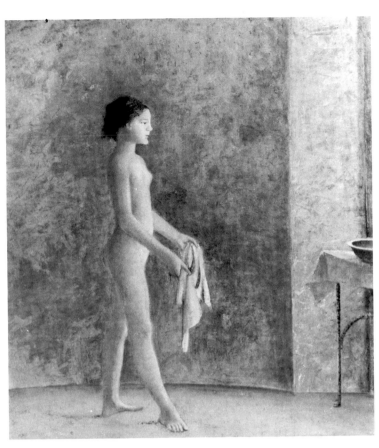

Fig. 90. Balthus, *Nude in Profile*, 1977. Oil on canvas, 88 × 79 in. (224 × 201 cm.). Private collection

years in Rome; in all he painted only thirteen large canvases. The surfaces of his works came to look more and more like rough stucco. Balthus now worked exclusively with casein tempera, applying it often in many layers, over many years. The resulting mat surface conveys the impression of a fresco or a picture painted on stone.

The painter's repertoire in Rome embraced old and new themes. He gave three fresh interpretations of *The Three Sisters*, a theme he had earlier treated in Chassy works dating from 1954–55 (pl. 34). Of larger scale than the two earlier ones, the three later versions depict the interior of the Villa Medici and are fresco-like in their pastel shades. The models did not pose again, and Balthus evoked them from memory. In the 1966–73 version of *The Card Players* (pl. 47) the players have become grotesquely weathered counterparts of those caught in the 1948–50 game (pl. 29). Now the girl's ominous superiority has turned into lethal ferocity.

For his new themes, Balthus, like so many French painters before him, looked to the Orient, both the Near and the Far East. A Moorish room at the Villa Medici inspired *The Turkish Room* of 1963–66 (pl. 46). Here, for the first time, we encounter Setsuko Ideta, the young Japanese woman whom Balthus met during an official visit to Japan in 1962. She acted as a translator during his visit to the temples at Kyoto. (She came to Rome that same year, and she and Balthus would later marry.) She also appears in the two companion works entitled *Japanese Figure with a Red Table* (fig. 87) and *Japanese Figure with a Black Mirror* (fig. 88), both dating from 1967–76. These paintings are based on *shunga*, a genre of Japanese pictures, whose erotic imagery symbolizes spring as a time of renewal. In his typical way, however, Balthus made radical changes in the traditional form. While small figures are characteristic of the Japanese source, he scaled his figures unusually large, more like those in the prints and paintings created by Utamaro in the late 1790s.

Now the adolescent girls who remained the painter's favorite subject matter seem possessed by a mood of detachment as they continue to rest and read as in *Nude Resting* (1977; fig. 89) and *Katia Reading* (1968–76; pl. 49). Katia and her sister Michelina were the daughters of an employee at the Villa Medici. In *Nude in Profile* (1973–77; fig. 90), an almost monochromatic work painted in tones of ocher, beige, and gold, Michelina walks toward a washbasin. The lithe young body would seem capable of evoking the emotions felt by the aging Aschenbach at the sight of Tadzio in Thomas Mann's *Death in Venice*. Balthus

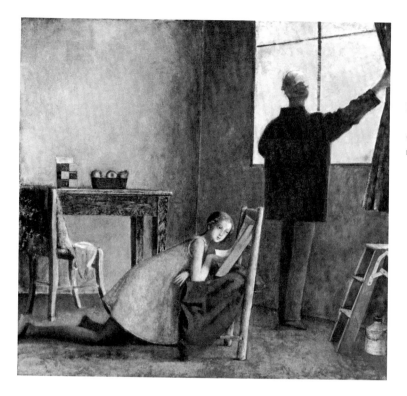

Fig. 91. Balthus. *The Painter and His Model*. 1980–81. Oil on canvas, 89 × 91 in. (226 × 231 cm.). Musée national d'art moderne, Centre Georges Pompidou, Paris

and Aschenbach idealize adolescence in its early stage, an attraction that is erotic, chaste, and not so chaste.

In 1977 Balthus moved to a small village in Switzerland, only a short distance from Beatenberg where he spent the summers of his youth. Here he lives with Setsuko and their young daughter who goes to the village school.

In *The Painter and His Model* (1980–81; fig. 91) he

again returned to themes from the past. Once more a painting has been set in the artist's own studio. The painter's gesture brings to mind that of the fierce little monster in *The Room* (1952–54; pl. 32) who pulled back the curtain to let in what appears to be a flash of lightning. But that earlier drama is gone. Now, as Balthus probably does every day, the painter calmly draws back the curtain, to admit light and continue painting.

## NOTES

Unless otherwise stated, translations from French and German sources are those of the author.

1. Dieter Bassermann, ed., *Rainer Maria Rilke et Merline* [pseud.] *Correspondance 1920–1926* (Zurich, 1954), p. 293

2. Max Osborn, "Mitsou, die Katze," *Literarische Umschau* 4 *Beilage zur Vossischen Zeitung*, February 12, 1922, p. 1

3. Quoted in Ingeborg Schnack, *Rainer Maria Rilke: Chronik Seines Lebens und Seines Werkes* (Passau, 1975), vol. 2, p. 766

4. Baladine Klossowski published her correspondence with Rilke, under the pseudonym of Merline, in two volumes. Only the letters of Rilke appear in *Lettres Française à Merline, 1919–1922* (Paris, 1950). Letters by both Rilke and Baladine appear in *Rilke et Merline: Correspondance* (see note 1)

5. *Rilke et Merline: Correspondance*, p. 38

6. Jean Cocteau, *Les Enfants terribles* (Paris, 1979), p. 23

7. Frederick Hartt, *History of Italian Renaissance Art: Painting, Sculpture, Architecture* (New York: Harry N. Abrams, 1974), p. 236

8. John Russell, *Balthus: A Retrospective Exhibition* (London, 1968), exhibition catalogue, p. 11. Jean Leymarie, *Balthus* (Geneva, 1978), unpaged; expanded illustrated edition (New York, 1982), p. 18

9. The Bibliothèque Littéraire Jacques Doucet, Paris, holds André Derain's manuscripts for this planned treatise on painting. Extensive excerpts from them were published as "Notes d'André Derain," *Cahiers du Musée National d'Art Moderne* (Paris, 1980, no. 5, pp. 348–62

10. Antonin Artaud, "Exposition Balthus à la Galerie Pierre," *La Nouvelle Revue Française*, no. 248 (May 1934), pp. 899–900. English translation from Russell, *Balthus*, p. 33

11. Gaston Poulain, "Des Étudiants innocents voisinent avec le Freud de la peinture," *Comoedia*, April 16, 1934, p. 3. I am grateful to Christian Derouet, curator at the Centre Georges Pompidou, for bringing this review to my attention

12. Antonin Artaud, "L'Evolution du decor," *Comoedia*, April 19, 1924, *Oeuvres complètes* (Paris, 1971), vol. 2, p. 13

13. Antonin Artaud, *Balthus*, *Art Press*, no. 39 (July–August 1980), p. 4

14. Antonin Artaud, "Annabella au Théâtre des Champs-Elysees," *La Nouvelle Revue Française*, no. 254 (November 1934), p. 797; *Oeuvres complètes* (Paris, 1961), vol. 2, pp. 198–99

15. The Museum of Modern Art, New York, *Diane Arbus* (An Aperture Monograph, 1972), pp. 1–2

16. Antonin Artaud, "La Jeune Peinture française et la tradition," *Oeuvres complètes* (Paris, 1971), vol. 8, p. 248

17. R. S. Short, "Erotically Lounging," *Times Literary Supplement*, September 30, 1983, p. 1063

18. The Surrealists also admired *Wuthering Heights*. See René Crevel, *Les Soeurs Brontë: Filles du vent* (Paris, 1930), with illustrations by Marie Laurencin

19. Pierre Jean Jouve, "Balthus," *La Nef*, September 1944, pp. 138–47

20. Rudolf Kassner, *Rainer Maria Rilke* (Zurich, 1976), p. 6

21. Rainer Maria Rilke, *Sämtliche Werke* (Wiesbaden, 1955–56), vol. 2, pp. 290–91

22. Cyril Connolly, *Balthus and a Selection of French Paintings* (London, 1952), exhibition catalogue, unpaged

23. This work could not be illustrated. See *Balthus* (Paris, 1983), exhibition catalogue, p. 349, no. 55

24. James Thrall Soby, *Balthus*, The Museum of Modern Art, New York, *Bulletin*, vol. 25 (1955–56), no. 6, p. 4

25. Alfred Einstein, *Mozart: His Character, His Work*, trans. Arthur Mendel and Nathan Broder (London, 1945), p. 446

26. Three critics observed this: Max Favalelli, *Paris Presse*, October 28, 1948, Roger Lannes, *Le Figaro Littéraire*, October 23, 1948, Claude Outie, *L'Aurore France Libre*, October 23–24, 1948

# CATALOGUE

# 1. THE QUAYS

LES QUAIS  1929

*Signed and dated (lower left): Balthus 29*

*Inscribed (lower right): à Pierre Matisse    Balthus*

*Oil on canvas, 28¼ × 23½ in. (73 × 60 cm.)*

*Collection Pierre Matisse, New York*

What do Parisians do along the quays of the Seine? Stroll, picnic, or just watch, like the four figures in *The Quays*. For his inspiration Balthus had only to consult the sketches he made of life along the river (fig. 92) and to look at postcards, a process that gave him the composite view of *The Quays*, as well as the justification for the plural title. The chief architectural element seems to be the esplanade below the Quai des Grands-Augustins; the distant trees and buildings on the right belong, however, to the Quai du Louvre, in reality too far away to be visible. Where the artist found the arches of the bridge can only be guessed. Another enigma arises from the light-dark division of the lower composition, created by a shadow whose intensity seems incongruous under the cloudy sky. However anomalous the various parts, the ensemble is richly evocative; the viewer has no difficulty in imagining the Seine on the far right.

A relatively early picture, produced when Balthus still painted with loose, impressionistic strokes, *The Quays* bears the hallmark of the artist's later work: a carefully thought-out, fine-tuned composition.

The stout spinster on the left has brought along her cat and a large bottle of wine, both carried in the roomy baskets at her feet. This eerie figure reappears throughout the painter's work, as does the cat. Twenty-five years later, in Balthus's last Parisian scene, *The Passage du Commerce Saint-André* (1952–54; pl. 33), she appears for the final time, frail and aged.

EXHIBITIONS: New York, 1939, cat. no. 3; New York, 1949, cat. no. 5, ill.; New York, 1956–57, cat. no. 2, ill. p. 11; New York, 1962, cat. no. 1, ill.; Cambridge, Mass., 1964, cat. no. 2, ill.; Chicago, 1964, cat. no. 4; London, 1968, cat. no. 2, ill. p. 46; Marseilles, 1973, cat. no. 1, ill.; Paris, 1983, pp. 122–23, ill.

BIBLIOGRAPHY: Leymarie, 1982, ill. p. 123; S. Klossowski, 1983, pl. 3.

Fig. 92. Balthus, *On the Quay*, ca. 1928–29. Colored crayon on a notebook page, 6¼ × 4 in. (16 × 10 cm.). Private collection. Photograph: Sabine Rewald

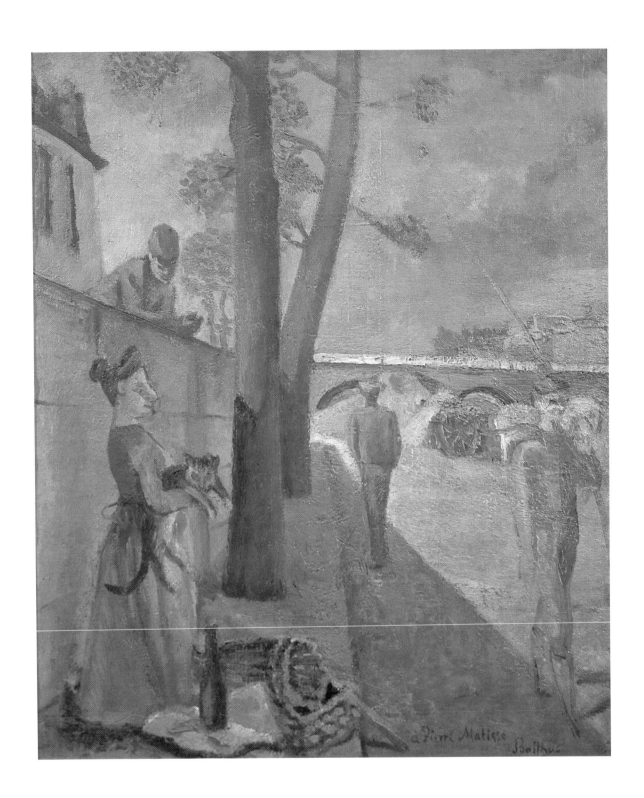

# 2. THE STREET

LA RUE   ca. 1929?–33

*Oil on canvas, 51 × 63 in. (130 × 160 cm.)*

*Private collection*

Balthus banished cars and other elements of modern urban life from his Parisian street scenes, focusing instead on the corners of Le Vieux Paris, a world untouched by time and progress. Horse-drawn carriages deliver goods, and quaint figures bustle about their daily routine. A maid with a child on her arm goes shopping. On the left, crossing the street with a youngster at each hand, is a dignified father, all in black. Coming toward him, all in white, is a mason carrying a plank. The chef on the left stands stock-still—he is, in fact, a restaurant sign on which the day's menu will be posted. The woodenness of this figure is matched by the flaneur who approaches like a somnambulist.

Balthus found his setting in the Rue Bourbon-le-Château, a small street near the Rue de Furstenberg, where, in the spring of 1933, the artist rented his first studio in Paris.

This painting, the first and smaller version of *The Street*

(pl. 3), has been variously assigned to the years 1928, 1929, and 1930 (only recently the artist himself remembered painting the picture in 1927). Two preparatory drawings (figs. 93 and 94), identical in style, medium, and format, exist for this composition. The earlier one, usually dated 1929, is more detailed than the later version (ca. 1933), which was done on the reverse of a study for *Cathy Dressing* (1933).

In this work Balthus still painted in an impressionistic manner. When he returned to the subject in 1933, his style was marked by crisp contours and flat colors.

EXHIBITIONS: New York, 1939, Pierre Matisse Gallery, *Early Paintings by French Modern Masters*, cat. no. 1 (dated 1930); New York, 1949, cat. no. 4 (dated 1928), ill.; New York, 1956–57, cat. no. 1 (dated 1929), ill. p. 8; Chicago, 1964, cat. no. 1; Cambridge, Mass., 1964, cat. no. 1; London, 1968, cat. no. 3.

BIBLIOGRAPHY: Leymarie, 1982, ill. p. 124; S. Klossowski, 1983, pl. 4.

Fig. 93. Balthus, *Study for "The Street,"* ca. 1929. Ink on paper, 6⅞ × 8½ in. (18 × 22 cm.). The Museum of Modern Art, New York, Gift of Mr. and Mrs. Eugene Victor Thaw

Fig. 94. Balthus, *Study for "The Street,"* ca. 1933. Ink on paper, 6⅞ × 8⅝ in. (18 × 22 cm.). The Museum of Modern Art, New York, Gift of James Thrall Soby

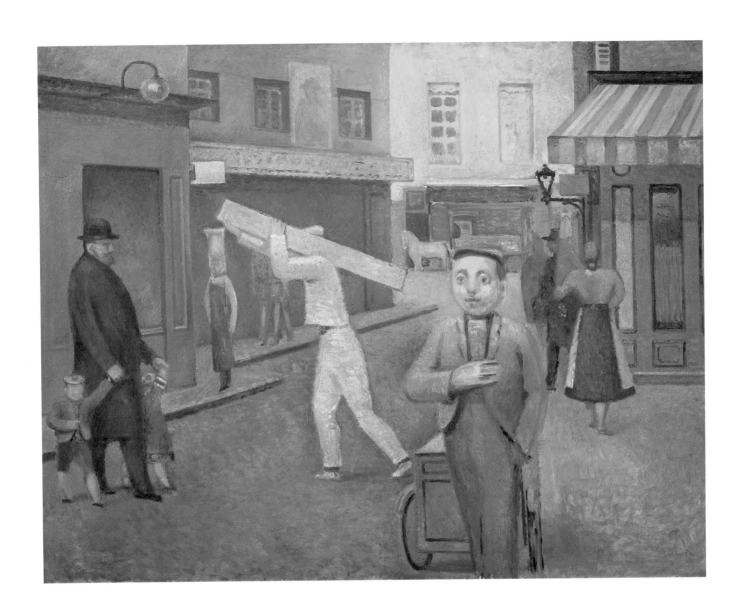

# 3. THE STREET

La Rue   1933

*Signed and dated (lower right): Balthus 1933*

*Oil on canvas, 76¼ × 94½ in. (195 × 240 cm.)*

*The Museum of Modern Art, New York, James Thrall Soby*

*Bequest, 1979*

An aproned maid carries a schoolboy in a sailor suit. A workman carries a plank; a child plays; people stroll. A typical working day on a picturesque Parisian street—or is it? According to one interpretation, the girl on the left is Lewis Carroll's Alice, under attack by Tweedledum. To the right of center, Tweedledee, approaching like a sleepwalker, ignores his twin's naughty behavior. Other characters may also have counterparts in *Through the Looking Glass*. The workman could be a mason or Carroll's carpenter (without his walrus companion); his vision is blocked by the board. The two women on the right turn their backs on the scene; their remote dignity echoes that of Piero della Francesca's figures, on whom they are based. No one in the painting can see "Alice's" predicament. Frozen in mid-movement, the characters look as wooden as the chef, who is actually a sign for a restaurant.

However mysterious its pedestrians, the identity of Balthus's street is easily established. It is the Rue Bourbon-le-Château, a small street in the sixth arrondissement. The only departure from reality is the bistro

on the right, an image borrowed from the nearby Rue Bonaparte.

Since the scene is viewed from a child's perspective, the figures appear large and tall. The houses disappear above the first floor. Their visible portions are as stark as those in Renaissance street scenes painted by Masolino and Piero, even though Balthus retained such lively, anecdotal elements as shopfronts, signs, lamps, a poster, and a red-and-white bistro awning.

If the single thin red line on the left of the awning were continued downward, it would intersect the center of the picture's lower left corner. This line is one of those that form the picture's underlying structure. Balthus describes this linear geometry as a sort of "private mathematics" to which all forms and figures must submit. Whereas his first treatment of the theme in 1929?–33 (pl. 2) shows his impressionist manner, he now gives sharp definition to all forms and fills them with flat, unmodulated color. Some critics have attributed this stylistic change to the clear Moroccan light Balthus had been exposed to during his military service in the early 1930s. A more plausible explanation may lie in the artist's study of the Swiss painter Joseph Reinhardt in the summer of 1932, when he copied several paintings from Reinhardt's Swiss Peasant Costume Cycle (1787–97) at the Historisches Museum in Bern (figs. 20–23). Reinhardt's mannerism, literalism, and precisely delineated forms impressed Balthus, and his mastery of this style is evident in the present picture.

For prototypes of *The Street*, one can also go back to eighteenth-century signboards, such as Hogarth's *Sign for a Pavior [Paver]* (fig. 95).

Some twenty years after he completed this painting, Balthus made an important change in the figure of Tweedledum, whose explicit misbehavior (fig. 33) was made less obvious. The American collector James Thrall Soby, who acquired *The Street* from the Galerie Pierre in 1937, explained this alteration in an unpublished letter:

No one in Paris would buy [*The Street*] because of the passage in question. I bought the picture that day and sweated about the problem of how to get it through U.S. customs. Luckily the customs officials in Hartford,

Fig. 95. Attributed to William Hogarth (1697–1746), *Sign for a Pavior [Paver]*. Oil on wood, 22 × 22 in. (56 × 56 cm.). Yale Center for British Art, New Haven, Paul Mellon Collection

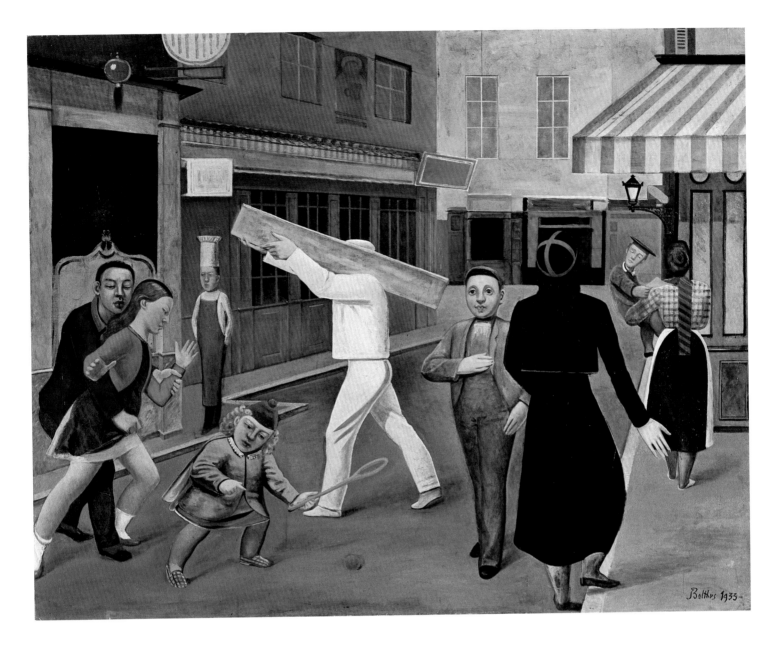

Conn., where I lived, had long since written me off as an eccentric and they opened the case up only far enough to be sure it was "hand-painted" oil, since duty free. I hung the picture in the living room in my house in nearby Farmington. I finally had to put it in a vault because my son—then about nine—and his friends would cluster around it and rush home and tell their mothers about the naughty passage they'd seen. I had always wanted to give the picture to The Museum of Modern Art, but I knew it couldn't be hung in a public gallery and I finally wrote Balthus in despair that this was a very great picture doomed never to be seen. To my utter astonishment—and I'd known Balthus personally for years—he wrote back that if I would send him the picture he would be glad to try to change the passage in question. . . . He kept the picture for nearly two years and in 1955 turned it over to me. He said: "I used to want to shock, but now it bores me." . . . I don't think any picture of Balthus' generation has excited me more.

EXHIBITIONS: Paris, 1934; New York, 1938, cat. no. 1; New York, 1956–57, cat. no. 3, ill. p. 12; New York, 1961, Knoedler & Co., *The James Thrall Soby Collection*, p. 24, ill. p. 25; Paris, 1966, cat. no. 1, ill. p. 17; Knokke-le-Zoute, 1966, cat. no. 1, ill.; London, 1968, cat. no. 4, ill. p. 10; Paris, 1974, Grand Palais, *Jean Paulhan à travers ses peintres*, cat. no. 444; Venice, 1980, cat. no. 1, p. 211; Paris, 1980–81, Musée national d'art moderne, Centre Georges Pompidou, *Les Réalismes*, ill. pp. 216–17; Paris, 1983, pp. 128–29, ill.

BIBLIOGRAPHY: Jouve, 1944, p. 139; Pierre Loeb, *Voyages à travers la peinture* (Paris: Bordas, 1945), pp. 37–39, pl. 8; *Documents 34* (Brussels), June 1934 (special number), "Intervention surréaliste," ill. p. 28; P. Klossowski, 1956, ill. p. 28; Marcel Jean, *L'Histoire de la peinture surréaliste* (Paris: Éd. du Seuil, 1959), p. 243; James Thrall Soby, "Genesis of a Collection," *Art in America*, January 1961, ill. p. 75; H. H. Arnason, *History of Modern Art* (New York: Harry N. Abrams, 1967), p. 390, fig. 608; Leymarie, 1982, pp. 15, 18–19, ill. pp. 16–17; S. Klossowski, 1983, pls. 5–7.

# 4. GARRISON IN MOROCCO

La Caserne  1933

*Signed and dated (lower right): Balthus 1933*

*Oil on canvas, 32 × 39⅜ in. (81 × 100 cm.)*

*Private collection*

Under a bluish Moroccan sky, three spahis attempt to
catch a horse, while others look on. In their colorful
uniforms and high red fezzes they look like marionettes
dangling from invisible strings. Balthus had probably
observed similar scenes during his military service in
Morocco from late 1930 to early 1932. He was stationed
in a garrison in the small town of Kenitra, which only
dates back to 1913. Balthus thought it was the most ugly
and vulgar place he had ever seen. The old cities of Rabat
and Fes captivated him, but as he later told a friend, he
found little inspiration in Morocco for his art. He
painted this work from memory in 1933 after he had
returned to Paris.

EXHIBITION. London, 1952, cat. no. 1

# 5. CATHY DRESSING

La Toilette de Cathy   1933

*Signed and dated (lower left): Balthus 1933*

*Oil on canvas, 65 × 59 in. (165 × 150 cm.)*

*Musée national d'art moderne, Centre Georges Pompidou, Paris*

This painting is based on an episode early in Emily Brontë's novel *Wuthering Heights* (1848). In anticipation of a visit from her suitor Edgar Linton, Cathy, assisted by the maid Nelly, arranges her dress. Heathcliff enters the room unexpectedly and wants to know if Cathy is going out. In response to her evasive reply, he asks suspiciously, "Why have you that silk frock on, then?" Balthus altered the atmosphere of the original scene. Instead of being dressed in "that silk frock," Cathy allows her gown to fall open, exposing her nude body and erect breasts. Her slippered feet are carefully placed on the small oriental carpet, whose green and red colors, along with the maid's slippers, provide the only accents in a composition of blacks, whites, and earthen hues.

Coming from the stable, Heathcliff might be expected to be in work clothes; instead he wears a white shirt, a bow tie, and a jacket. In fact, the figures are portraits of Balthus and of Antoinette de Watteville, his future wife. In Balthus's *Wuthering Heights* illustration for this episode (fig. 96), Cathy is properly dressed, and Heathcliff turns to address his question to Cathy and the evil-looking maid, Nelly. In the painting Heathcliff turns away, fierce, brooding, and handsome. He is as remote as Cathy, who seems lost in a trancelike state.

Where is the lighthearted sensuality usually present in pictures of women dressing? It seems to have been replaced by grim anticipation of a somber erotic rite.

---

EXHIBITIONS: Paris, 1934; Brussels, 1934, Palais des Beaux-Arts, *Exposition Minotaure*, cat. no. 4; New York, 1938, cat. no. 2; New York, 1949, cat. no. 7, ill.; New York, 1962, cat no. 3, ill.; London, 1968, cat. no. 5; Paris, 1977, Musée national d'art moderne, Centre Georges Pompidou, *Paris–New York*, ill. p. 460; Paris, 1979, Musée d'Art Moderne de la Ville de Paris, and Brussels, 1979, Musée d'Ixelles, *L'Aventure de Pierre Loeb*, cat. no. 17, ill. p. 58; Saint-Étienne, 1979, Musée d'Art et Industrie, *L'Art dans les années 30 en France*, cat. no. 8, ill. p. 62; Paris, 1983, pp. 124–25, ill.

BIBLIOGRAPHY: Gaston Poulain, "Des Étudiants innocents voisinent avec le Freud de la peinture," *Comoedia*, April 16, 1934, p. 3; Antonin Artaud, "Exposition Balthus à la Galerie Pierre," *La Nouvelle Revue Française*, no. 248 (May 1934), pp. 899–900; E. Tériade, "Aspects actuels de l'expression plastique," *Minotaure*, no. 5 (February 1934), fig. 1; Jouve, 1944, pp. 139, 143; W. George, *Corps et visages feminens de Ingres à nos jours* (Paris: Éd. d'Art et Industrie, 1955), pl. 10; Antonin Artaud, "Balthus," *Art Press*, no. 39 (July–August 1980), ill. p. 4; Leymarie, 1982, ill. p. 139; S. Klossowski, 1983, pl. 9.

Fig. 96. Balthus, *Illustration for "Wuthering Heights"* ("Why have you that silk frock on, then?"), 1934–35. Ink on paper, 10 × 9½ in. (25 × 24 cm.). Private collection

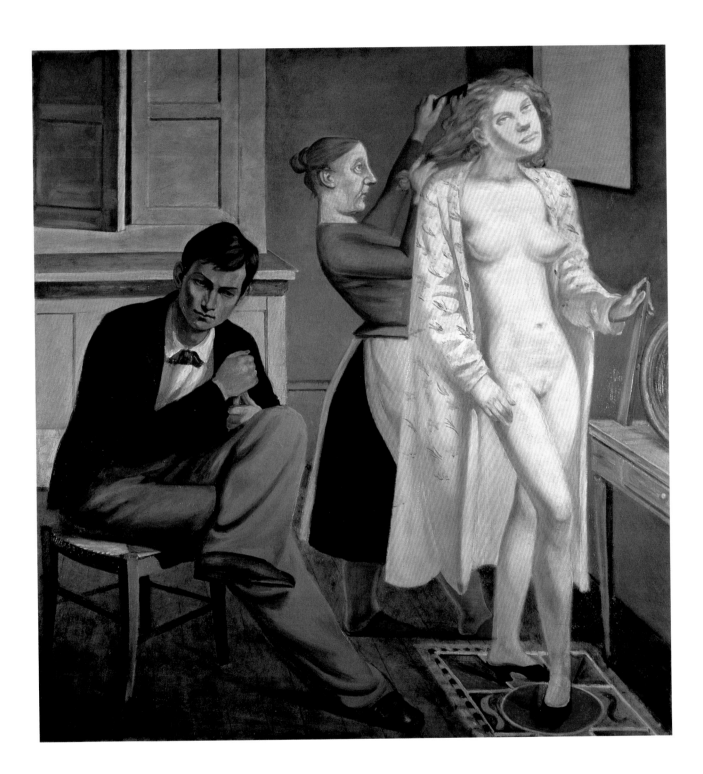

# 6. THE WINDOW

LA FENÊTRE   1933

*Oil on canvas, 63¼ × 44⅛ in. (161 × 112 cm.)*

*Indiana University Art Museum, Bloomington*

When the young model Elsa Henriquez (fig. 97) first arrived at Balthus's studio in the Rue de Furstenberg, he opened the door dressed in his old army uniform, a dagger in his hand and a scowl on his face. He grabbed her blouse and tried to pull it open. Elsa recoiled in horror, just as Balthus had intended. Now she looked like the frightened Sarah from the Tobias Legend, a subject planned for another painting. This work, which was to have a contemporary Swiss setting, was never executed and only studies for it survive (fig. 98).

Elsa, whose nickname was Chiquita, was the fifteen-year-old daughter of the Peruvian dancer Helba Huara. Shy and convent-educated, she did not pose with her blouse open, and her fear is evident in the figure's sharp angularity. Today Elsa works as a children's book illustrator in Paris.

The view from this window was described by Pierre Jean Jouve in an article in *La Nef* (1944): "From Balthus's place, were it not for the houses surrounding the courtyard, whose austerity brings to mind the paintings of David, he could have seen the studio where Delacroix died. . . . The neighboring streets, narrow and amusingly old-fashioned, seem like elements from a dream."

EXHIBITIONS: Paris, 1934; New York, 1949, cat. no. 6, ill.; New York, 1962, cat. no. 2, ill.; Cambridge, Mass., 1964, cat. no. 4; Chicago, 1964, cat. no. 4; Detroit, 1969, cat. no. 3, ill.; Paris, 1983, pp. 126–27, ill.

BIBLIOGRAPHY: Jouve, 1944, p. 139; Leymarie, 1982, ill. p. 129.

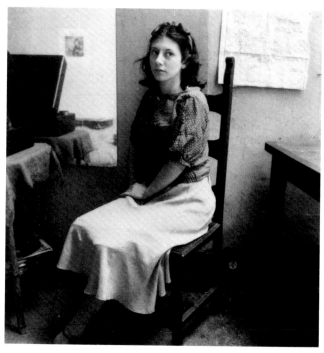

Fig. 97. Elsa Henriquez, 1933. Private collection

Fig. 98. Balthus, *Study of the Frightened Sarah*, 1927. Ink on paper, 8¼ × 5⅞ in. (22 × 15 cm.). Private collection

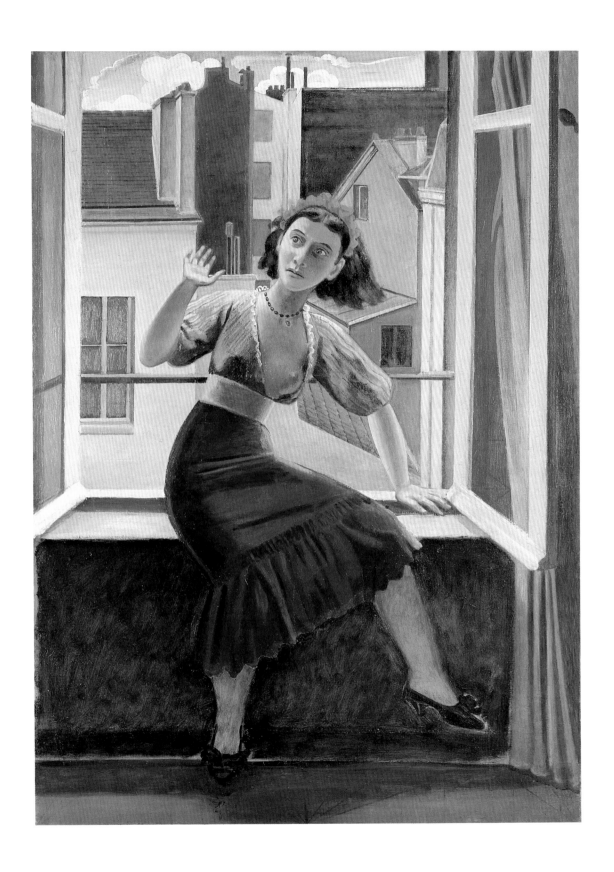

# 7. MME PIERRE LOEB

1934

*Signed and dated (on reverse): Balthus 1934*

*Oil on canvas, 28¼ × 20½ in. (72 × 52 cm.)*

*Collection Albert Loeb*

Born in Trieste in 1905, Silvia Luzzatto spent her girl-hood in that city. In 1928 she married the art dealer Pierre Loeb who, in 1934, mounted Balthus's first exhibition at his Galerie Pierre. This picture is probably one of the two small portraits included in that show.

As in most of his portraits of that period, Balthus adopted Reinhardt's mannerist style and format, placing his figure against a monochromatic background and adding a prop or two. The sittings for this portrait stretched over many months. Mme Loeb was not well, and after posing for five minutes, she had to rest for ten.

As if viewed from the wrong end of a telescope, the delicate Mme Loeb looks forlorn in her modish, frilly blouse amid the plain kitchen furniture of the painter's studio. The sitter wistfully remembers that she was a young woman who "dressed in style, was surrounded by fine furniture, and lived well." She is still somewhat mystified that Balthus should have depicted her in such stark surroundings and looking so melancholy. It is little wonder that the portrait was never hung in the Loeb apartment.

EXHIBITIONS: Paris, 1934; Paris, 1979, Musée d'Art Moderne de la Ville de Paris, and Brussels, 1979, Musée d'Ixelles, *L'Aventure de Pierre Loeb*, cat. no. 19, ill. p. 58.

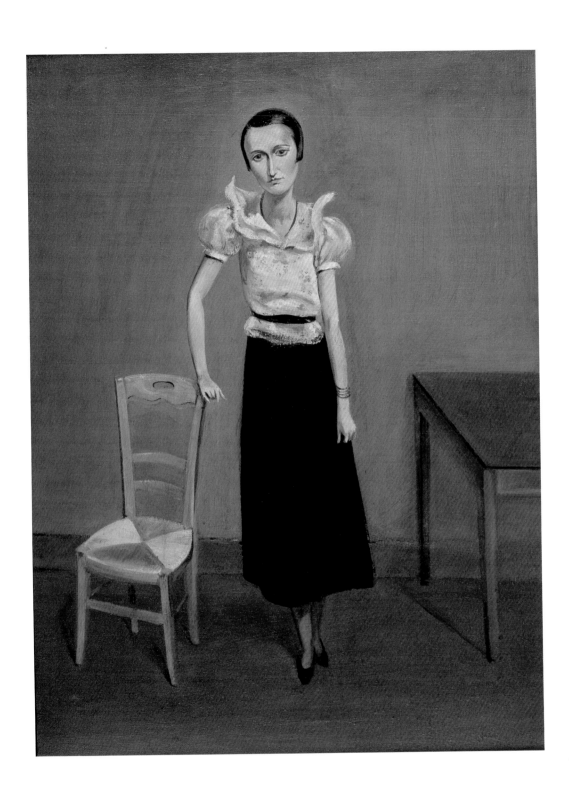

# 8. LADY ABDY

1935

*Signed and dated (lower left): B 1935*

*Oil on canvas, 73¼ × 55⅛ in. (186 × 140 cm.)*

*Collection Iya Lady Abdy*

Has the sixteenth-century Beatrice Cenci strayed into a Parisian apartment? Is she wondering how she got there? One can imagine a corpse with a knife in its back somewhere in the room. The Russian-born Lady Iya Abdy played the role of Beatrice Cenci (fig. 99) in Antonin Artaud's production of *Les Cenci* in 1935, the year Balthus painted this picture. Barefoot and wearing a gown by Grès, she posed in the painter's studio on the top floor of 4 Rue de Furstenberg.

Artaud commented on this picture: "Balthus depicts Iya Abdy as a primitive artist would have painted an angel; with as sure a technique and the same understanding of space, of line, of hollows, of the rays of light that create space. . . . This is Iya Abdy's face, these are her hands devoured by light. But another being, who is Balthus, seems to be behind her face and in her body, like a sorcerer who would take possession of the body and soul of a woman, while he himself is slumped on his bed with a dagger in his heart."

BIBLIOGRAPHY: Antonin Artaud, *Oeuvres complètes* (Paris: Gallimard, 1964 and 1970), vol. 5, pp. 43–44.

Fig. 99. Lady Abdy in Artaud's production of *Les Cenci*, 1935. Photograph: Lipnitzki-Viollet

# 9. THE KING OF CATS

1935

*Inscribed: A PORTRAIT OF H.M. THE KING OF CATS painted by*

      *HIMSELF MCMXXXV*

*Oil on canvas, 28 × 19 in. (71 × 48 cm.)*

*Private collection*

In this self-portrait the twenty-seven-year-old Balthus appears, at first glance, rather haughty and romantic. He might be a poet or a Byronic dandy, but nothing identifies him as a painter, other than an inscription on the tomblike slab: "A PORTRAIT OF H.M. THE KING OF CATS *painted by* HIMSELF MCMXXXV." After his first exhibition at the Galerie Pierre in early 1934, with its highly erotic, scandal-provoking works, Balthus stopped painting. In 1935, however, he began to do portraits in the "Reinhardt manner."

In painting *The King of Cats*, the artist may have had in mind Delacroix's self-portrait as Hamlet. Instead of drama, however, Balthus chose irony, evident in the lion tamer's whip curled up on a stool, while a fat tiger cat rubs his head against the painter's knee. Do the cat and whip represent the two sides of the subject's nature, the sensualist and the ascetic, each battling for dominance? An affirmative answer has come from Yves Bonnefoy in his essay "L'Invention de Balthus" (*L'Improbable*, 1959). Whatever his significance, the tomcat is no invention. He used to visit the painter in the Rue de Furstenberg, coming in through the skylight. Since childhood Balthus has had cats in both his life and his work. The title he gave to this self-portrait alludes to the artist's friendship with a young Englishwoman whom he called "The Queen of the Forests." He gave the picture to her, and it has remained in her house until it was sent to New York for this exhibition.

# 10. ANDRÉ DERAIN

1936

*Signed and dated (lower left): Balthus 1936*

*Oil on wood, 44⅜ × 28½ in. (113 × 72 cm.)*

*The Museum of Modern Art, New York, Acquired through the*

*Lillie P. Bliss Bequest, 1944*

A good friend of Balthus's, the painter Derain had a hearty sense of humor, and he may have been amused at being portrayed as a glaring, ogre-like character. Derain was known for his appetite for sensuous pleasures. Rather than underplaying these inclinations, Balthus exaggerated them.

Derain's bulky silhouette looks formidable in the magnificently painted robe, which, according to his niece, he never wore. This garment looks as though it had been carved in stone or wood and is reminiscent of the robes seen in medieval representations of saints. It also brings to mind the robes worn by Piero's monks and Bellini's Saint Francis. Perhaps Balthus was making a playful allusion to Derain's unmonkly life.

Although this picture was painted in Balthus's studio at the Cour de Rohan, Derain has been placed in the context of one of his own works, *The Model* (fig. 100). In Balthus's portrait Derain almost pushes his model out of the canvas. There is no room for her hands or feet; at the same time, the tapering almost dainty fingers of Derain, so carefully rendered, appear incongruous on his heavy frame. The model, her face numb, slumps in exhaustion, as if worn out by Derain's demands. She was

Raymonde, Derain's mistress and the mother of his son. Raymonde actually suffered from an ailment that made her fall asleep at odd moments, just as she does here.

The reduced color scheme must have pleased Derain, who painted in a similar fashion and who advocated this style in his unpublished treatise on the subject. Alfred Barr, then director of the Museum of Modern Art in New York, bought this portrait for an American collector in 1936; in 1944 it joined that museum's collection.

EXHIBITIONS: New York, 1938, cat. no. 8; Paris, 1946, cat. no. 1; New York, 1949, cat. no. 10, ill.; New York, 1956–57, cat. no. 5, ill. p. 14; Marseilles, 1973, cat. no. 3, ill.; New York, 1976, Wildenstein and Co., *The Artist and His World: Portraits and Self-Portraits in the Twentieth Century*; Vienna, 1977, Museum des 20. Jahrhunderts, *Neue Sachlichkeit und Realismus zwischen den Kriegen*, cat. no. 1, ill. p. 15; Paris, 1980–81, Musée national d'art moderne, Centre Georges Pompidou, *Les Réalismes*, ill. p. 11, Paris, 1983, p. 133, ill.

BIBLIOGRAPHY: *L'Exposition 1937 et les artistes à Paris* (Paris: Arts Sciences et Lettres, 1937), ill. facing p. 16; Monroe Wheeler, *Twentieth Century Portraits* (New York: The Museum of Modern Art, 1942), p. 133, ill. p. 100; William S. Lieberman, "The Painter Looks at People," *Art News*, September 1947, pp. 28–29, ill. p. 29; H. H. Arnason, *History of Modern Art* (New York: Harry N. Abrams, 1967), p. 391, fig. 610; Leymarie, 1982, p. 25, ill. p. 22; S. Klossowski, 1983, pl. 12.

Fig. 100. André Derain, *The Model*, 1919. Oil on canvas, 28¼ × 32¼ in. (73 × 83 cm.). Collection Julien Lévy. Photograph: André Godin

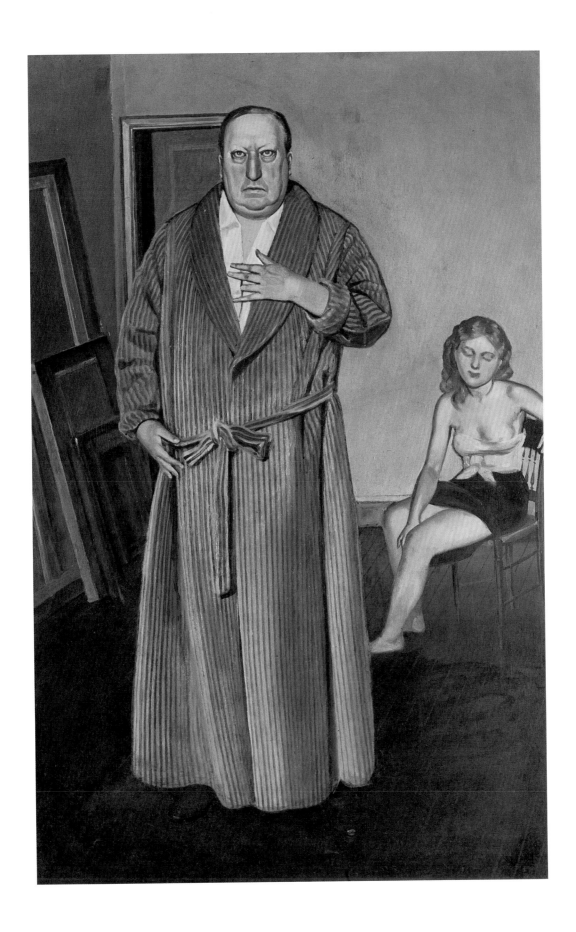

# 11. THE VICOMTESSE DE NOAILLES

La Vicomtesse de Noailles   1936

*Signed and dated (lower right): Balthus 1936*

*Oil on canvas, 62¼ × 53⅛ in. (158 × 135 cm.)*

*Private collection*

Between 1925 and 1960, Marie-Laure de Noailles (née Bischoffsheim; 1903–1970) was one of Paris's most glittering hostesses. Society figures and artists flocked to her house at 11 Place des États-Unis. The vicomtesse was a passionate patroness of the arts, bold enough to finance Cocteau's avant-garde film *Sang du poète* (1925) as well as Dali and Buñuel's *L'Age d'or* (1930). The spirit that animated these commitments may also have made her proud to be related to the marquis de Sade through her grandmother, Laure de Sade, who was a model for Proust's duchesse de Guermantes. As a collector, the vicomtesse acquired the manuscript of her notorious ancestor's *Les 120 Jours de Sodome* (1785).

The vicomtesse also wrote and painted. A pupil of the painter Oscar Dominguez, she developed a pictorial style characterized by the writer Marcel Schneider as derivative of Odilon Redon. Her book *Le Journal d'un peintre* appeared in 1966. It is in this role—the emancipated woman artist rather than the lioness of society—that Balthus has portrayed her. Mannishly dressed in black, she posed with a detached haughtiness. In contrast to her customary sumptuous surroundings, Balthus placed her in the cell-like setting of his studio at the Cour de Rohan.

EXHIBITIONS: New York, 1938, cat. no. 9; Paris, 1946, cat. no. 2; New York, 1949, cat. no. 9, ill.; New York, 1956–57, cat. no. 4, ill. p. 13.

BIBLIOGRAPHY: Jouve, 1944; p. 144; Leymarie, 1982, ill. p. 126; S. Klossowski, 1983, pl. 1.

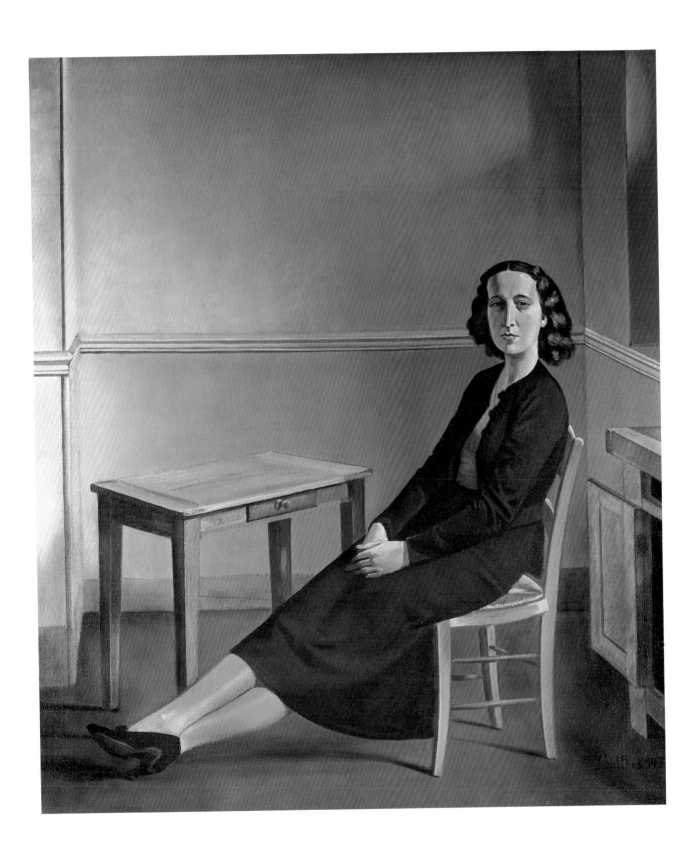

# 12. JOAN MIRÓ AND HIS DAUGHTER DOLORES

Joan Miró et sa fille Dolores   1937–38

*Signed and dated (lower left): Balthus 1938*

*Signed and dated (on reverse): Balthus Oct. 1937–Jan. 1938*

*Oil on canvas, 51¼ × 35 in. (130 × 89 cm.)*

*The Museum of Modern Art, New York, Abby Aldrich Rockefeller Fund, 1938*

Balthus began this portrait of the Spanish painter Joan Miró in October 1937 and completed it in the following January. The many sittings may account for the slightly bored expressions on the faces of both Miró and his six- or seven-year-old daughter Dolores. Miró was one of the group of artists represented by the Galerie Pierre, whose owner, Pierre Loeb, commissioned the portrait in honor of Miró's forty-fifth birthday. Balthus portrayed the Spanish painter as an unassuming and accommodating man who could be a minor civil servant or a bank clerk. Balthus's fine eye and truthful realism record the too-snug jacket, the woolen undervest, and the suede shoes. The position of their hands conveys the affection between father and daughter, although the girl is restless, even exasperated. The piping on Dolores's dress and her father's tie are the only accents of bright color, set off against a background as flat and simple as the landscape-like grounds in Miró's own contemporary works. Here the environment seems as empty and two-dimensional as that in Reinhardt's *Better Meyer and His Young Sister* (fig. 101), which Balthus had copied during the summer of 1932.

Given the nature of the commission, Balthus was surprised when, in the fall of 1938, the picture entered the collection of New York's Museum of Modern Art.

EXHIBITIONS: New York, 1938, cat. no. 14; New York, 1949, cat. no. 15, ill.; Minneapolis, 1954, Walker Art Center, *Reality and Fantasy 1900–1954*, cat. no. 7, ill. p. 30; New York, 1956–57, cat. no. 9, ill. p. 15; Paris, 1966, cat. no. 6, ill. p. 20; Knokke-le-Zoute, 1966, cat. no. 6; London, 1968, cat. no. 10, ill. p. 53; Detroit, 1969, cat. no. 6, ill.; Williamstown, Mass., 1977, Sterling and Francine Clark Art Institute, *The Dada and Surrealist Heritage*, cat. no. 11, ill. p. 35; Paris, 1979, Musée d'Art Moderne de la Ville de Paris, and Brussels, 1979, Musée d'Ixelles, *L'Aventure de Pierre Loeb*, cat. no. 20, ill. p. 58; Paris, 1983, p. 143, ill.

BIBLIOGRAPHY: Monroe Wheeler, *Twentieth Century Portraits* (New York: The Museum of Modern Art, 1942), p. 133, ill. p. 102; Pierre Loeb, *Voyages à travers la peinture* (Paris: Bordas, 1945), pl. 24; *Painting and Sculpture in the Museum of Modern Art* (New York: The Museum of Modern Art, 1948), no. 23, ill. p. 189; William S. Lieberman, ed., *Modern Masters: Manet to Matisse* (New York: The Museum of Modern Art, 1975), cat. no. 3, ill. p. 255; Leymarie, 1982, p. 25, ill. p. 23; S. Klossowski, 1983, pl. 21.

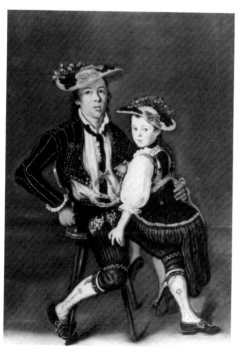

Fig. 101. Joseph Reinhardt, *Kanton Zug: Better Meyer and His Young Sister*, 1794. Oil on canvas, 27½ × 19¼ in. (70 × 50 cm.). Historisches Museum, Bern

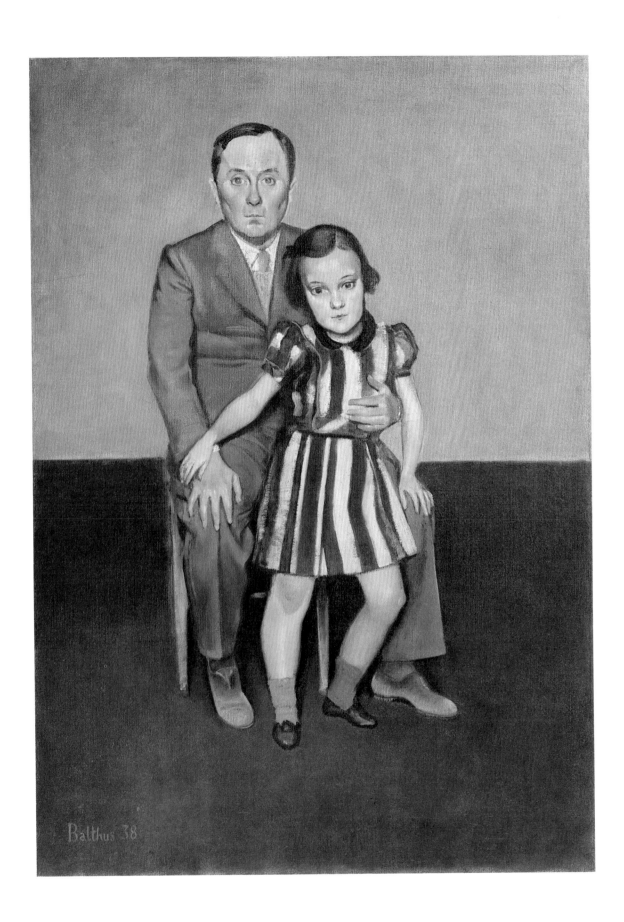

# 13. THE WHITE SKIRT

LA JUPE BLANCHE 1937

*Signed and dated (lower left): Balthus 1937*

*Oil on canvas, 51¼ × 63¾ in. (130 × 162 cm.)*

*Private collection*

The "white skirt," an old flannel tennis skirt, once belonged to the subject's mother. Here it becomes a splendid passage of painting. Antoinette de Watteville, Balthus's model and by then his wife, insisted on wearing her brassière. "I did not want my breasts exhibited in a museum," she later declared. The semitransparent brassière may, however, enhance the suggestiveness of the image. It also gave the artist another subtle shade and texture to render along with the whites and creams of the casual outer garments. Rose, eggshell, and ivory, as well as Antoinette's tanned skin, create a golden luminescence within the dark Cour de Rohan studio.

Balthus treated the young woman's wholesome sensuality with tenderness and truth. A certain wistfulness emerges from the inclined head, its tumbling russet mane continuing the downward curve of the high-backed Louis Philippe chair. The knotted fringe of the heavy Moroccan curtain is as carefully observed as the knitted pattern in the red, blue, and white slippers.

The dreamy, self-absorbed mood of this picture, as well as the subject's physical appearance, recalls the various portraits that Courbet painted of the beautiful Irish model Jo, who had first appeared in the pictures of Whistler.

---

EXHIBITIONS: Paris, 1946, cat. no. 3; London, 1952, cat. no. 3; Paris, 1966, cat. no. 4, ill. p. 19; Knokke-le-Zoute, 1966, cat. no. 4, ill.; London, 1968, cat. no. 8, ill. p. 51; Paris, 1983, pp. 140–41, ill.

BIBLIOGRAPHY: Leymarie, 1982, p. 20, ill. p. 21; S. Klossowski, 1983, pl. 19.

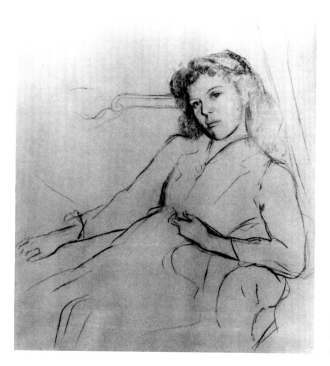

Fig. 102. Balthus, *Portrait of A.*, 1943. Pencil on paper, 33¼ × 30¼ in. (85 × 77 cm.). Private collection

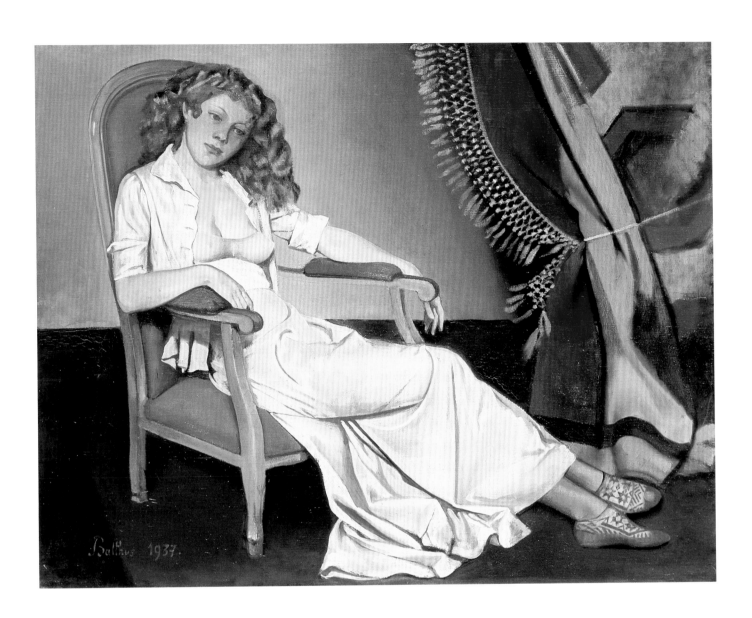

# 14. THE MOUNTAIN

LA MONTAGNE   1937

*Oil on canvas, 98 × 144 in. (249 × 366 cm.)*

*The Metropolitan Museum of Art, New York, Purchase, Gifts of Mr. and Mrs. Nate B. Spingold and Nathan Cummings, Rogers Fund and The Alfred N. Punnett Endowment Fund, by exchange, and Harris Brisbane Dick Fund, 1982*

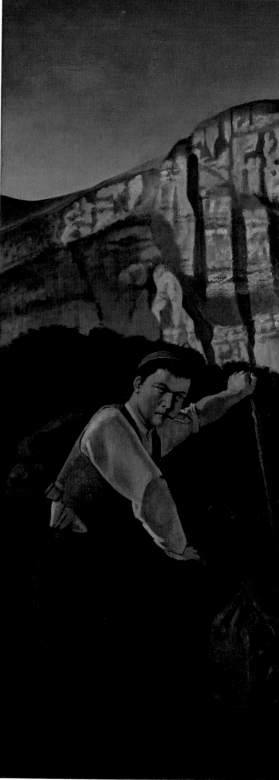

*The Mountain,* Balthus's largest canvas up to that date, was exhibited at the Pierre Matisse Gallery in New York in 1939 with the note: "Summer: The first of the four panels depicting the seasons." The artist did not, however, continue this series.

This mountainscape is composed of real, though transformed elements as well as invented ones. The scene is an imaginary plateau near the top of the Niederhorn in the Bernese Oberland. In the 1930s, without today's cable lift, it was a day's climb from Beatenberg, the village where the painter had spent his summers as a boy, to the peak of the Niederhorn. The nearby mountains are the Sigriswiler Rothorn on the left and the Burgfeld Stand on the right, across a deep valley whose width has been compressed. The sharp outlines evoke the clear atmosphere of high altitudes in which forms become accentuated and magnified. The brilliant blue and limpid light are unparalleled in Balthus's work.

The masterly composition is sharply divided into light and dark zones. Like a phoenix, the blond woman rises dramatically from the dark. She is the focal point of the picture and is the source of order in the composition. (The model for this figure was Antoinette de Watteville, Balthus's wife.)

In *The Mountain* Balthus paid homage to several of the painters he admired, among them Poussin, Reinhardt, and Courbet. The woman, for example, lies in the manner of Narcissus in Poussin's *Echo and Narcissus* (fig. 10), a work Balthus copied in 1925. The posture of the pipe-smoking guide recalls that of Courbet's stone-breaker; at the same time his face resembles that of Christen Heumann in Reinhardt's *Kanton Freiburg* group, which Balthus copied in 1932 (figs. 22 and 23).

EXHIBITIONS: New York, 1939, cat. no. 1; New York, 1947, The Museum of Modern Art, *Large Scale Modern Paintings,* cat. no. 18; New York, 1949, cat. no. 12, ill.; New York, 1956–57, cat. no. 7, ill. p. 20; New York, 1962, cat. no. 5, ill.; Cambridge, Mass., 1964, cat. no. 6, ill.; Paris, 1966, cat. no. 2, ill. p. 17; Knokke-le-Zoute, 1966, cat. no. 2; London, 1968, cat. no. 6, ill. p. 15; Marseilles, 1973, cat. no. 4, ill.; Venice, 1980, cat. no. 2, ill. p. 210; Paris, 1980–81, Musée national d'art moderne, Centre Georges Pompidou, *Les Réalismes,* ill. p. 213; Paris, 1983, pp. 138–39, ill.

BIBLIOGRAPHY: Jouve, 1944, p. 144; Bonnefoy, 1959, p. 48; William S. Lieberman, ed., *Modern Masters: Manet to Matisse* (New York: The Museum of Modern Art, 1975), cat. no. 2, ill. p. 193; Leymarie and Fellini, 1980, pls. 4–7; Leymarie, 1982, pp. 31, 34, ill. pp. 32–33; S. Klossowski, 1983, pls. 10–11

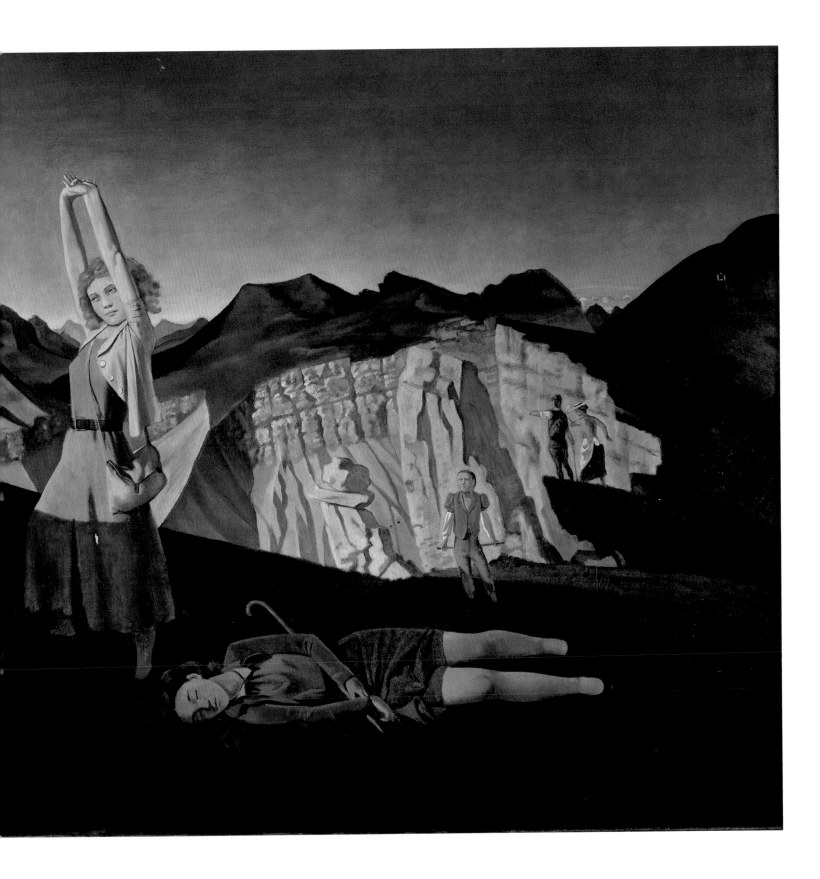

# 15. STILL LIFE

NATURE MORTE    1937

*Signed and dated (lower left): Balthus 1937*

*Oil on wood, 32 × 39 in. (81 × 99 cm.)*

*Wadsworth Atheneum, Hartford, Connecticut, The Ella Gallup*
*Sumner and Mary Catlin Sumner Collections*

Still lifes are often composed of objects that delight the eye or the palate, which are frequently given symbolic value. Rarely do they depict foods savagely pierced and vessels deliberately smashed, as in Balthus's *Still Life.*

The aesthetic opposition that Balthus establishes between warm browns and chilly blues has its counterpart in his choice of motifs—satin fabric, glistening crystal ware, a silver fork, a hammer, and a kitchen knife—all set on a rough kitchen table. Despite a superficial appearance of randomness, the objects are orchestrated around the hammer, which forms the main axis of the picture. The angry mood is expressed in a fine composition whose formal harmony evokes Balthus's earlier still life of Swiss peasant objects (fig. 103).

Balthus's *Still Life* might have been conceived in a spirit kindred to that of Miró's *Still Life with an Old Shoe*

(1937), a painting filled with personal feelings about the Spanish Civil War. Miró represented an apple pierced by tines, a loaf of bread, an old shoe, and a bottle of gin partially wrapped in paper. The objects had been set up on the second floor of the Galerie Pierre, where Miró and Balthus exhibited their works, and Miró painted them there daily for a month.

---

EXHIBITIONS: Chicago, 1940, The Arts Club, *Origins of Modern Art*, cat. no. 28; New York, 1949, cat. no. 14, ill.; New York, 1956–57, cat. no. 8, ill. p. 18; Hartford, Conn., 1958, Wadsworth Atheneum, *A. Everett Austin, Jr.: A Director's Taste and Achievement*, cat. no. 4, ill.; Cambridge, Mass., 1964, cat. no. 8, ill.; Paris, 1966, cat. no. 5, ill. p. 20; Knokke-le-Zoute, 1966, cat. no. 5; London, 1968, cat. no. 9, ill. p. 52.

BIBLIOGRAPHY: Leymarie, 1982, ill. p. 129; S. Klossowski, 1983, pl. 18.

Fig. 103. Balthus, *Swiss Peasant Still Life*, ca. 1932. Oil on canvas, 22 × 28 in. (56 × 71 cm.). Private collection

# 16. THE CHILDREN

Les Enfants  1937

*Signed and inscribed (on reverse): Les enfants—Hubert et Thérèse
 Blanchard; Balthus 1937*

*Oil on canvas, 49¼ × 50¾ in. (125 × 129 cm.)*

*Musée du Louvre, Paris, Donation Pablo Picasso*

The painter's spartan studio at the Cour de Rohan was
not conducive to merriment. In any case, Balthusian
children seem indifferent to light-hearted games. Lan-
guid or moody, they prefer to while away the time in
closed rooms, daydreaming or scanning the pages of a
book. Adults, unwelcome, never dare to intrude.

Hubert and Thérèse Blanchard, the artist's neighbors,
seem at home in the somber studio setting. They are
dressed in everyday clothes; he wears the schoolboy's
classic black smock, and she a pleated skirt, sleeveless
vest, and striped shirt. They lean forward and crouch on
the floor in ways typical of adolescents allowed to lounge
about as they please. Postures such as these greatly
appealed to Balthus, and they appear often in his work.

In a never-ending eventless afternoon, the self-
absorbed children are as remote from one another as
they are from the viewer. In the *Wuthering Heights* illustra-
tion (fig. 104) that is the source of this composition,
Balthus created a different mood. There Heathcliff,

impatient and tense, turns toward Cathy, who writes in
her diary, to urge her to join him in more exciting
adventures. In *The Children*, however, the boy gravely
turns his head away from the girl, his "lost profile"
rediscovered by light from two different sources, one to
the left of the foreground and the other of mysterious
origin but striking the rear wall. The dark silhouette of
the bag of coal rhymes with that of the boy's illuminated
head and back.

Picasso, who admired Balthus's work, owned *The
Children*.

EXHIBITIONS: Paris, 1946, cat. no. 5; New York, 1949, cat. no. 8; New
York, 1956–57, cat. no. 6, ill. p. 17; Paris, 1982–83, Musée national
d'art moderne, Centre Georges Pompidou, *Paul Éluard et ses amis peintres,
1895–1952*, ill. p. 76; Paris, 1983, pp. 134–35, ill.

BIBLIOGRAPHY: P. Klossowski, 1956, ill. p. 30; Bonnefoy, 1959, pp. 51,
74; *Donation Picasso: La Collection personelle de Picasso* (Paris: Musée du
Louvre, 1978), cat. no. 1, p. 16, ill. p. 17; Leymarie, 1982, pp. 26–28,
ill. p. 27; S. Klossowski, 1983, pl. 16.

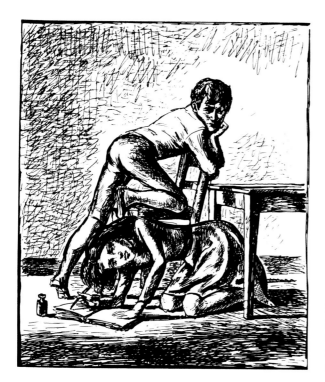

Fig. 104. Balthus, *Illustration for "Wuthering
Heights"* *("I have got the time on with writing for
twenty minutes.")*, 1934–35. Ink on paper,
10 × 9½ in. (25 × 24 cm.). Private
collection

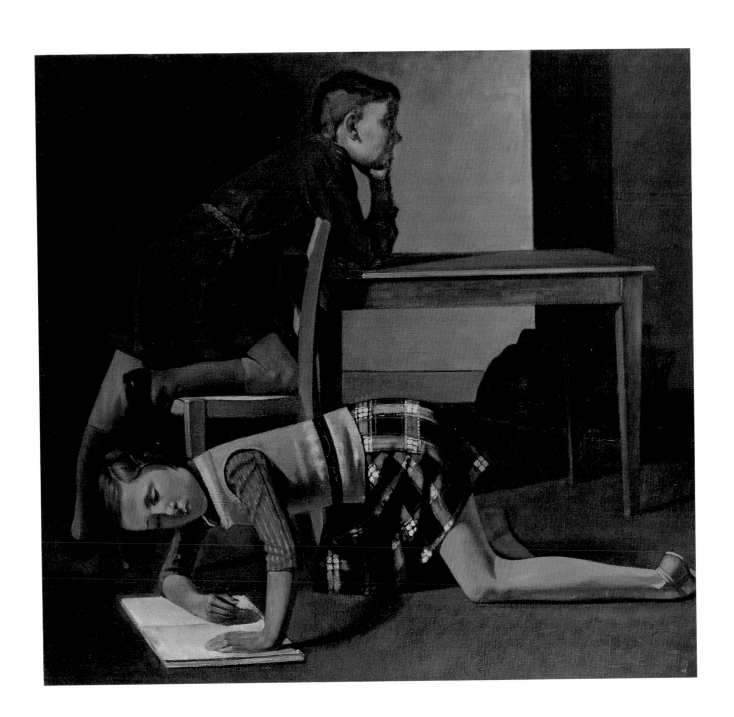

# 17. GIRL WITH A CAT

Jeune Fille au chat   1937

*Signed and dated (lower left): Balthus 1937*

*Oil on wood, 34½ × 30¾ in. (88 × 78 cm.)*

*Collection Mr. and Mrs. E. A. Bergman*

From 1936 to 1938, Thérèse Blanchard, Balthus's young neighbor at the Cour de Rohan, was his favorite model. The subject of various portraits, she also posed with her brother in *The Children* (1937; pl. 16) and with her cat, as here. A later version of the same subject is *Thérèse Dreaming* (1938; pl. 19). Both pictures express one of Balthus's recurrent themes: an adolescent and a cat in a closed room, where they are lost in their own thoughts or in sleep. Here the brown cat lying at her feet echoes the inscrutable expression of Thérèse's face.

With kneesock fallen down and sleeve pulled up, Thérèse looks as if she has been called away from play. The young sitter's pale skin and her turquoise, white, and red garments stand out against the harsh background of the painter's studio. Characteristically, Balthus has imbued her quite innocent exhibitionism with suggestiveness. This erotic mood is heightened by the strict discipline of the composition.

Exhibitions: New York, 1962, cat. no. 4, ill.; London, 1968, cat. no. 7, ill. p. 50; Chicago, 1980, cat. no. 2, ill.; Paris, 1983, pp. 135–36, ill.

Bibliography: Leymarie, 1982, ill. p. 130; S. Klossowski, 1983, pl. 17.

Fig. 105. Balthus, *Study for "The Dream,"* 1938. Pencil on paper, 9½ × 9½ in. (24 × 24 cm.). Collection Mr. and Mrs. Ralph I. Goldenberg

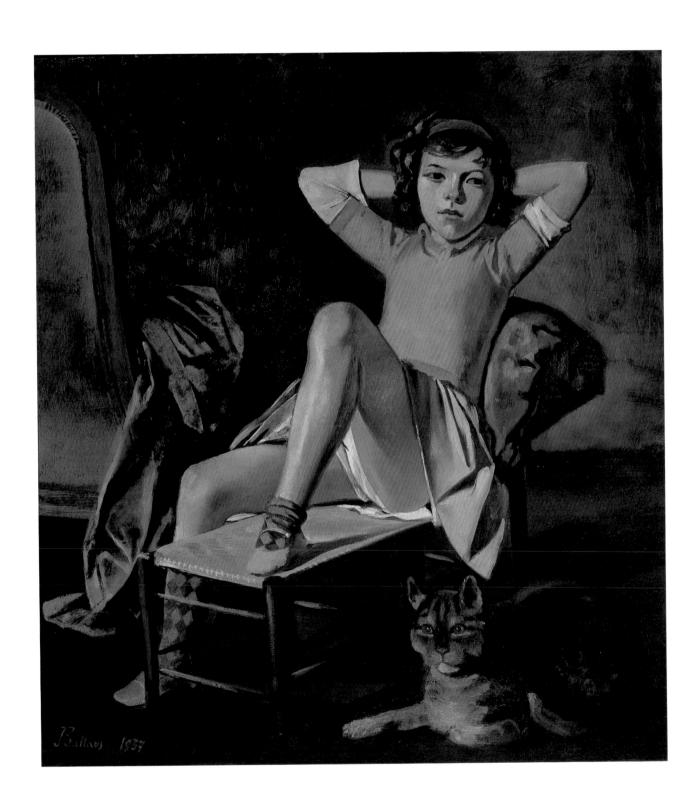

# 18. THÉRÈSE

1938

*Signed and dated (lower left): Balthus 1938*

*Oil on heavy cardboard mounted on wood, 38¾ × 31¼ in.*

*(98 × 79 cm.)*

*Collection Mrs. Allan D. Emil*

The pensive expression of the young model Thérèse
Blanchard might be sulkiness or merely boredom at
having to sit for too long. The composition invites
comparison with Courbet's portrait of his young sister
Juliette (fig. 106); but while Juliette's expression is prim
and somehow haunting and malicious, that of Thérèse is
moody and nonchalant. The casual elegance of Thérèse's
pose endows her with the maturity and daring of some-
one much older. Like so many of Balthus's adolescent
girls, she is young yet knowing, vulnerable yet tough.

EXHIBITIONS: London, 1958, Obelisk Gallery; New York, 1963, AFA
Gallery, cat. no. 1; New York, 1965, Knoedler Gallery, *Lawyers Collect*,
cat. no. 5; Paris, 1966, cat. no. 7, ill. p. 21; Knokke-le-Zoute, 1966,
cat. no. 7; London, 1968, cat. no. 11, ill. p. 54; Detroit, 1969, cat. no.
7, ill.; Marseilles, 1973, cat. no. 6, ill.; Paris, 1983, pp. 144–45, ill.

BIBLIOGRAPHY: Leymarie, 1982, ill. p. 130; S. Klossowski, 1983, pl. 14.

Fig. 106. Gustave Courbet, *Juliette Courbet*, 1844. Oil on
canvas, 30¾ × 24½ in. (78 × 62 cm.). Musée du Petit
Palais, Paris. Photograph: Bulloz

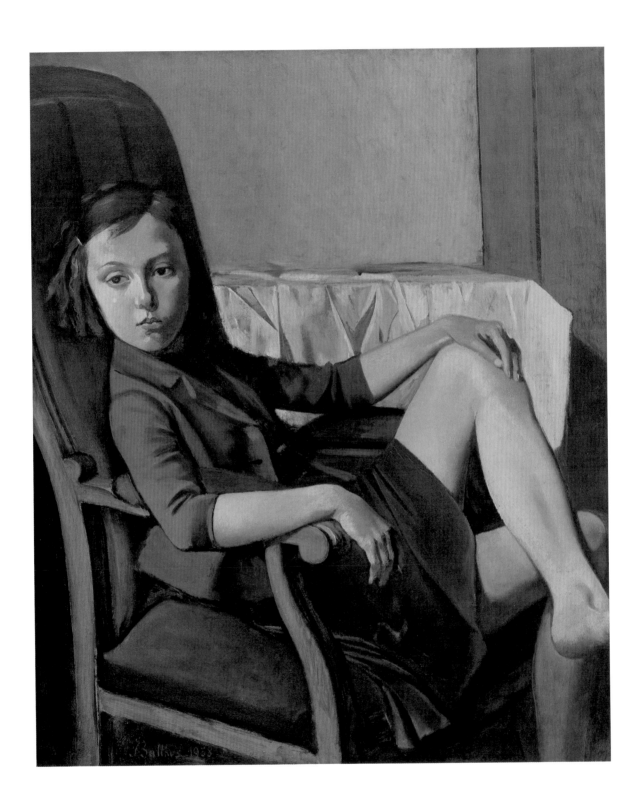

# 19. THÉRÈSE DREAMING

THÉRÈSE RÊVANT    1938

*Signed and dated (lower left): Balthus 1938*

*Oil on canvas, 59 × 51 in. (150 × 130 cm.)*

*Private collection*

Most viewers have remarked on the eroticism present in Balthus's pictures of dreaming or languid girls. Told of this response, the artist seemed surprised and made explicit denials, which adds to the ambiguity of the art, causing its erotic content to seem even more pronounced to the critic.

Her hands folded over her head, a rapt expression on her face, and her legs uncovered, young Thérèse is the epitome of dormant adolescent sexuality. And is that large gray cat lapping milk from a saucer yet another erotic metaphor? The girl's taut, slender body does not rest against the fluffy turquoise pillow. Thérèse could not have dreamt long in such an uncomfortable position.

No one has ever painted the knees of adolescents with as much care, or so often, as Balthus. The cap of Thérèse's left knee is no less finely modeled, shaded, and highlighted than her left cheek. Against the subdued background, the clear white of the girl's skirt and under-garments surrounds her legs like a paper cornucopia wrapped about a romantic bouquet of flowers. Echoes of Morandi and Cézanne are sounded in the simple vases, the lidded drumlike container, and the negligently folded cloth which form an exquisite still life on the plain wooden table.

For many years this painting belonged to Rev. James McLane of Los Angeles, an early admirer of Balthus's work.

EXHIBITIONS: New York, 1949, cat. no. 16, ill.; New York, 1956–57, cat. no. 10, ill. p. 19; Cambridge, Mass., 1964, cat. no. 10, ill.; London, 1968, cat. no. 12, ill. p. 55; Marseilles, 1973, cat. no. 5, ill.; Paris, 1983, pp. 137–38, ill.

BIBLIOGRAPHY: Bonnefoy, 1959, p. 49; Leymarie, 1982, ill. p. 130; S. Klossowski, 1983, pl. 22.

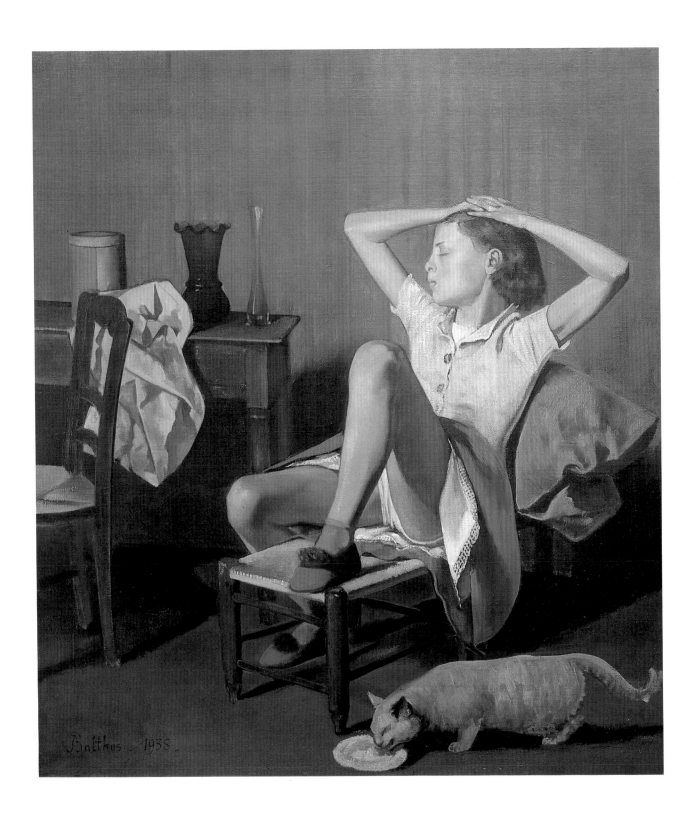

# 20. THE VICTIM

La Victime    1939–46
*Oil on canvas, 52¼ × 86½ in. (133 × 220 cm.)*
*Private collection*

Begun before Balthus left Paris and completed after his
return, this painting depicts a girl about fourteen years
old, sprawled life-size and apparently lifeless on a white
sheet thrown over a sofa. A kitchen knife on the floor
points to her heart. Its blade, however, is clean, and the
girl's body shows neither wound nor blood. A similar
knife, this one blood-stained, lies on the floor in David's
1793 tribute to the assassinated Marat.

    Here the adolescent's finely shaped and elongated
body appears not really dead, perhaps only momentarily
drained of life. She may be in a trance after having been
raped as is Dorothée in Pierre Jean Jouve's novel *La
Victime* (1935), which was dedicated to Balthus.

---

EXHIBITIONS: Paris, 1946, cat. no. 27; Paris, 1966, cat. no. 3, ill. p. 18;
Knokke-le-Zoute, 1966, cat. no. 3, ill.; Paris, 1983, pp. 150–51, ill.

BIBLIOGRAPHY: Leymarie, 1982, ill. p. 139; S. Klossowski, 1983, pl. 23.

Fig. 107. Balthus, *Study for "The Guitar Lesson,"* 1934. Pencil on paper, 8⅛ × 12⅛ in.
(21 × 31 cm.). Collection Fernando Botero

# 21. LARCHANT

1939

*Oil on canvas, 51¼ × 63½ in. (130 × 161 cm.)*

*Private collection*

Larchant, a small village in the Seine-et-Marne department, lies a short distance from Paris. Balthus painted this work just before the outbreak of World War II. Under a vast expanse of sky, the scene looks even flatter and more still than it is in reality. Balthus's interpretation can be checked against a 1930s postcard showing a general view of Larchant (fig. 108). In this painting the ruined thirteenth-century belfry of the church of Saint-Mathurin dominates landscape and village alike. The various houses look like pawns on a chessboard.

During his wartime exile in Geneva, Pierre Jean Jouve, a friend of Balthus's, wrote *Les Bois des pauvres* (1943), a long poem evoking the agony of occupied France. Its opening lines, freely translated, could read:

> The rooks from Larchant's steeple took to flight
> and headed for the oaks of Pauper's Wood;
> the plain below was steeped in purple light,
> while far-off clouds in golden splendor stood.

EXHIBITIONS: Paris, 1946, cat. no. 6; London, 1952, cat. no. 4; New York, 1956–57, cat. no. 12, ill. p. 18; Paris, 1966, cat. no. 8, ill. p. 22; Knokke-le-Zoute, 1966, cat. no. 8; London, 1968, cat. no. 14; Paris, 1983, pp. 148–49, ill.

BIBLIOGRAPHY: Bonnefoy, 1959, pp. 46, 48; Leymarie and Fellini, 1980, pl. 8; S. Klossowski, pl. 24.

LARCHANT — Vue Générale (Nᵒ 23)                A. Poignard, phot., Nemours

Fig. 108. Larchant. Postcard, 1930s

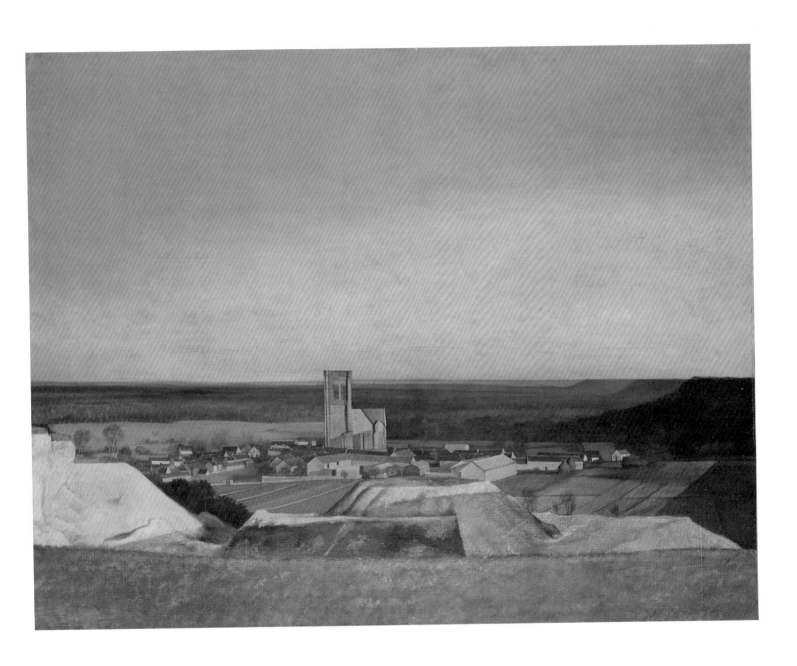

# 22. THE CHERRY TREE

LE CERISIER    1940

*Signed (lower left): Balthus*

*Oil on canvas, 35½ × 28¾ in. (90 × 73 cm.)*

*Collection Mr. and Mrs. Henry Luce III*

In 1940, after the outbreak of World War II, Balthus and
his wife, Antoinette, left Paris and went to live at
Champrovent, a farmhouse in the French Savoy. This
small canvas was the first landscape that he painted after
their arrival. Here we see the farm's meadows and trees in
late June. Antoinette reaches out to pluck cherries from
the tree, which still stands at Champrovent (fig. 109).
(Balthus shifted the mountain so that the thick branches
of the tree could stretch against the luminous sky.)

EXHIBITIONS: Geneva, 1943, cat. no. 1; Paris, 1946, cat. no. 9; New
York, 1956–57, cat. no. 16; Marseilles, 1973, cat. no. 11; Venice,
1980, cat. no. 4, p. 211; Paris, 1983, p. 153, ill.

BIBLIOGRAPHY: Pierre Jean Jouve, "Oeuvre peinte de Balthus," *Lettres I*
(Geneva), no. 1 (January 1943), pp. 37–38, ill.; Leymarie and Fellini,
1980, pl. 10; Leymarie, 1982, p. 40, ill. p. 37; S. Klossowski, pl. 25.

Fig. 109. Cherry tree at Champrovent, 1981.
Photograph: Sabine Rewald

Fig. 110. Balthus, *Study of a Tree*, 1939. Ink wash on paper,
18¼ × 11⅝ in. (46 × 30 cm.). Collection Frédérique Tison

# 23. STILL LIFE WITH A FIGURE

LE GOÛTER    1940

*Signed and dated (indistinctly, lower right): Balthus*

*Oil on wood, 28¾ × 36¼ in. (73 × 92 cm.)*

*Private collection*

Georgette, the thirteen-year-old daughter of the farmer who worked Champrovent, grimly faces a frugal repast of home-baked bread, local cider, and the last apples of the season.

Balthus usually gives his pictures the setting in which he happened to find himself. After his arrival in Champrovent, the severe atmosphere of his Parisian work is replaced by the more decorative forms and richer colors of the farm. The resulting pictures often have an Old Master character, evident here in the deep claret of the curtain and table covering and in the finely painted apples and Victorian fruit bowl, which form a still life reminiscent of Caravaggio's fruit baskets.

Even more resonant of the past is Georgette's gesture.

In Christian iconography a drawn curtain signifies the revelation of a sacred space. But while the bread, cider, and silver bowl are laid out on the lace-trimmed tablecloth, as upon an altar, any evocation of the Eucharist has been undercut by the knife thrust into the loaf of bread.

EXHIBITIONS: Geneva, 1943, cat. no. 2; Paris, 1946, cat. no. 10 (dated 1941); Paris, 1966, cat. no. 10, ill. p. 23; Knokke-le-Zoute, 1966, cat. no. 10, ill. p. 24; London, 1968, cat. no. 17; Marseilles, 1973, cat. no. 11, ill.; Paris, 1983, pp. 152–53, ill.

BIBLIOGRAPHY: *Cahiers d'Art*, vol. 20–21 (1945–46), ill. p. 201; Jean Clair, "Balthus ou les métempsycoses," *La Nouvelle Revue Française*, no. 163 (July 1966), pp. 148–53; Leymarie, 1982, ill. p. 130; S. Klossowski, 1983, pl. 26.

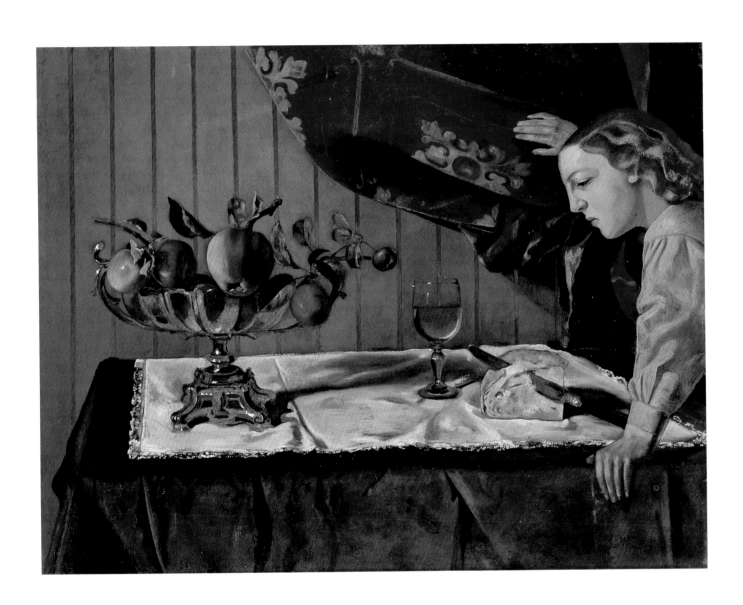

# 24. THE LIVING ROOM

LE SALON    1941–43

*Signed and dated (lower left): Balthus 1941–1943*

*Oil on canvas, 44¾ × 57¾ in. (114 × 147 cm.)*

*The Minneapolis Institute of Arts, The John R. Van Derlip*
*and William Hood Dunwoody Funds*

Georgette, the daughter of the farmer who worked
Champrovent, served as the model for both figures in
this painting. Apple-cheeked and wholesome, she naps
on the canapé. On the floor, in the same position as that
taken by Thérèse in *The Children* (1937; pl. 16), she
reads a book. Now a robust grandmother, Georgette
recalls posing for this picture: "Balthus had me kneel on
the floor reading a book. But I did not care for books.
And when I rested on the sofa, I would go to sleep."

In 1942 Balthus executed another version of *The
Living Room* (fig. 111); the two pictures are virtually
identical in size, but the composition of the second
picture has more finish and greater detail. He then
completed the present picture, which radiates more light
and shows broader brushwork than the second version.

Balthus left Champrovent in late 1941, and he no

doubt used a small study (fig. 112) to complete this work
and to paint the 1942 version.

---

EXHIBITIONS: Geneva, 1943, cat. no. 6; Paris, 1946, cat. no. 13;
London, 1952, cat. no. 7; New York, 1958, The Museum of Modern
Art, *Fifty Selections from the Collection of Mr. and Mrs. Walter Bareiss*, cat.
no. 2, ill.; Munich, 1965, Neue Staatsgalerie, *Die Sammlung von Walter
Bareiss*; Paris, 1966, cat. no. 11; Knokke-le-Zoute, 1966, cat. no. 11;
London, 1968, cat. no. 19, ill. p. 58; Cologne, 1981, *Weltkunst*,
cat. no. 296, ill. p. 36; Paris, 1983, pp. 156–57, ill.

BIBLIOGRAPHY: Maurice Reynal, *Peintures du vingtième siècle* (Geneva: Skira,
1947), ill. p. 35; *The Minneapolis Institute of Arts Bulletin*, vol. 55 (1966),
ill. pp. 53–54; *Cahiers d'Art*, vol. 20–21 (1945–46), p. 202;
George Heard Hamilton, *Painting and Sculpture in Europe 1880–1940*,
(Harmondsworth, Middlesex: Penguin Books, 1967), pp. 441–42,
pl. 261; Leymarie, 1982, pp. 41, 44, ill. pp. 42–43.

Fig. 111. Balthus, *The Living Room*, 1942. Oil on canvas, 45¼ × 57⅞
in. (115 × 147 cm.). The Museum of Modern Art, New York,
Estate of John Hay Whitney

Fig. 112. Balthus, *Study for "The Living Room,"* 1941. Oil on wood,
19 × 23¼ in. (48.2 × 59 cm.). Private collection

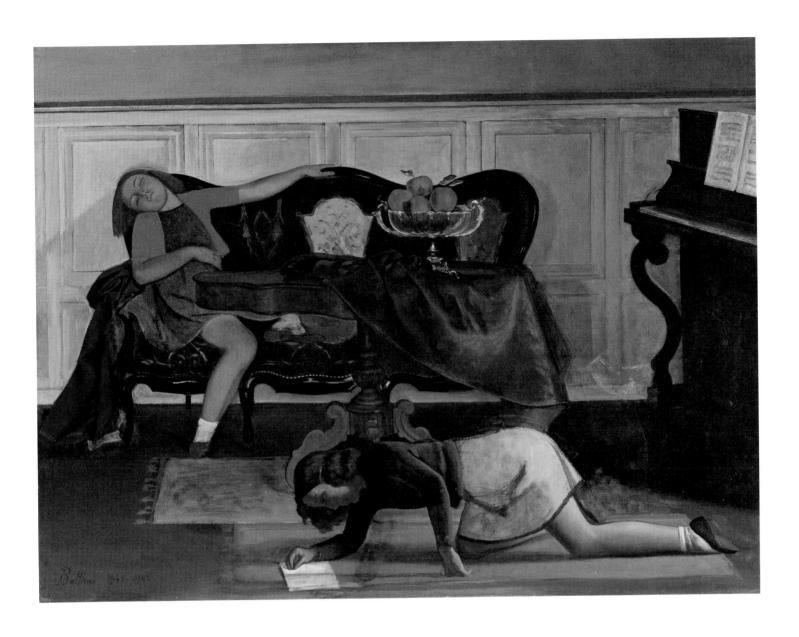

# 25. LANDSCAPE OF CHAMPROVENT

PAYSAGE DE CHAMPROVENT    1941–43

*Oil on canvas, 38½ × 51¼ in. (98 × 130 cm.)*

*Private collection*

During his year and a half at Champrovent, Balthus worked on three landscapes. The present picture and its companion work, *Vernatel (Landscape with Oxen)* (1941–42; pl. 26), form a continuous panorama, extending from north to west as seen only a few steps from the farmhouse door. Resembling an idealized classical landscape, a picture that might have been painted in the early nineteenth century, *Landscape of Champrovent* also presents a faithful rendition of the natural scene (fig. 113).

In the mid-distance, just to the left of center, stands the Château de la Petite Forêt, beyond which spreads the Bois de Leyière. On the far side of the ridge runs the Rhone in its deep valley. In the blue distance the Colombier mountain range stands against the sky, and the Lake of Bourget lies behind the ascending Charvaze on the far

right. It is August, and the late afternoon sun casts long shadows and turns the stubble a deep orange.

Balthus completed this work after he left Champrovent in late 1941. From memory, he placed Georgette, the farmer's daughter, in the stubble field. Home from school for the holidays, she lies dreaming, propped up on her elbow. Today Georgette remembers that "often my brother and I would nap in the field at the end of a summer day."

---

EXHIBITIONS: Geneva, 1943, cat. no. 5; Paris, 1946, cat. no. 14; Paris, 1983, pp. 158–59, ill.

BIBLIOGRAPHY: Leymarie and Fellini, 1980, pl. 9; Leymarie, 1982, p. 41, ill. p. 38; S. Klossowski, 1983, pls. 28–29.

Fig. 113. Landscape of Champrovent, 1981. Photograph: Sabine Rewald

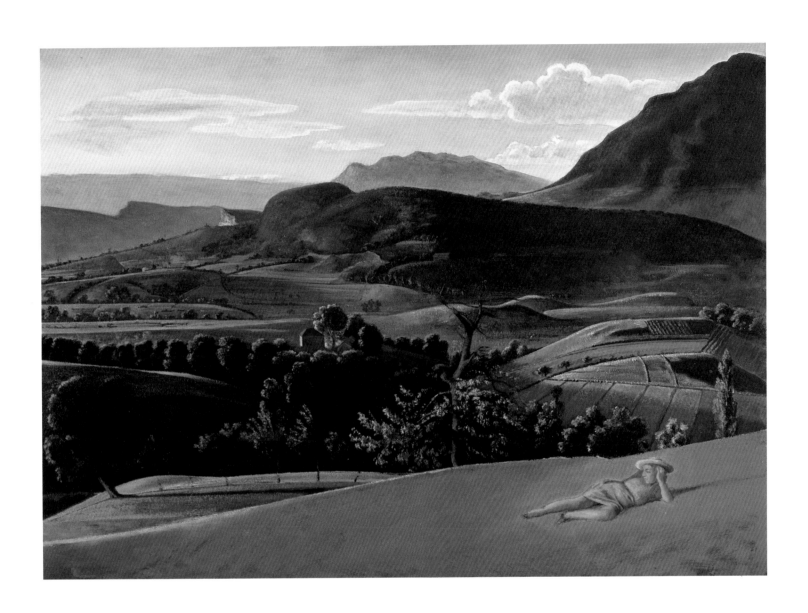

# 26. VERNATEL (LANDSCAPE WITH OXEN)

VERNATEL (PAYSAGE AUX BOEUFS)   1941–42

*Signed and dated (on reverse): Balthus 1941–42*

*Oil on canvas, 28⅜ × 39⅜ in. (72 × 100 cm.)*

*Private collection*

The crest of the Charvaze blocks the horizon in its rise from the Col du Chat pass. This impressive mountain backdrop continues to the right in the Vacherie de la Balme; the tiny red-roofed village of Vernatel nestles below. Georgette, the girl seen dreaming in the foreground of *Landscape of Champrovent* (1941–43; pl. 25), lives today in one of its houses with her husband, and, occasionally, their visiting grandchildren. Had Balthus faithfully rendered the landscape behind the ominous tree, we would see Monthoux, another small village. The overcast light of a late November day gives the landscape a sober, Courbet-like realism. During summer adolescent girls dream in sunny meadows, but the advent of winter brings out the farmer and his oxen, pulling in wood.

EXHIBITIONS: Marseilles, 1973, cat. no. 12, ill.; Paris, 1983, pp. 154–55, ill.

BIBLIOGRAPHY: Leymarie, 1982, pp. 40–41, ill. p. 39.

Fig. 114. Landscape of Vernatel, 1981. Photograph: Sabine Rewald

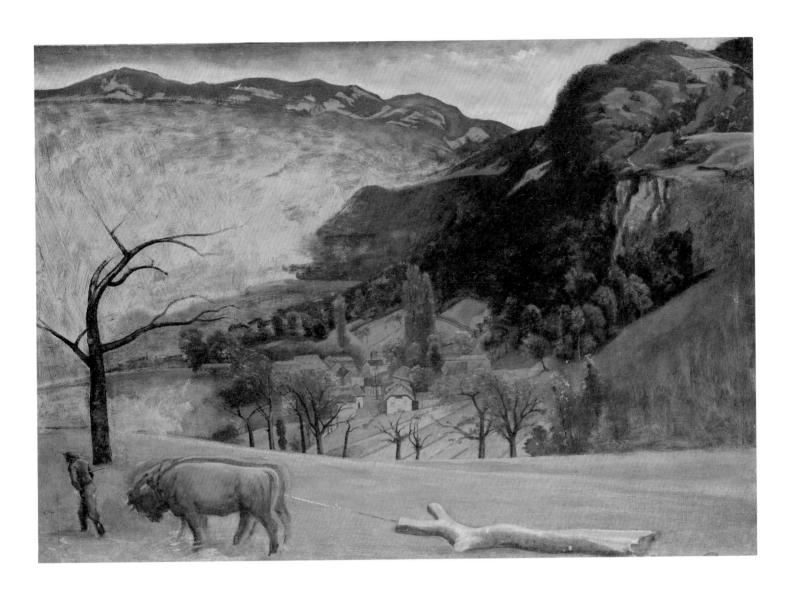

# 27. THE GAME OF PATIENCE

LA PATIENCE    1943

*Signed and dated (lower left): Balthus 1943*

*Oil on canvas, 63 × 65 in. (160 × 165 cm.)*

*The Art Institute of Chicago, The Joseph Winterbotham Collection.*

A girl ponders a game of patience. Only one card remains in her right hand. All the others are laid out in three rows on the table. Jeanette Aldry, the young model, leans forward in a posture similar to that of Hubert Blanchard in *The Children* (pl. 16). The elegant Louis XV armchair, stool, and table have, however, replaced the kitchen furniture of the earlier painting. Balthus probably posed his subject in the rented house in Fribourg where he and his wife lived with their two small sons soon after their departure from Champrovent. It was in this old Swiss town that Balthus painted portraits of Louis de Chollet and his daughters and of Princess Stanislas Radziwill. Pierre Jean Jouve, who waited out the hostilities in Geneva, admired *The Game of Patience*,

seeing in it an allusion to the émigrés' long vigil.

A second version, painted in 1954–55, reinterprets this scene in flat, fresco-like terms.

EXHIBITIONS: Geneva, 1943, cat. no. 11; Paris, 1946, cat. no. 17; New York, 1949, cat. no. 20; New York, 1956–57, cat. no. 15, ill. (frontispiece); New York, 1962, cat. no. 6, ill.; Cambridge, Mass., 1964, cat. no. 12; Chicago, 1964, cat. no. 12, ill.; London, 1968, cat. no. 20, ill. p. 60; Chicago, 1980, cat. no. 3; Paris, 1983, pp. 160–61, ill.

BIBLIOGRAPHY: Jouve, 1944, p. 145; *Cahiers d'Art*, vol. 20-21 (1945–46), ill. p. 205; Robin Ironside, "Balthus," *Horizon*, April 1948, ill. after p. 266; John Russell, "Master of the Nubile Adolescent," *Art in America*, November–December 1967, ill. p. 100; J. Maxon, *The Art Institute of Chicago* (New York, 1970), ill. p. 273; Leymarie, 1982, ill. p. 131; S. Klossowski, 1983, pl. 31.

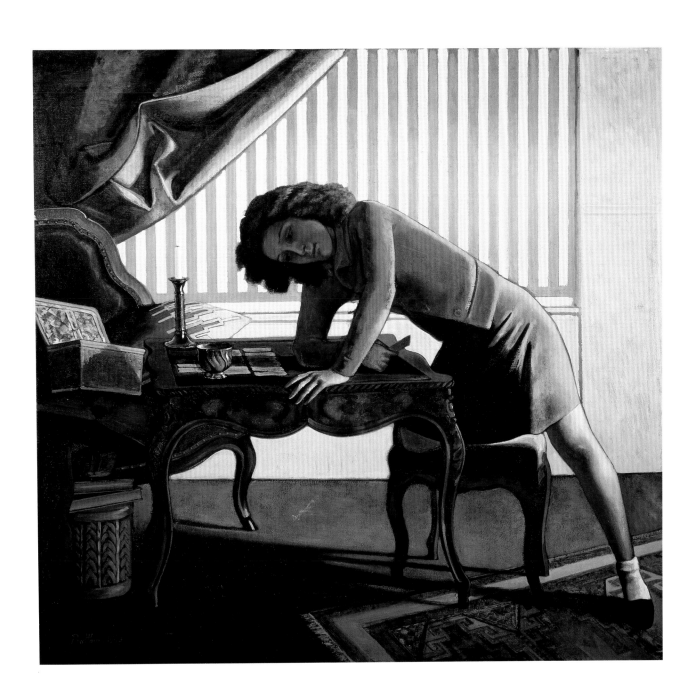

# 28. THE GOLDEN DAYS

Les Beaux Jours   1944–45

*Oil on canvas, 58¼ × 78⅜ in. (148 × 199 cm.)*

*The Hirshhorn Museum and Sculpture Garden, Smithsonian*

*Institution, Washington, D.C.*

A pretty adolescent peers at herself in a mirror, which also reflects the daylight from a window behind. Her small-waisted body is tense. She has allowed her bodice to slip off one shoulder, and her short skirt reveals her long, slender legs. A man, dressed in a tight reddish sweater and trousers, tends the fire. Are they Cathy and Heathcliff from Emily Brontë's *Wuthering Heights*? What has happened or is about to happen?

Balthus started *The Golden Days* in Fribourg and completed it at the Villa Diodati in Geneva. The picture's smooth facture and color scheme seem to have been inspired by the faded Victorian canapé, with its seaweed-green velvet covering and claret border. For all its ambiguity, the scene unfolds in a well-defined composition, in which daylight and firelight oppose one another. The effacement of the man in the background matches that of Echo in Poussin's *Echo and Narcissus* (fig. 10), a painting that Balthus had copied many years earlier, while the girl

is as well defined and self-involved as Narcissus himself.

Although Balthus described *The Golden Days* as a memory of Champrovent, the farm in the French Savoy where he spent the early war years, this room does not exist at Champrovent.

EXHIBITIONS: Paris, 1946, cat. no. 25; New York, 1949, cat. no. 19, ill.; New York, 1956–57, cat. no. 16, ill. p. 23; Paris, 1966, cat. no. 13, ill. p. 25; Knokke-le-Zoute, 1966, cat. no. 13; London, 1968, cat. no. 23; Des Moines, Iowa, 1978, Des Moines Art Center, *Art in Western Europe: The Postwar Years, 1945–1955*, cat. no. 5, ill.; Venice, 1980, cat. no. 6, p. 211; Paris, 1981, Musée national d'art moderne, Centre Georges Pompidou, *Paris-Paris*, cat. no. 62, ill. p. 243; Paris, 1983, pp. 164–65, ill.

BIBLIOGRAPHY: *Cahiers d'Art*, vol. 20–21 (1945–46), ill. p. 199; Christian Zervos, "Exposition d'art contemporain," *Cahiers d'Art*, vol. 22 (1947), ill. p. 301; Leymarie and Fellini, 1980, pls. 11–13; Leymarie, 1982, pp. 46–47, ill. pp. 48–49; G. Bataille, *Die Tränen des Eros* (Munich: Matthes & Seitz Verlag, 1981), ill. p. 218; S. Klossowski, 1983, pl. 32.

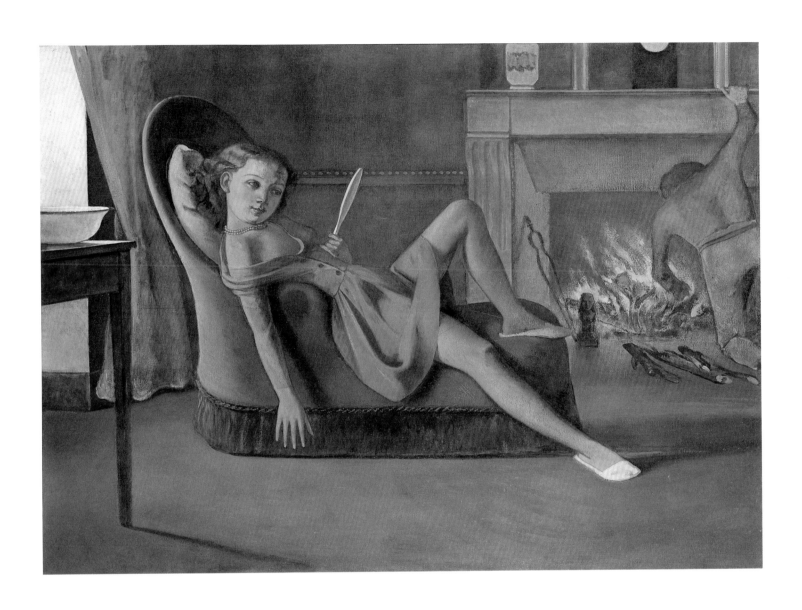

# 29. THE GAME OF CARDS

La Partie de cartes  1948–50

Signed and dated (lower left): Balthus 1948–50

Oil on canvas, 55⅛ × 76⅜ in. (140 × 194 cm.)

Collection Thyssen-Bornemisza

Balthus ignored all the genre-like, anecdotal, or medita-tive elements usually associated with this subject. No bystanders frolic about as the players—eerie children—pursue their game with grim concentration. Should these children ever grow into adults, they might not be the sort one would enjoy meeting on a dark, lonely street. The game appears decided in favor of the girl, who, holding several cards to the boy's one, makes her move with ominous superiority.

Light means everything here. It enters the picture from the lower right and moves diagonally upward, following the angle of the boy's silhouette. Illuminating certain areas, casting others into shadow, it makes the girl's face resemble one of Picasso's Cubist heads, an integration of both front and side views.

A wicked expression belies the innocence of the pale blue dress worn by the girl; her steely presence is unmatched by the boy, whose strong body appears to support a feeble mind. Dressed in a snug vermilion top and orange breeches, the youth could be a Renaissance page. The girl sits ramrod straight as if she reigned upon a throne, while her male adversary balances precariously on a jester's stool.

EXHIBITIONS: New York, 1956–57, cat. no. 15, ill. p. 28; London, 1968, cat. no. 29, ill. p. 65; Zurich, 1982, Thomas Ammann Fine Art, *Balthus and Twombly*, cat. no. 3, ill.; New York, 1983, The Metropolitan Museum of Art, *Twentieth Century Masters: The Thyssen-Bornemisza Collection (Recent Acquisitions)*, ill. (on the cover); Paris, 1983, pp. 166–67, ill.

BIBLIOGRAPHY: Leymarie, 1982, ill. p. 133; S. Klossowski, 1983, pl. 38.

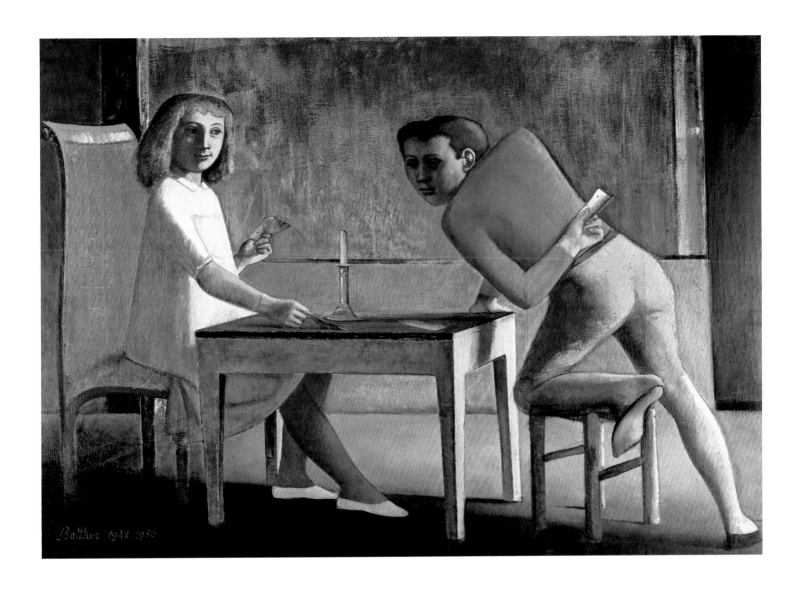

# 30. THE WEEK WITH FOUR "THURSDAYS"

La Semaine des quatre jeudis   1949

*Signed and dated (lower right): Balthus 1949*

*Oil on canvas, 38½ × 33 in. (98 × 84 cm.)*

*Private collection*

French schools were traditionally closed on Thursdays, and four such holidays in a week would be complete bliss. This feeling is evident on the face of the girl who, attired in a white smock, sprawls in an armchair in one of Balthus's favorite postures. Her smiling cat clings to the back of the chair. This painting and *Nude with a Cat* (1949; pl. 31) are two of a series of four works on the same theme that Balthus painted in 1949. Only the present painting is called *The Week with Four "Thursdays,"* but this title could serve well for the entire series. These works represent a girl playing with a cat, while another figure stands by a window in the background.

EXHIBITIONS: New York, 1949, cat. no. 26; New York, 1956–57, cat. no. 22, ill. p. 27.

Fig. 115. Balthus, *Study for "Nude with a Cat,"* ca. 1949. Ink and pencil on paper, 11⅞ × 17¾ in (30 × 45 cm.). The Museum of Modern Art, New York, John S. Newberry Collection

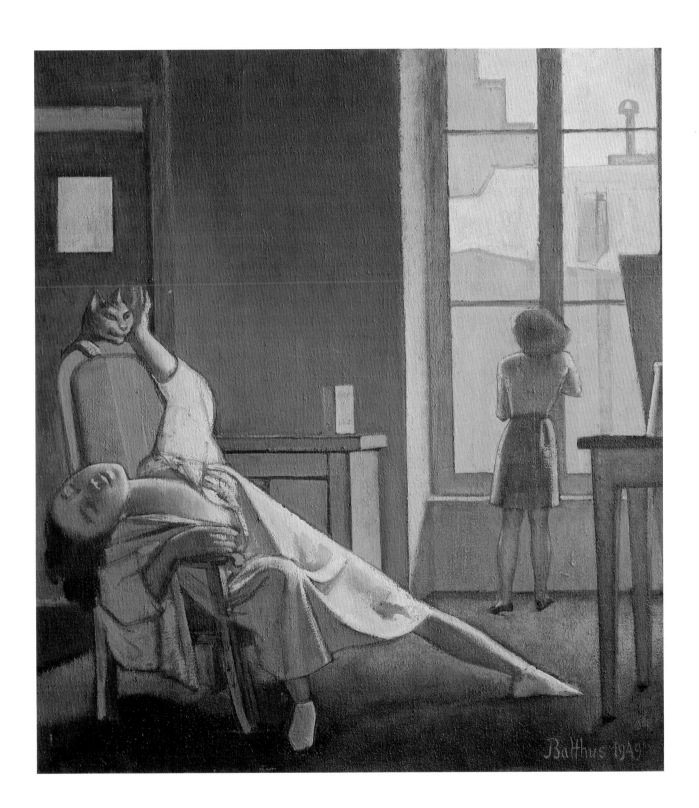

# 31. NUDE WITH A CAT

Nu au chat (Nu à la bassine)    1949

*Signed and dated (lower right): Balthus 1949*

*Oil on canvas, 25⅝ × 31 in. (65 × 79 cm.)*

*National Gallery of Victoria, Melbourne, Felton Bequest, 1952*

The setting is again the painter's studio at the Cour de Rohan, now seen in close-up. The washbasin on the floor and the water cans on the chest on the left suggest that the girl has just taken a bath.

The light from the distant window models her body. The figure's undulating movement—from the tip of the left foot to the hand flung back to fondle the cat—dominates the composition. The figure at the window is not included in the games played by the girl and cat.

*Nude with a Cat* is the most accomplished work in the series that includes *The Week with Four "Thursdays"* (1949;

pl. 30). This group of pictures is related to the large painting *The Room* (1952–54; pl. 32), in which cat and girl no longer play, and the figure at the window, no longer uninvolved, suddenly acts fiercely.

EXHIBITIONS: London, 1952, cat. no. 12; New York, 1956–57, cat. no. 26, ill. p. 30; London, 1968, cat. no. 38, ill. p. 72; Des Moines, Iowa, 1978, Des Moines Art Center, *Art in Western Europe: The Postwar Years, 1945–1955*, cat. no. 6.

BIBLIOGRAPHY: Bonnefoy, 1959, p. 50; Leymarie, 1982, ill. p. 142; S. Klossowski, 1983, pl. 39.

Fig. 116. Balthus, *Study for "Nu à la bassine,"* 1949. Ink and pencil on paper, 11¼ × 17¼ in. (29 × 44 cm.). Collection John Rewald. Photograph: Eric Pollitzer

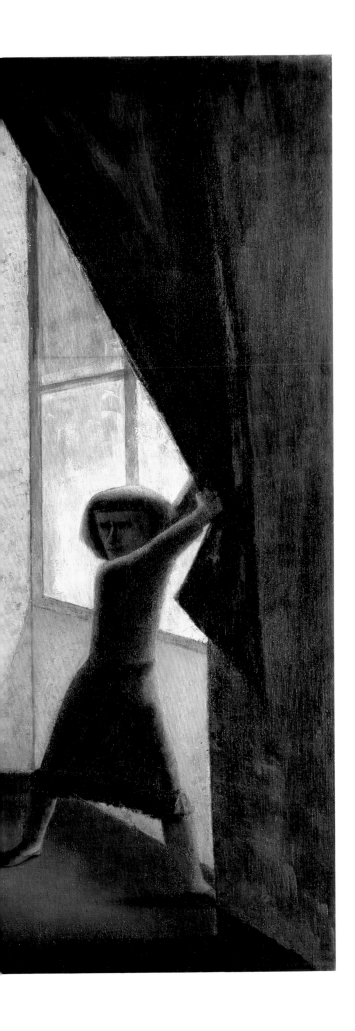

# 32. THE ROOM

La Chambre 1952–54

*Oil on canvas, 106 × 130 in. (269 × 330 cm.)*

*Private collection*

This nude is the most erotic and self-abandoned of Balthus's narcissistic adolescent girls. Her languid rapture is about to be rudely awakened by the gnomelike figure who angrily draws back the curtain to expose her to the light. The room is bare and sinister. The cupboard in the background is fit for a giant's wardrobe.

As in *The Week with Four "Thursdays"* and *Nude with a Cat* (pls. 30 and 31), light caresses and sculpts the girl's full body. A disquieting relationship exists between the voluptuous, passive nude and the malevolent sexless imp, who might have sprung from a cruel nineteenth-century German fairy tale. Meanwhile, the cat watches owl-like from a safe distance.

Balthus's *The Room* has all the ambiguity and mystery of Henry Fuseli's *Nightmare* (fig. 117). And like Fuseli's painting, it keeps its secret—all interpretations are dependent on the beholder's imagination.

EXHIBITIONS: New York, 1956–57, cat. no. 25, ill. p. 31 (not exhibited); New York, 1957, cat. no. 4, ill.; Turin, 1961, cat. no. 1; Paris, 1966, cat. no. 19, ill. p. 32; Knokke-le-Zoute, 1966, cat. no. 19, ill.; London, 1968, cat. no. 34, ill. p. 70; Venice, 1980, cat. no. 8, ill. p. 210; Paris, 1981, Musée national d'art moderne, Centre Georges Pompidou, *Paris-Paris*, cat. no. 63, ill. p. 242.

BIBLIOGRAPHY: P. Klossowski, 1956, ill. p. 26; Bonnefoy, 1959, p. 55; Thomas B. Hess, "Balthus: Private Eye," *Vogue*, January 1974, ill. pp. 104–105; Leymarie and Fellini, 1980, pls. 17–18; Leymarie, 1982, pp. 52, 56–57, ill. pp. 54–55; G. Bataille, *Die Tränen des Eros* (Munich: Matthes & Seitz Verlag, 1981), ill. p. 217; S. Klossowski, 1983, pls. 40–41.

Fig. 117. Henry Fuseli, *The Nightmare*, 1781. Oil on canvas, 40 × 50 in. (102 × 127 cm.). Detroit Institute of Arts, Gift of Mr. and Mrs. Bert L. Smokler and Mr. and Mrs. Lawrence A. Fleischman

# 33. THE PASSAGE DU COMMERCE SAINT-ANDRÉ

LE PASSAGE DU COMMERCE SAINT-ANDRÉ   1952–54

*Oil on canvas, 115 × 130 in. (292 × 330 cm.)*

*Private collection*

The tiny Parisian street called the Passage du Commerce Saint-André runs between the Rue Saint-André-des-Arts and the Boulevard Saint-Germain at the Carrefour de l'Odéon. In this painting Balthus viewed it from the entrance of 19 Rue de l'Ancienne Comédie. The artist often passed through here on the way to his studio at the Cour de Rohan just around the corner to the left.

Small though it may be, the Passage du Commerce Saint-André has played a considerable role in history. Its houses date from the 1770s. Behind the facade of one of them, the shopfront bearing the sign REGISTRE, Marat published his *L'Ami du peuple* in 1793 (until July 14, when Charlotte Corday plunged a knife into his chest). Following the Reign of Terror, the widow of the Girondin Jacques-Pierre Brissot de Warville opened a renowned reading room in the same building. She operated it under an assumed name and used as her stock her husband's collection of books. Among those frequenting the library was Sainte-Beuve, who also lived in the Passage. Another reader was Balzac's Lucien Chardon, the hero of *Les Illusions perdues* and a man eager "to keep up with the intellectual movement." Less literary events took place around the corner to the left, at no. 9, where in 1792 Dr. Guillotin constructed the guillotine and tried it out on sheep in the shop of the German carpenter Schmidt. Hence that sheeplike dog in the axis of the picture?

With one of Paris's smallest streets as his subject, Balthus painted his largest picture, endowing every color and contour with an almost hushed softness. To achieve this effect, he used only primary colors and applied them in superimposed coats, covered by translucent scumbling. This technique produced the aged, patinated look of the weathered stone facades and wooden shopfronts.

*The Passage du Commerce Saint-André* can be seen as the pendant to *The Street* (1933; pl. 3) which represents an aspect of a Parisian working day. Here another side of Parisian life is shown. It is Sunday and the shops are closed; only the *boulangerie* is open, and a man (perhaps Balthus) has just bought a baguette. Children play while

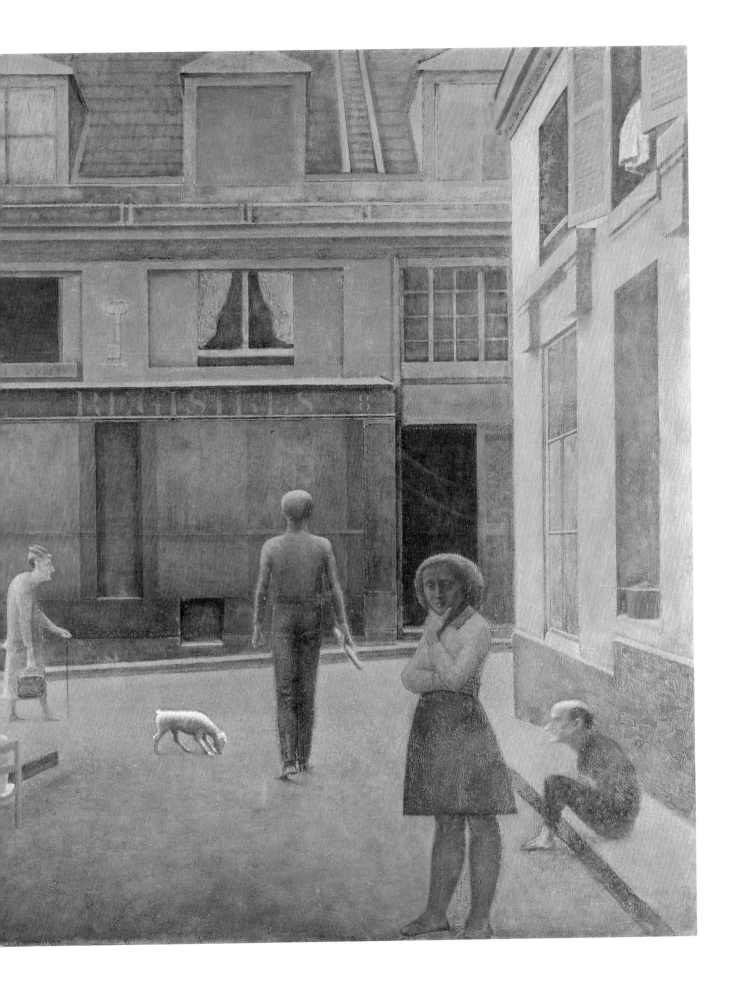

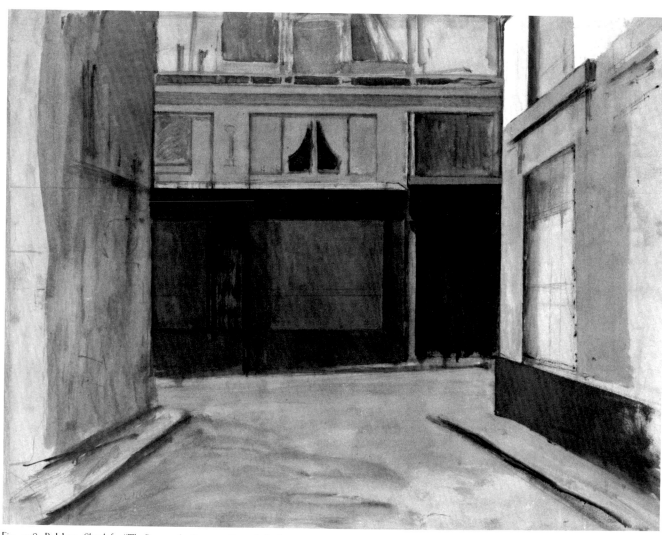

Fig. 118. Balthus, *Sketch for "The Passage du Commerce Saint-André,"*
1952. Oil on Isorel, 28 × 35½ in. (71 × 90 cm.). Collection
Henriette Gomès, Paris. Photograph: Jacqueline Hyde

a wizened old man watches them. A pensive girl in the
foreground stares out at the viewer. An old spinster,
bent and worn, goes, or comes, from church. The
concierge in the doorway on the far left looks on.

With this picture Balthus concluded his scenes of
Paris, bidding farewell to the city before taking up
residence at the Château de Chassy in 1953.

In a small oil sketch (fig. 113), we see the site empty
of figures.

EXHIBITIONS: New York, 1956–57, cat. no. 24, ill. p. 19; Turin, 1961,
cat. no. 2, ill.; Venice, 1980, cat. no. 9, p. 211; Paris, 1983, pp.
170–71, ill.

BIBLIOGRAPHY: P. Klossowski, 1956, ill. p. 29; Bonnefoy, 1959, pp.
51–53; Leymarie and Fellini, 1980, pls. 19–21; S. Klossowski, 1983,
pls. 42–43.

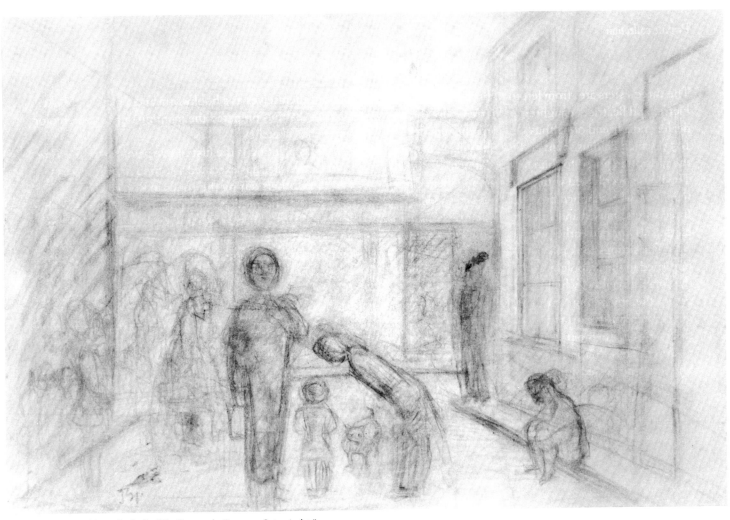

Fig. 119. Balthus, *Study for "The Passage du Commerce Saint-André,"*
1952. Pencil on paper, 14⅝ × 20⅞ in. (37 × 53 cm.). Private
collection

Fig. 120. Balthus, *Study for "The Passage du Commerce Saint-André,"*
1952. Charcoal on paper, 11¼ × 8⅞ in. (30 × 23 cm.). Collection
Frédérique Tison

# 34. THE THREE SISTERS

*Les Trois Soeurs* 1954–55

*Oil on canvas, 23⅝ × 47 in. (60 × 119 cm.)*

*Private collection*

The three sisters are, from left to right, Sylvia, Marie-Pierre, and Beatrice, daughters of Pierre Colle, the art dealer and a friend of Balthus's. During the summer of 1953, which Balthus spent at the Colle villa in Biarritz, the girls often posed for him before going to the beach. The house overflowed with guests, among them Christian Dior, who supplied boxes of chocolates to keep the three sisters amused and still during their sessions with Balthus. (Dior had earlier worked with Pierre Colle.)

The sittings took place in the *petit salon*, a room furnished in the Napoleon III style. The actual color of the sofa was yellow, which Balthus changed to dark green, thereby giving Marie-Pierre's gardenia-red dress greater luminosity. Arranged in a frieze-like fashion, the sitters express their personalities and ages by their postures. Thus, Marie-Pierre, at the center, dominates. She is self-possessed and seductive, while her sisters present themselves as a bookworm and a mere child. At Biarritz, Balthus prepared the painting only in watercolor and pencil sketches.

This painting is the first of five paintings in the *Three Sisters* series. Balthus executed a second picture in 1955 and three others during the 1960s in Rome.

By then his models, who posed only for the sketches made in Biarritz, had grown up. Years had gone by, but although their poses and dresses were modified, the girls remained the same age, except for Beatrice, who caught up with her sisters.

Sylvia Colle-Lorant has recently written about Balthus's designs for the theater.

---

Exhibitions: Paris, 1966, cat. no. 21; London, 1968, cat. no. 43; Paris, 1983, pp. 186-87, ill.

Bibliography: Bonnefoy, 1959, p. 55.

 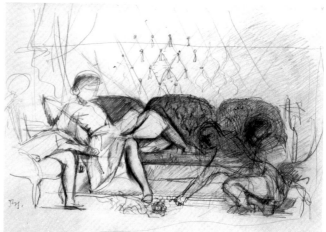

Fig. 121 and 122. Balthus, *Study for "The Three Sisters"* (double-sided drawing), 1955. Pencil and crayon on paper, 12 × 16¾ in. (31 × 43 cm.). Gertrude Stein Gallery, New York. Photographs: eeva-inkeri

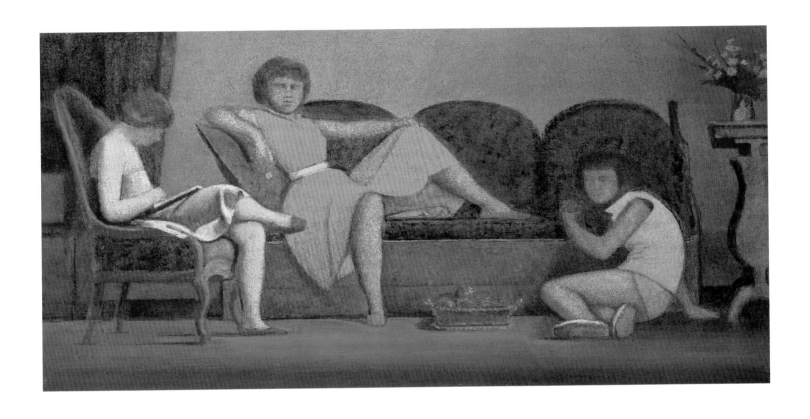

# 35. THE DREAM 1

Le Rêve I  1955

*Signed and dated (lower right on carpet): Balthus 1955*

*Oil on canvas, 51 × 64 in. (130 × 163 cm.)*

*Private collection*

This dreaming girl with long brown hair and classic features is Frédérique Tison, the painter's niece by marriage. Seventeen years old at the time she posed for this picture, Frédérique became Balthus's favorite model at the Château de Chassy, where she took up residence in 1954.

The picture is set in the main living room at Chassy. The background has been made to look shallow, and this flatness is emphasized by a checkerboard propped against the wall on what appears to be a side cabinet. The human forms are endowed with a monumental earthiness like that of Piero della Francesca's figures. In her pink skirt and green blouse, Frédérique could be a sleeping angel in one of the fifteenth-century master's works.

The figure entering from the right, so large that the top of her bowed head has been cut off, has a sense of movement rarely seen in Balthus's art. She treads as lightly as the angel of the Annunciation, carrying her red flower with the grace of a good fairy waving her magic wand in a dream.

Exhibitions: New York, 1957, cat. no. 13, ill; Turin, 1958, Galleria d'Arte "Galatea," cat. no. 5, ill. (on the cover); Turin, 1961, cat. no. 10, ill.; Paris, 1966, cat. no. 27, ill. p. 38; Knokke-le-Zoute, 1966, cat. no. 27, ill.; London, 1968, cat. no. 42, ill. p. 76; Marseilles, 1973, cat. no. 29, ill.; Venice, 1980, cat. no. 13, ill. p. 210; Paris, 1983, pp. 178–79, ill.

Bibliography: Leymarie and Fellini, 1980, pls. 25–27; G. Bataille, *Die Tränen des Eros* (Munich: Matthes & Seitz Verlag, 1981), ill. p. 220; Leymarie, 1982, p. 88, ill. pp. 84–85; S. Klossowski, 1983, pl. 52.

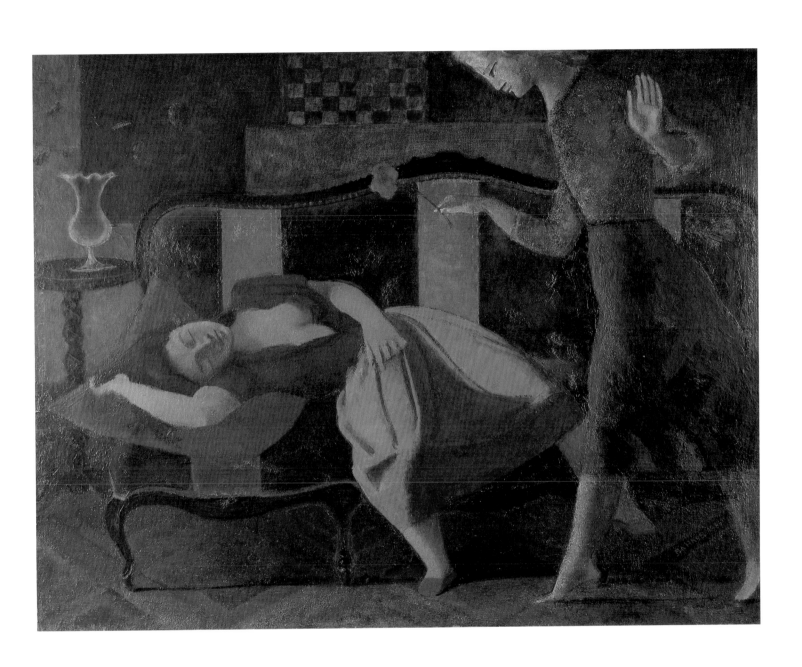

# 36. GIRL IN WHITE

Jeune Fille à la chemise blanche   1955
*Oil on canvas, 45 × 35 in. (114 × 89 cm.)*
*Private collection*

The girl, dressed in white, is again Frédérique Tison. At the age of nine, she had first posed for the artist. Later, while living with him at Chassy, she frequently appeared in the interiors that he painted there. She is as indolent and drowsy as the adolescents that Balthus has always favored.

Here, however, she is seventeen, and her attitude has changed. She sits against a plain background that has no decorative detail. A raking light from the left emphasizes her classical features and throws her near arm and breast into strong relief. Most of her body remains in the shade where it adopts a deeper value of the greenish-gray background. The white smock, fallen below her breasts, continues the outlines of her powerful torso and serves as a pedestal.

---

EXHIBITIONS: New York, 1956–57, cat. no. 30, ill. p. 34; London, 1968, cat. no. 39, ill. p. 73; Marseilles, 1973, cat. no. 26, ill.; New York, 1977, cat. no. 44, ill.; Des Moines, Iowa, 1978, Des Moines Art Center, *Art in Western Europe: The Postwar Years, 1945–1955,* cat. no. 7.

BIBLIOGRAPHY: Leymarie, 1982, p. 64, ill.

Fig. 123. Balthus, *Girl in Profile,* 1948–49. Pencil on paper, 13½ × 8¾ in. (34 × 22 cm.). Collection John Rewald
Photograph: Eric Pollitzer

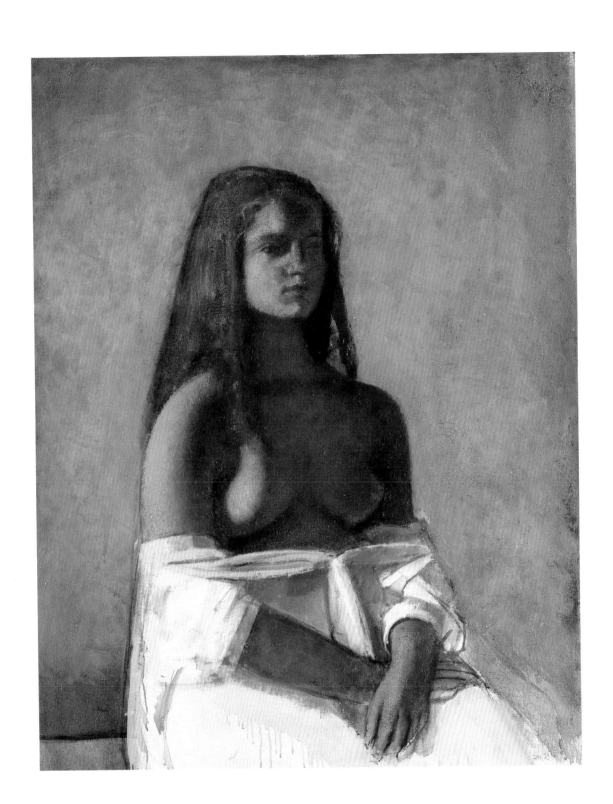

# 37. NUDE IN FRONT OF A MANTEL

NU DEVANT LA CHEMINÉE    1955

*Signed and dated (lower right): Balthus 1955*

*Oil on canvas, 75 × 64½ in. (191 × 164 cm.)*

*The Metropolitan Museum of Art, Robert Lehman Collection, 1975*

When a nude adolescent girl looked at herself in a mirror in Balthus's earlier works, she was seen more or less frontally and usually accompanied by an elderly maid.

Now all has changed. Seen in profile, this monumental nude faces a mirror resting on an ornate mantel of gray marble. As she stands rooted to the floor, the solid, sculpturesque girl looks as though she too might be carved from marble. Like a figure in an Egyptian frieze, she plants one foot in front of the other.

Another innovation is the clear, even light that fills the room. The harmony and stillness of the scene is enhanced by a palette of pale blues, off-whites, beiges, and a few darker tonalities.

The inspiration for this nude came from a magazine illustration. Balthus placed the figure in front of a fireplace in one of the downstairs rooms at Chassy. An earlier work, *Young Girl at Her Toilette* (fig. 124), may be regarded as a study for this painting.

---

EXHIBITIONS: New York, 1957, cat. no. 11; Venice, 1980, cat. no. 12, ill. p. 213; Paris, 1983, pp. 182–83, ill.

BIBLIOGRAPHY: P. Klossowski, 1956, ill. p. 31; Leymarie and Fellini, 1980, pls. 23–24; E. Luce-Smith, *The Body Images of the Nude* (London, 1981), ill. p. 133; Leymarie, 1982, p. 88, ill. p. 83; S. Klossowski, 1983, pl. 49.

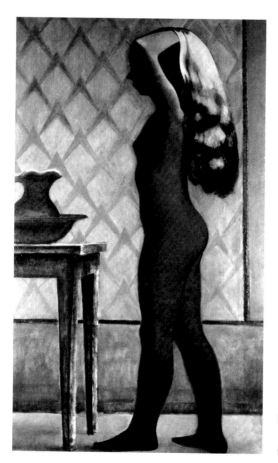

Fig. 124. Balthus, *Young Girl at Her Toilette,* 1949–51. Oil on canvas, 54½ × 31¾ in. (139 × 81 cm.). Private collection

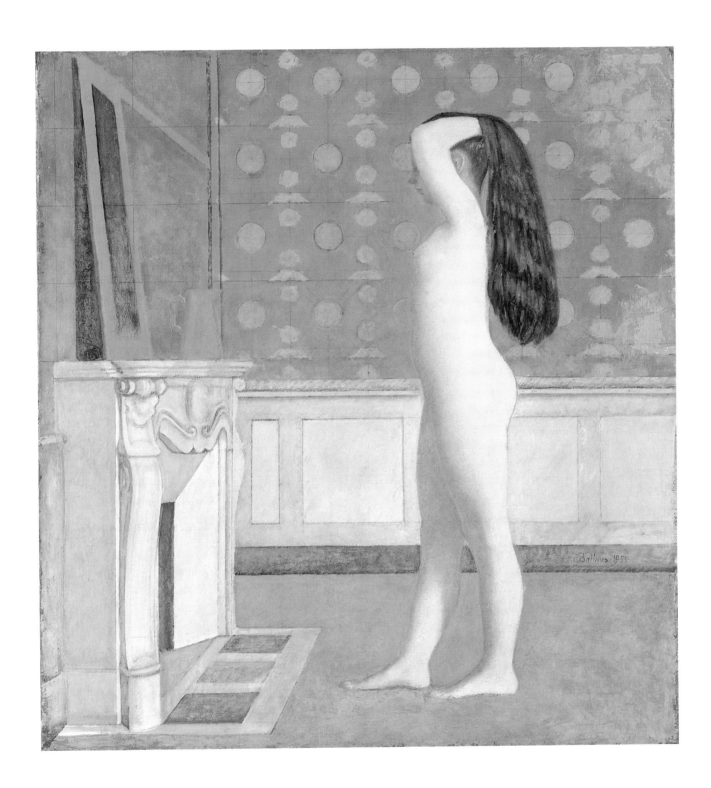

# 38. LANDSCAPE WITH TREES (THE TRIANGULAR FIELD)

GRAND PAYSAGE AUX ARBRES (LE CHAMP TRIANGULAIRE) 1955

*Signed and dated (lower right): Balthus 1955*

*Oil on canvas, 45 × 64 in. (114 × 163 cm.)*

*Collection Henriette Gomès, Paris*

The Château de Chassy stands in an austere but pleasant landscape in the Morvan, a mountainous region in the Nièvre, a department in central France. Balthus lived in the château from 1953 to 1961. Its rooms provided the settings for the interior scenes that he painted, and the views from its windows provided his landscape motifs. High in the north tower, one window overlooks this tilled hillside studded with gnarled apple trees. The painting's richly scumbled surface makes the trees look fibrous, the soil dry, and the light cool.

From the shade at the left strides the farmer Riri who waves at a horse let loose in the sunshine. Across a wooden fence, three sheep graze in a meadow. At the right in the far distance, a man works one corner of the triangular field. This same field appears again in other landscapes that Balthus painted at different seasons.

EXHIBITIONS: New York, 1957, cat. no. 15, ill.; Turin, 1958, cat. no. 7; Paris, 1966, cat. no. 25, ill. p. 36; Knokke-le-Zoute, 1966, cat. no. 23; London, 1968, cat. no. 41, ill. p. 75; Marseilles, 1973, cat. no. 28, ill.; Venice, 1980, cat. no. 11, p. 211; Paris, 1981, Musée national d'art moderne, Centre Georges Pompidou, *Paris-Paris*, cat. no. 64, ill. pp. 244–45; Paris, 1983, p. 181, ill.

BIBLIOGRAPHY: P. Klossowski, 1956, ill. p. 30; Leymarie and Fellini, 1980, pl. 22; Leymarie, 1982, pp. 66, 74–75, ill. pp. 68–69; S. Klossowski, 1983, pl. 46.

Fig. 125. Balthus, *The Valley of the Yonne*, 1955. Watercolor and pencil on paper, 8⅞ × 11⅛ in. (23 × 30 cm.). Private collection

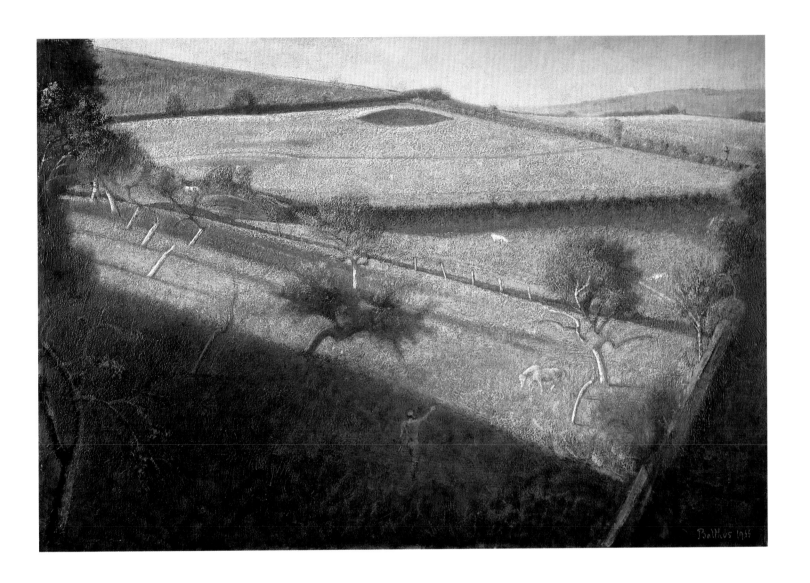

# 39. THE FORTUNE TELLER

La Tireuse de cartes    1956

*Oil on canvas, 78 × 78 in. (198 × 198 cm.)*

*Collection Jerold and Dolores Solovy*

While at Chassy, Balthus used the château's rooms as settings for his pictures. *The Fortune Teller* takes us into the salon, where Frédérique Tison spreads her cards in front of the fireplace. The undercurrent of drama, tension, and foreboding present in the painter's earlier interior scenes has vanished at Chassy, replaced by a preoccupation with form and space. The oblique view gives the impression of depth, and all the furnishings abide by the rules of perspective. Following the line of recession on the left is the sofa on which Frédérique lay dreaming in *The Dream I* (1955; pl. 35). In the present composition Balthus's niece sits bolt upright. With her enigmatic, masklike face, her flat torso, and her outstretched arm, she resembles a figure on a tarot card.

Exhibitions: New York, 1957, cat. no. 17, ill.; New York, 1962, cat. no. 10, ill.; Chicago, 1964, cat. no. 22; Cambridge, Mass. 1964, cat. no. 19; London, 1968, cat. no. 44, ill. p. 77; Detroit, 1969, cat. no. 10; Marseilles, 1973, cat. no. 30; Venice, 1980, cat. no. 14, ill. p. 211; Paris, 1983, pp. 188–89, ill.

Bibliography: Leymarie and Fellini, 1980, pl. 28; Leymarie, 1982, p. 88, ill. p. 87.

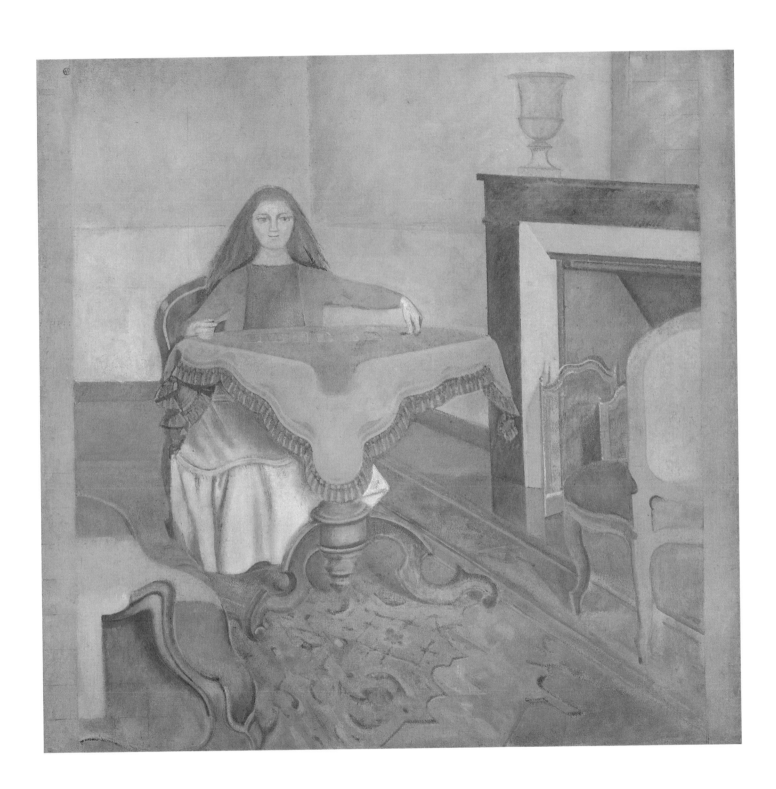

# 40. GIRL AT A WINDOW

JEUNE FILLE À LA FENÊTRE    1957

*Oil on canvas, 63 × 63¾ in. (160 × 162 cm.)*

*Private collection*

Frédérique Tison, Balthus's niece, looks out on a summer morning from one of the windows at Chassy. The view is that of the garden with the red-roofed sheds and the two gates of the farm's courtyard beyond. In the veiled distance lies the valley of the Yonne River. Like a filter of fine gauze, the shimmering sunlight softens the contours and colors of all forms. Seen against the sunlight, Frédérique's body assumes a dark solidity. Streaming past her, the rays strike the window frames, which cast shadows against the left wall. The sun also illuminates Frédérique's hair, causing it to blend into the pale red-brick color of the roofs beyond. In the series of paintings he did of this spot, Balthus included the tree on the left, usually stripped bare of its foliage. A photograph of Chassy's facade (fig. 126) shows the tree from its opposite side, as well as "Frédérique's window," at the extreme left on the ground floor.

EXHIBITIONS: Turin, 1961, cat. no. 13; Paris, 1966, cat. no. 32; Knokke-le-Zoute, 1966, cat. no. 30; New York, 1977, cat. no. 7, ill.; Paris, 1983, pp. 194–95, ill.

BIBLIOGRAPHY: Leymarie, 1982, p. 82, ill. p. 79; S. Klossowski, 1983, pl. 56.

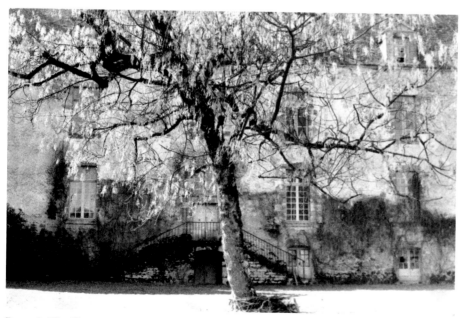

Fig. 126. The Château de Chassy. Photograph: Pierre Zuccha

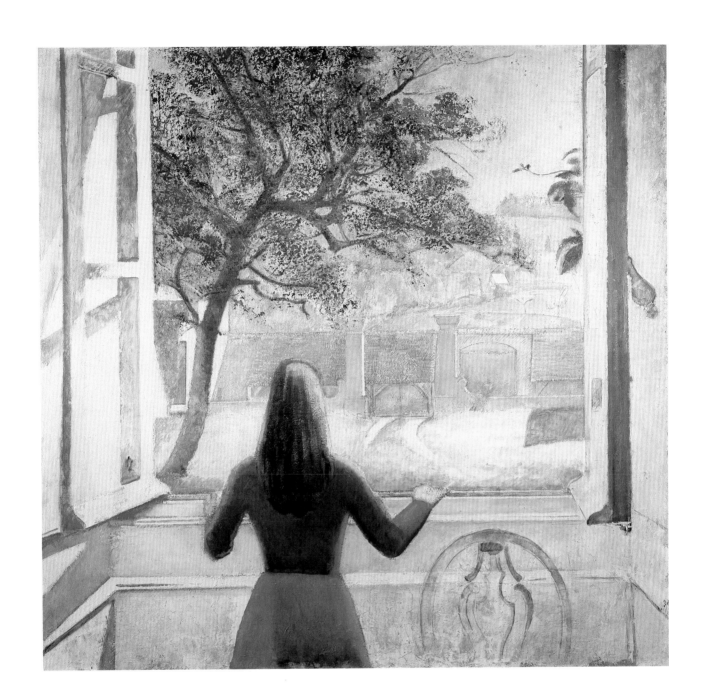

# 41. THE GOLDEN FRUIT

LE FRUIT D'OR    ca. 1959

*Oil on canvas, 62⅝ × 63¼ in. (159 × 161 cm.)*

*Private collection*

The bearer of the "golden fruit" looks like a witch from a fairy tale. In fact, the figure's features resemble those of the painter himself. The round-faced girl, slumped in mid-afternoon sleep on an antique sofa, seems unthreatened by the strange being, who perhaps exists only in the adolescent's dream. The setting, however, is no figment of the imagination, but Chassy's very real salon illuminated by a window to the left, outside the picture.

In both theme and setting, *The Golden Fruit* is a variation of *The Dream I* (1955; pl. 35). It does, however, differ from the earlier picture in its spatial conception. In the flattened environment of *The Dream I*, all forms are aligned parallel to the picture plane. *The Golden Fruit* presents a deeper view into space. Through the lattice back of the side chair on the left, one sees the receding lines of the patterned carpet.

This composition contains a number of fine details—the still life on the table, composed of trays, coffeepots, a folded napkin, and a cup set slightly off-center on its saucer; and the folds of the girl's green skirt, its clear tone invigorating the picture's medley of beiges, browns, and burnt orange.

---

EXHIBITION: Paris, 1983, pp. 190–91, ill.

Fig. 127. Balthus, *Study for Still Life in "The Golden Fruit,"* ca. 1959. Pencil on graph paper, 7 × 5½ in. (18 × 14 cm.). Private collection

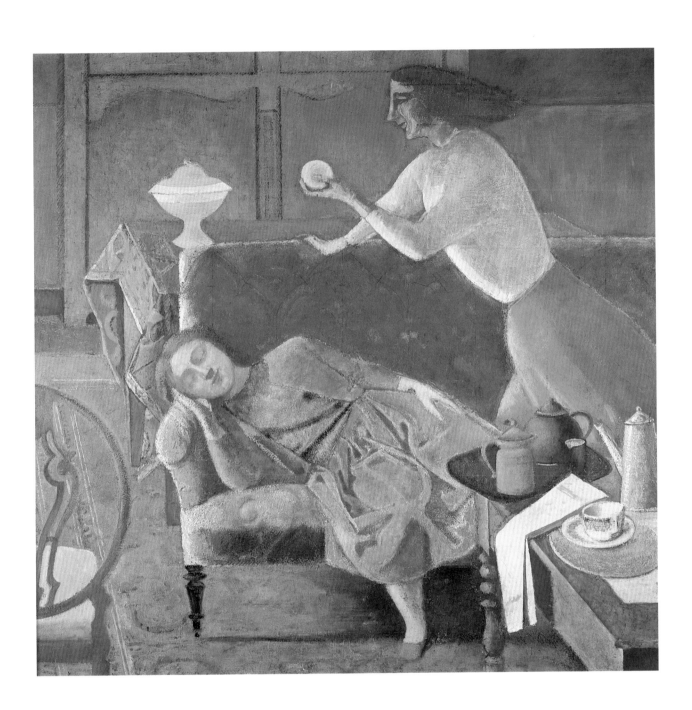

# 42. THE MOTH

Le Phalène    1959

*Casein tempera on canvas, 63¾ × 51¼ in. (162 × 130 cm.)*

*Private collection*

A nude in profile tiptoes toward the light, her right arm
lifted above a large moth fluttering about the flame of an
oil lamp. Could Balthus have found his inspiration in
Pierre Jean Jouve's *Paulina 1880*? In this 1925 novel
a butterfly meets its death in a similar manner, forecasting
the tragedy that awaits the young heroine.

The bright lamp, which attracts the moth, illumi-
nates the girl's body, the still life on the night table, the
red-and-white patterned quilt, and the bed, with its
white sheets and pillows tumbling over the checkered skirt.

Here Balthus created a surface as rough as a stuc-
coed wall. With this he initiated the direction his work
would take in Rome.

---

Exhibitions: Turin, 1961, cat. no. 19, ill.; Paris, 1966, cat. no. 38, ill.
(frontispiece); Knokke-le-Zoute, 1966, cat. no. 34; London, 1968,
cat. no. 50; Marseilles, 1973, cat. no. 35, ill.; Paris, 1979, Musée
national d'art moderne, Centre Georges Pompidou, *L'Oeil double de
Gaëton Picon*; Venice, 1980, cat. no. 16, p. 211, ill. p. 212; Paris, 1983,
pp. 196–97, ill.

Bibliography: Leymarie and Fellini, 1980, pls. 33–34; Leymarie, 1982,
p. 90, ill. p. 89; S. Klossowski, 1983, pl. 61.

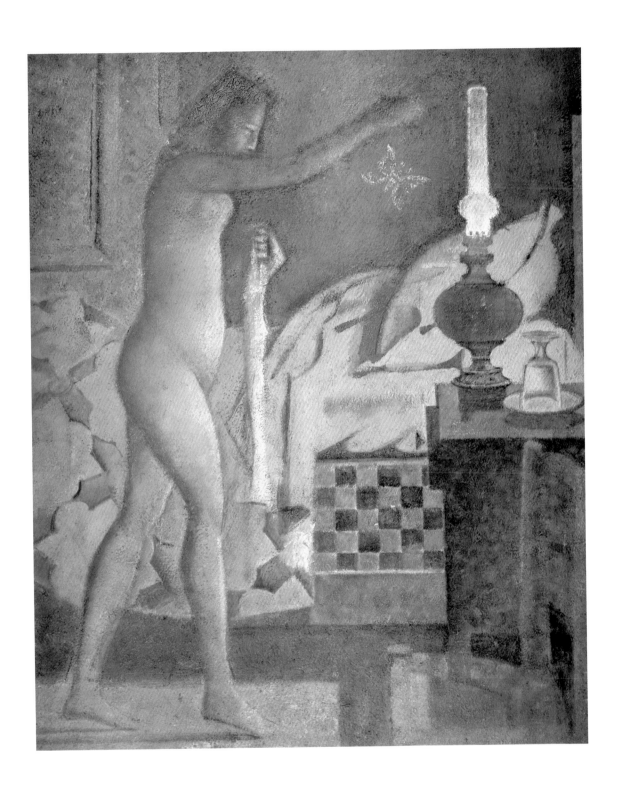

# 43. LANDSCAPE WITH A COW

GRAND PAYSAGE AVEC VACHE    1959–60

*Signed and dated (lower left): B 1959–60*

*Oil on canvas, 64 × 51 in. (163 × 130 cm.)*

*Private collection*

On a clear winter day a farmer stands next to his cow in the field and signals with his arm. He is probably Riri, who worked Chassy's farm. The view is that framed by one of several windows that lined the west wall of Balthus's studio on the château's second floor. The cobalt blue sky has an intensity reminiscent of Poussin. The bare, spiky branches of three old trees—two flanking the window and a third at midground center—form a gray lacework pattern that contrasts with the cubist abstractions of the distant, rose-colored architecture.

EXHIBITIONS: Turin, 1961, cat. no. 21, ill.; New York, 1962, cat. no. 15, ill.; Cambridge, Mass., 1964, cat. no. 23, ill.; Paris, 1966, cat. no. 39, ill. p. 47; Knokke-le-Zoute, 1966, cat. no. 35; London, 1968, cat. no. 51, ill. p. 83; Marseilles, 1973, cat. no. 37, ill.; New York, 1977, cat. no. 10, ill.; Venice, 1980, cat. no. 17, p. 211; Paris, 1983, pp. 198–99, ill.

BIBLIOGRAPHY: Leymarie and Fellini, 1980, pl. 32; Leymarie, 1982, p. 75, ill. p. 73; S. Klossowski, 1983, pl. 59.

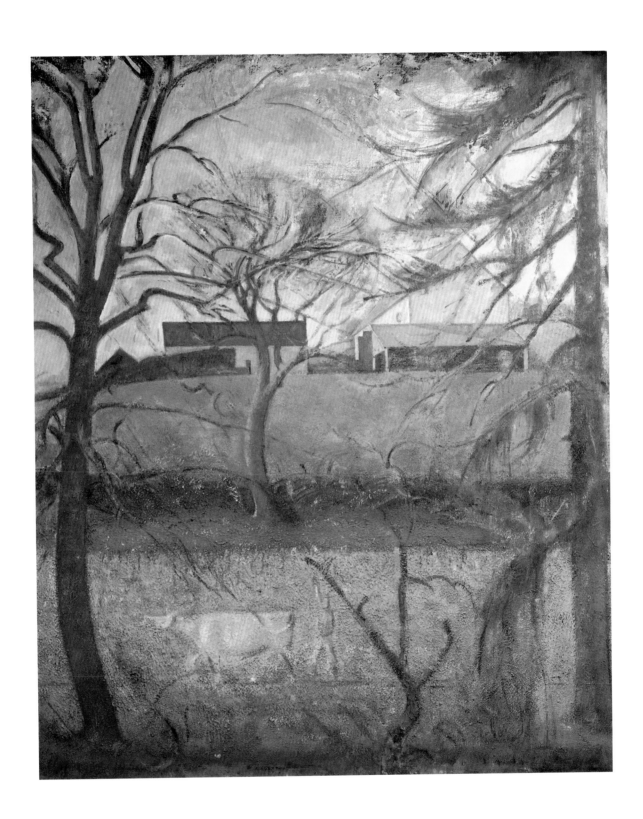

# 44. THE COURTYARD OF THE FARM AT CHASSY

La Cour de ferme à Chassy    1960

Oil on canvas, 35 × 37¾ in. (89 × 96 cm.)

Collection Henriette Gomès, Paris

The tree at which Frédérique looked in *Girl at a Window* (1957; pl. 40) stands here at the far right. The season is no longer summer. Firewood lies in the courtyard. The soil looks moist. The subdued light of a late autumn sun colors the masonry of the sheds, houses, and courtyard gates with subtle tints of violet and rose, which intensify the green of the distant field. This view of the garden and courtyard can be seen from the windows in the east wall of Balthus's studio. A favorite motif, the scene first appeared in Balthus's painting in 1954 and then reappeared on at least five other occasions. Except for two springtime pictures, this series represents the autumn and winter landscapes at Chassy.

---

Exhibitions: Paris, 1966, cat. no. 42, ill. p. 49; Knokke-le-Zoute, 1966, cat. no. 38; Venice, 1980, cat. no. 20, p. 211; Paris, 1983, pp. 200–201, ill.

Bibliography: Leymarie and Fellini, 1980, pl. 36; Leymarie, 1982, p. 75, ill. p. 72.

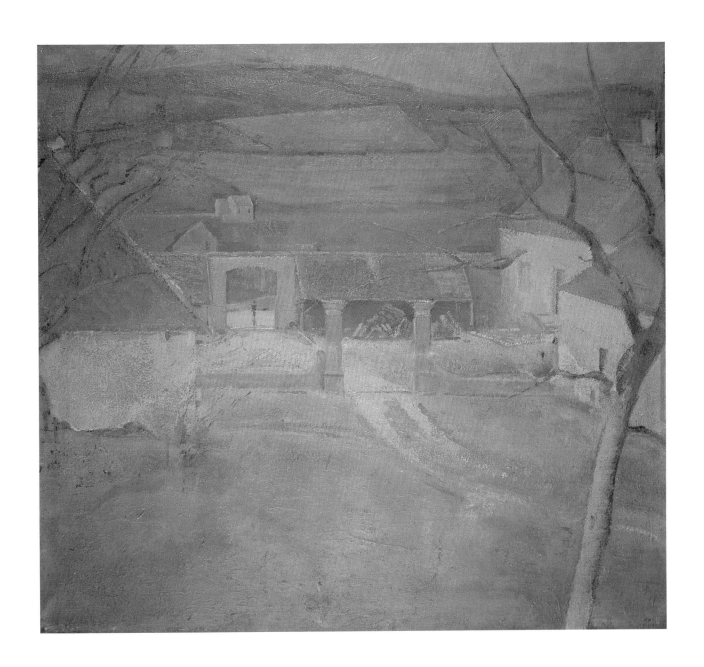

# 45. LANDSCAPE WITH A TREE

GRAND PAYSAGE À L'ARBRE    1958–60

*Oil on canvas, 51¼ × 63¾ in. (130 × 162 cm.)*

*Collection Henriette Gomès, Paris*

The farmer Riri walks through Chassy's courtyard on a bright winter day. The scene is the same as that in *The Courtyard of the Farm at Chassy* (1960; pl. 44), but it is viewed from a window farther to the right and is rendered on a larger, more ambitious scale.

The distant, horizon-blocking hillside is seen through the ramified pattern of the tree. In the foreground all is order and harmony. Sunlight has turned everything into a symphony of ochers, ranging from pale yellow-green through brick-orange to slate-gray. In the shade, a cool beige prevails.

Of the six works in the Chassy courtyard series, *Landscape with a Tree* seems to have been the last Balthus completed before moving to Rome in early 1961.

EXHIBITIONS: Turin, 1958, cat. no. 20, ill.; Paris, 1966, cat. no. 44, ill. p. 51; Knokke-le-Zoute, 1966, cat. no. 40; London, 1968, cat. no. 54, ill. p. 6; Marseilles, 1973, cat. no. 41, ill.; Venice, 1980, cat. no. 21, p. 214; Paris, 1983, pp. 202–203, ill.

BIBLIOGRAPHY: Leymarie and Fellini, 1980, pls. 37–38; Leymarie, 1982, p. 75, ill. pp. 70–71; S. Klossowski, 1983, pl. 60.

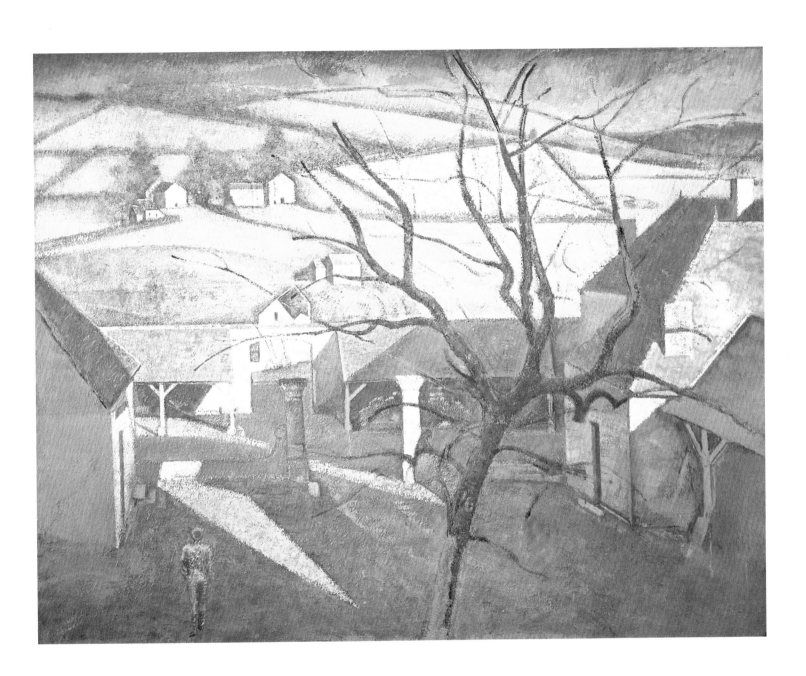

# 46. THE TURKISH ROOM

LA CHAMBRE TURQUE    1963–66

*Casein tempera with marble powder on canvas,*

*70¾ × 82¾ in. (180 × 210 cm.)*

*Musée national d'art moderne, Centre Georges Pompidou, Paris*

The odalisque is Setsuko Ideta. Balthus had met her while visiting Japan in 1962. She joined the painter in Rome and later became his wife. Here Setsuko poses in a Moorish room in one of the towers of the Villa Medici, the home of the French Academy in Rome, which Balthus directed from 1961 until 1977. Designed during Horace Vernet's directorship in 1828–35, the room reflects the taste of those times for things oriental, an example of which is Ingres's *Turkish Bath*, painted in 1863, exactly one century before Balthus began work on his *Turkish Room*. (Ingres, one of the most illustrious directors of the Villa Medici, succeeded Vernet in 1835.)

To the rich pattern of the glazed tiles on walls and floors, Balthus added the geometric and organic designs of the blanket and printed saffron bed cover, integrating all the decorations so cleverly that they complement one another to present a set of cool but sumptuous relationships.

The open robe reveals a rounded, lissome body whose contours and proportions are reminiscent of those favored by Ingres. Setsuko holds a Japanese mirror of polished metal, symbol of a woman's soul. The eggs set in a dish before the green shuttered window are yet another female emblem. The simple still life to the right—a cup and vase on a green table—may be a tribute to Giorgio Morandi, the Italian master of still life who died in 1964 while Balthus was painting this work.

EXHIBITIONS: Paris, 1966, cat. no. 51, ill. p. 55; Knokke-le-Zoute, 1966, cat. no. 47, ill.; New York, 1967, cat. no. 1, ill.; London, 1968, cat. no. 57, ill. (on the cover); Marseilles, 1973, cat. no. 45, ill.; Paris, 1983, pp. 204-205, ill.

BIBLIOGRAPHY: Leymarie and Fellini, 1980, pl. 43; Leymarie, 1982, pp. 91, 94, ill. pp. 92–93; J. Michel, "Un peintre dont on se sait rien: 'L'Entre-Deux-Mondes de Balthus,'" *Le Monde*, August 17, 1983, ill.; S. Klossowski, 1983, pls. 64–65.

Fig. 128. Balthus, *Nude*, 1968. Pencil on paper, 15¾ × 11¾ in. (40 × 30 cm.). Collection Harry Torczyner

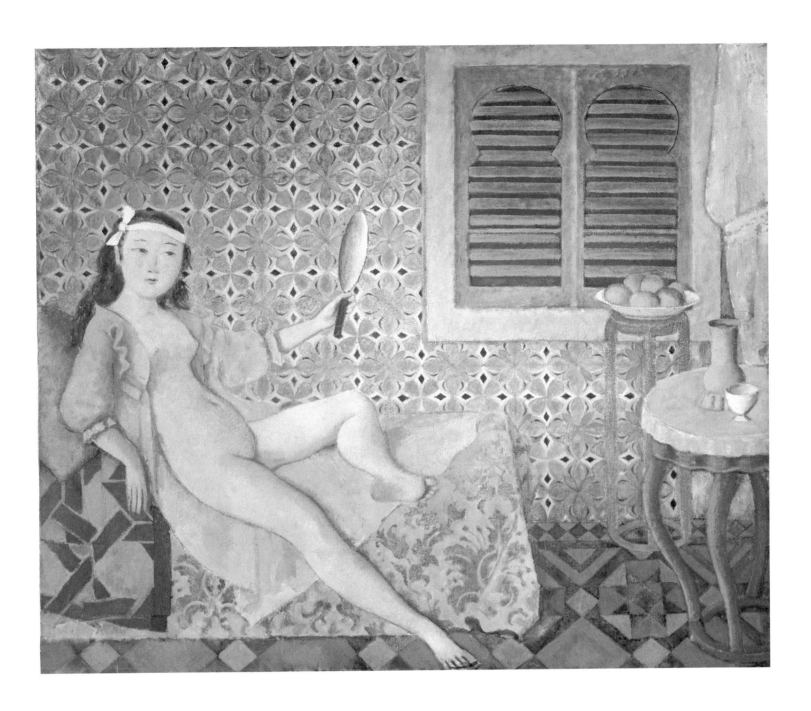

# 47. THE CARD PLAYERS

LES JOUEURS DE CARTES    1966–73

*Signed (on reverse): Balthus*

*Casein tempera on canvas, 74¾ × 88½ in. (190 × 225 cm.)*

*Museum Boymans–van Beuningen, Rotterdam*

Balthus took seven years, and many layers of casein tempera, to complete this picture. The extraordinarily thick surface has the texture of rough stucco. One could be looking at a fresco or a picture painted on stone. This surface quality is characteristic of most of the paintings created by Balthus while he was director of the French Academy in Rome. The mottled backgrounds of the Roman pictures match the interior walls of the Renaissance villa as restored under Balthus's direction.

With their enlarged heads, flattened brows, slit eyes, and feral expressions, the card players look barely human. Since the game of twenty years earlier (pl. 29), the players have had time to grow more grim and hostile, with their bitter mood turning the picture's colors into the bleached tonalities of aged stone. The empty page in the record book implies that no score has been kept. Yet with an imperious gesture, the girl makes her play, while clutching reserves in her left hand. She seems to hold the winning card, and her expression makes one fear the fate of the loser.

---

EXHIBITIONS: London, 1968, cat. no. 60; Marseilles, 1973, cat. no. 47; New York, 1977, cat. no. 11, ill.; Venice, 1980, cat. no. 25, p. 211; Paris, 1983, pp. 206–207, ill.

BIBLIOGRAPHY: Gustav A. Berger, "Unconventional treatments for unconventional paintings," *Studies in Conservation*, vol. 21 (1976), no. 3, pp. 115–28, fig. 17; Leymarie and Fellini, 1980, pls. 45–46; Leymarie, 1982, pp. 101, 104, ill. pp. 102–103; S. Klossowski, 1983, pl. 66.

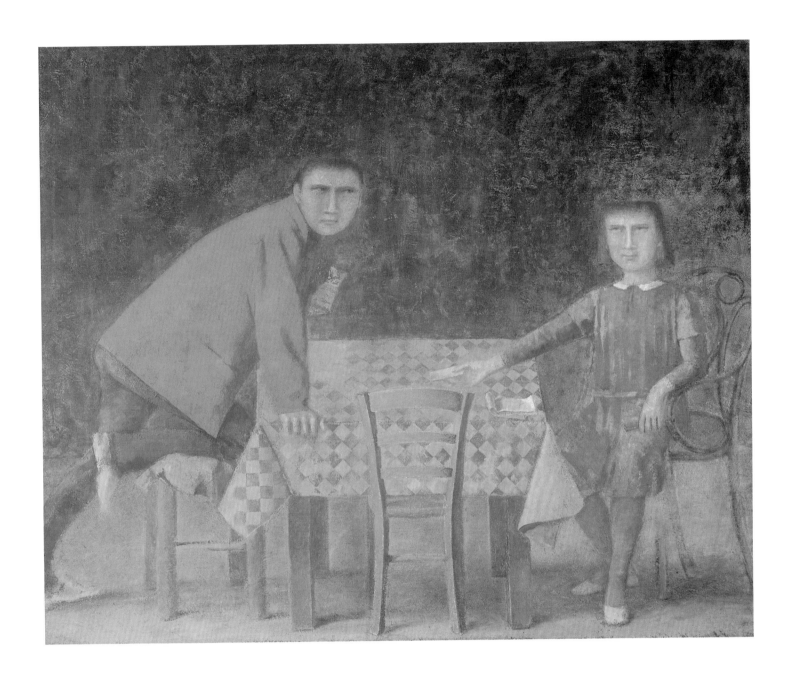

# 48. JAPANESE FIGURE WITH A BLACK MIRROR

*Japonaise au miroir noir*   1967–76

*Casein tempera on canvas, 59 × 77 in. (150 × 196 cm.)*

*Private collection*

The model is Setsuko, whom Balthus met during his visit to Japan in 1962. They married in 1967, the year the artist began this work.

With its pendant, *Japanese Figure with a Red Table* (fig. 87), the painting derives from a genre of Japanese pictorial art called *shunga*, in which erotic imagery is symbolic of springtime renewal. But whereas the traditional figures are small, Balthus painted his subjects in an unusually large scale, like those in Utamaro's prints of the late 1790s.

The moment depicted in *Japanese Figure with a Black Mirror* might be that following love-play. Indeed, according to conventional Japanese symbolism, the young woman is about to turn the small black-lacquer cheval glass around to gaze at herself. Viewed from above and at close range, the stylized body spans the width of the composition; in a similar manner the floor tilts up until it all but fills the pictorial space from bottom to top.

With his "Japanese" pictures, Balthus again expressed his lifelong fascination with Far Eastern culture. They remind us that as an adolescent Balthus had illustrated Chinese novels and had designed, in maquette form, sets for a Chinese play.

---

EXHIBITION: New York, 1977, cat. no. 12, ill.

BIBLIOGRAPHY: Leymarie, 1982, pp. 94, 99, ill. p. 95; S. Klossowski, 1983, pl. 67.

Fig. 129. Balthus, *Figure Study (Setsuko)*, 1964. Pencil on paper, 19¾ × 14¾ in. (50 × 38 cm.). Collection Henriette Gomès, Paris

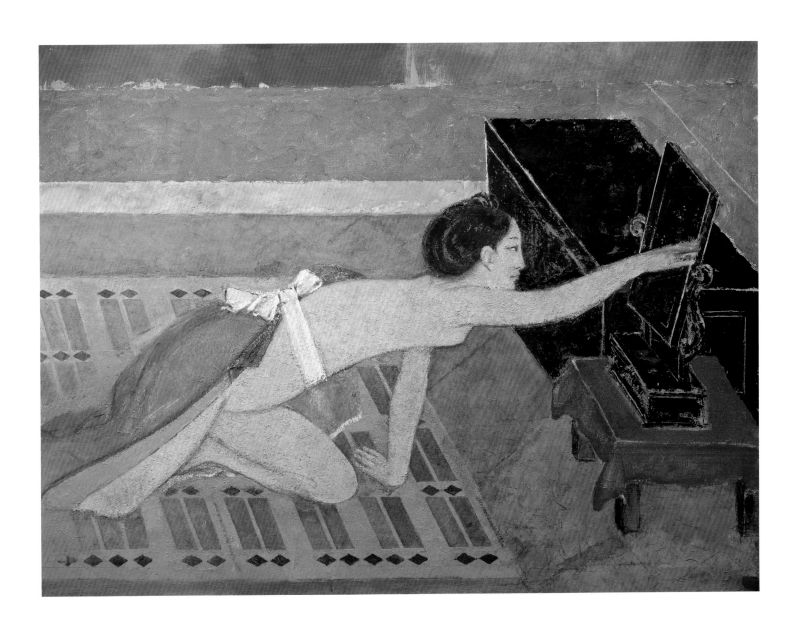

# 49. KATIA READING

KATIA LISANT    1968–76

*Casein tempera on canvas, 71 × 82½ in. (180 × 210 cm.)*

*Private collection*

By the time Balthus finished this picture, eight years after the first sitting, the preadolescent model had turned into a young woman. Katia and her sister Michelina posed for several paintings and many drawings (fig. 130). Both girls were the daughters of an employee at the Villa Medici in Rome. The mottled ground behind Katia is a wall in one of the studios at the villa, where the pensionnaires, the recipients of France's Prix de Rome, paint, sculpt, or draw.

Katia's pose seems to revive that of Thérèse some thirty-five years earlier (pls. 18 and 19). And just as Thérèse only pretended to dream, Katia merely pretends to read. Of course, she could be just looking at the pictures, since the volume in her hand is *Tintin*, the painter's favorite comic book.

EXHIBITIONS: New York, 1977, cat. no. 14, ill.; Venice, 1980, cat. no. 26, p. 211; London, 1981, cat. no. 13, ill.; Paris, 1983, pp. 208–209, ill.

BIBLIOGRAPHY: Leymarie and Fellini, pl. 44; Leymarie, 1982, p. 112, ill. pp. 110–11; S. Klossowski, 1983, pl. 71.

Fig. 130. Balthus, *Katia*, ca. 1970. Pencil on paper, 12½ × 11¾ in. (32 × 30 cm.). Collection Mr. and Mrs. James Foster

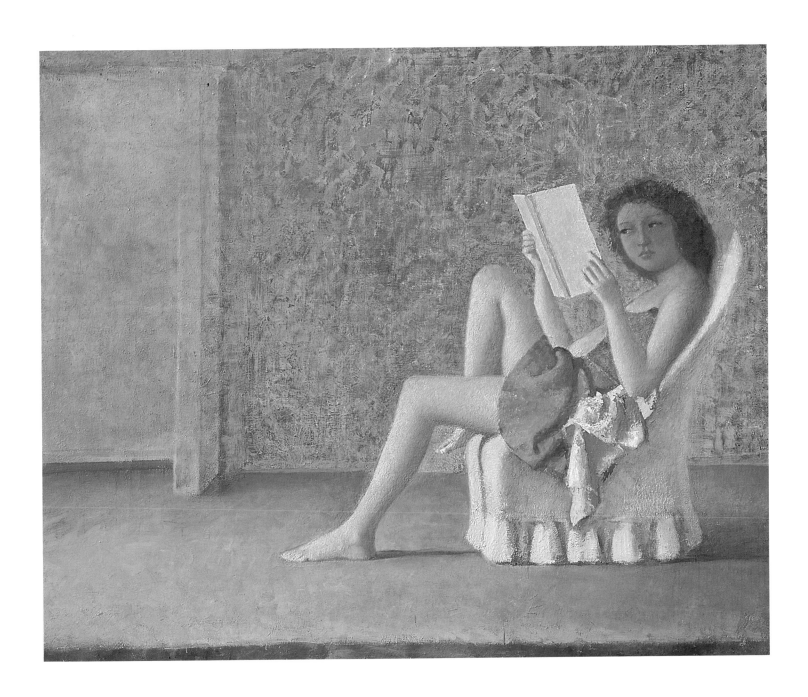

# 50. VIEW FROM MONTECALVELLO

Vue de Montecalvello    1979

*Casein tempera on canvas, 51⅛ × 63¾ in. (130 × 162 cm.)*

*Pierre Matisse Gallery, New York*

Balthus painted this landscape from a top window of Montecalvello, his sixteenth-century castle in Italy. The elevated vantage point gives a bird's-eye view of the nearby hills and the distant valley, which runs from Viterbo in the north to Rome in the south. Strong Mediterranean light means little to Balthus; he thus chooses an autumn morning whose overcast light has turned everything a hazy pink, beige, mauve, or rust color. Further softening the atmosphere is the fog in the rocky gorge below.

The ruined watch tower on the opposite mountain dates from the thirteenth century. Its sturdy walls are observed by a man and a child from Montecalvello's terrace in the lower right corner of the picture.

Might Balthus have been inspired by a similar tower that Guidoriccio da Fogliano passes on horseback in the famous fourteenth-century fresco that Simone Martini painted in Siena's Palazzo Pubblico?

EXHIBITIONS: Venice, 1980, cat. no. 28, p. 211; London, 1981, cat. no. 14, ill.; Paris, 1983, p. 211–12, ill.

BIBLIOGRAPHY: Leymarie and Fellini, 1980, pls. 49–50; Leymarie, 1982, ill. pp. 120–21; S. Klossowski, 1983, pl. 73.

Fig. 131. Detail from Simone Martini, *Guidoriccio da Fogliano*, 1328. Fresco. Council Chamber, Palazzo Pubblico, Siena. Photograph: Alinari-Scala

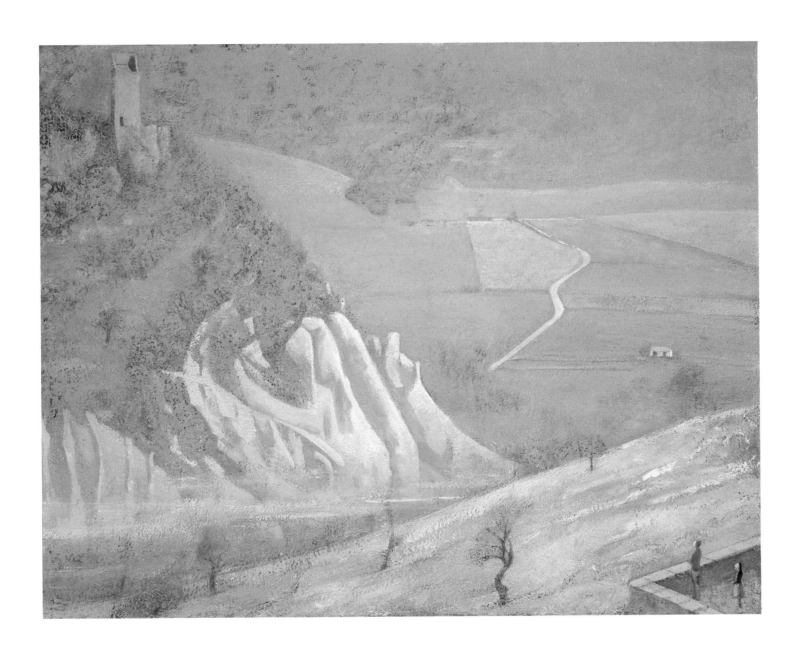

# 51. SLEEPING NUDE

Nu assoupi    1980

*Signed (lower left): B*

*Casein tempera on canvas, 78¾ × 59 in. (200 × 150 cm.)*

*Private collection*

After sixteen years in Rome, Balthus gave up his director-ship of the French Academy and in 1977 moved to a village in Switzerland. Having changed his surroundings, the artist once more changed the setting of his pictures. Now, instead of the bare, mottled walls that had pre-vailed in the Villa Medici paintings from the 1970s, his interiors became more varied. In this corner of a room, for example, the painter rediscovered, although in simpler form, the orientalism of *The Turkish Room* (pl. 46), a 1963–66 work inspired by a Moorish room at the Villa Medici. New to Balthus's art, however, is the rich combination of violet and warm reds. As for the nude adolescent, she joins the host of his earlier dozing girls, but at least her position is more comfortable.

---

EXHIBITIONS: Venice, 1980, cat. no. 30, p. 211; London, 1981, cat. no. 18, ill.; Paris, 1983, p. 213, ill.

BIBLIOGRAPHY: Leymarie and Fellini, 1980, pls. 54–56; Leymarie, 1982, ill. p. 145; S. Klossowski, 1983, pls. 76–77.

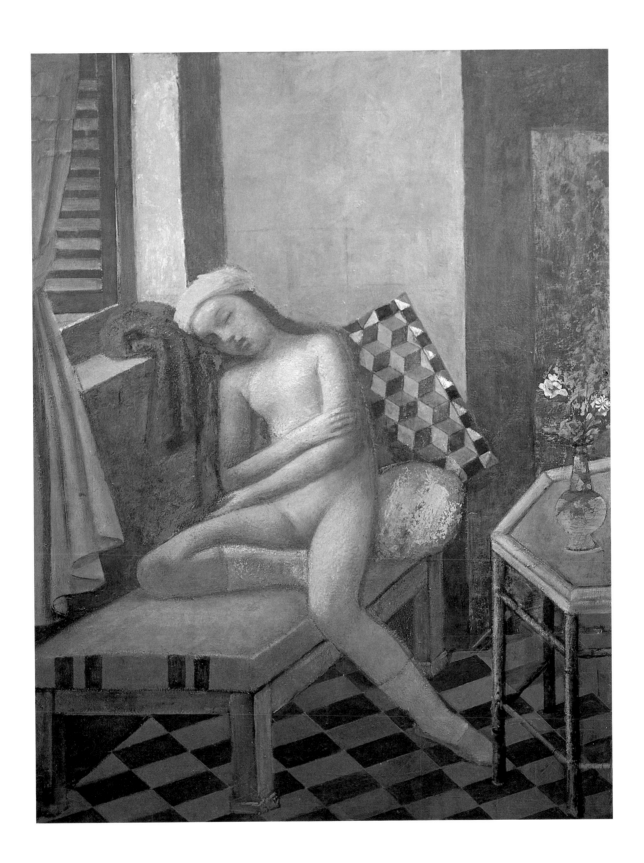

# 52–65. ILLUSTRATIONS FOR *WUTHERING HEIGHTS*

ca. 1934–35

*Each illustration bears an inscription in English*

*Ink on paper, 10 × 9½ in. (25 × 24 cm.)*

*Private collection*

Balthus was the first French artist to attempt to illustrate Emily Brontë's *Wuthering Heights* (1848), a book he greatly admired. Set in the wild moorlands of Yorkshire, this novel tells of the love betwen Cathy and Heathcliff. The latter, a foundling, was brought to Wuthering Heights by Cathy's father. Their passionate attachment, formed during childhood, haunts them forever after.

Balthus's illustrations cover only the first part of the novel, focusing mainly on Cathy's and Heathcliff's adolescence. Heathcliff is present in most of the episodes he chose to illustrate. Unlike Brontë's character, Balthus's Heathcliff is not "ignoble" and does not walk with a "slouching gait." In fact, his defiant and handsome features are those of the artist himself. As for Cathy, she is a portrait of Antoinette de Watteville, a young Swiss woman with whom Balthus was in love.

Balthus's somewhat arbitrary and deeply personal interpretation of Brontë's novel is related to events in his own life. Antoinette and her brother Robert had been friends of his since the late 1920s. When visiting Bern,

he stayed at their family mansion. A poor and unknown painter, Balthus had nothing to offer as a suitor. During his difficult courtship of Antoinette (they married in 1937), he came to identify with Heathcliff, the romantic outsider who battles against defeat. During 1934 Balthus suffered a severe crisis and stopped painting altogether. He then returned to the *Wuthering Heights* drawings that he had begun in late 1932. He probably completed these drawings sometime in 1934–35, and eight of them were published in late 1935 in the periodical *Minotaure*.

Drawings related to the *Wuthering Heights* series are shown in figs. 132–137.

---

EXHIBITIONS: New York, 1939, cat. nos. 5–18; New York, 1963, cat. nos. 9–14; Chicago, 1964, cat. nos. 25–38; Detroit, 1969, Donald Morris Gallery, *Balthus*, cat. nos. 16–25; Spoleto, 1982, cat. nos. 4–17; Paris, 1983, pp. 26–38, ill.

BIBLIOGRAPHY: *Minotaure*, 2ième année (1935), no. 7, pp. 60–61, ill.; Carandente, 1983, nos. 4–17, pp. 25–31, ill.

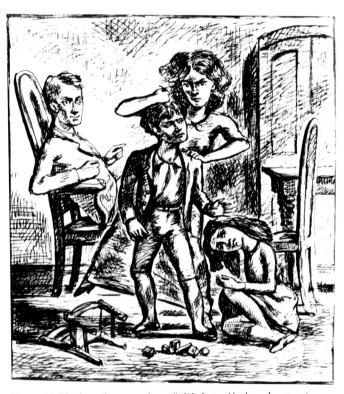

Pl. 52. *"Pull his hair when you go by . . ."* (*Wuthering Heights,* chapter 3)

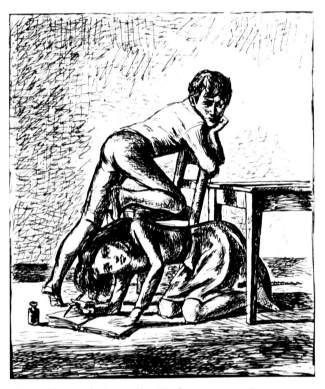

Pl. 53. *"I have got the time on with writing for twenty minutes."*
(*Wuthering Heights,* chapter 6)

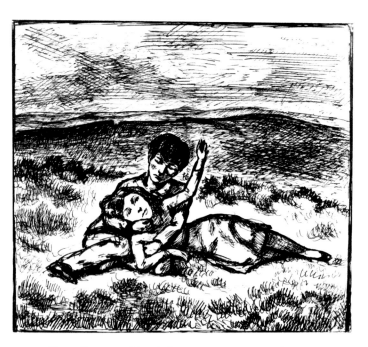

Pl. 54. *"It was one of their chief amusements to run away to the moors."*
(*Wuthering Heights*, chapter 6)

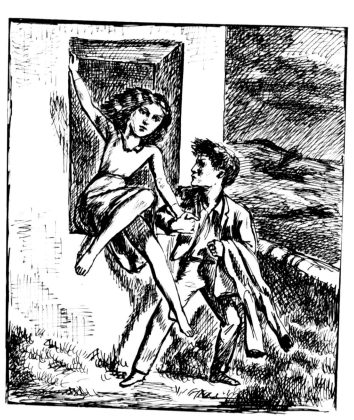

Pl. 55. *"Cathy and I escaped from the wash-house to have a ramble at liberty."*
(*Wuthering Heights*, chapter 6)

Fig. 132. Balthus, *Study for "Wuthering Heights,"* 1932–33. Ink on paper, 10½ × 8 in. (26 × 20 cm.). Collection Mr. and Mrs. Richard L. Selle. Photograph: Geoffrey Clements

Fig. 133. Balthus, *Study for "Wuthering Heights,"* 1932–33. Ink on paper, 10 × 9 in. (25 × 22 cm.). Collection Mr. and Mrs. Walter Bareiss

Pl. 56. *"We ran from the top of the Heights."* (*Wuthering Heights*, chapter 6)

Pl. 57. *"The devil had seized her ankle."* (*Wuthering Heights*, chapter 6)

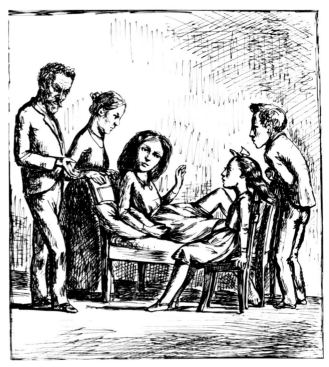

Pl. 58. *"I saw that they were full of stupid admiration."* (*Wuthering Heights*, chapter 6)

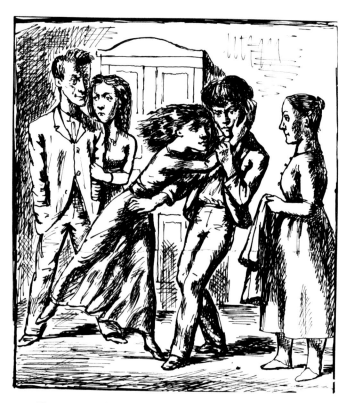

Pl. 59. *"You needn't have touched me."* (*Wuthering Heights,* chapter 7)

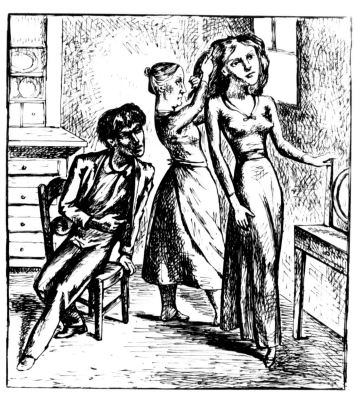

Pl. 60. *"Why have you that silk frock on, then?"* (*Wuthering Heights,* chapter 8)

Fig. 134. Balthus, *Study for "Wuthering Heights"* (*"Miss Cathy seized him again,"* chapter 7), 1932–33. Ink on paper, 11⅞ × 11¼ in. (30 × 29 cm.). The Museum of Modern Art, New York, John S. Newberry Collection. See fig. 137 for verso of this drawing.

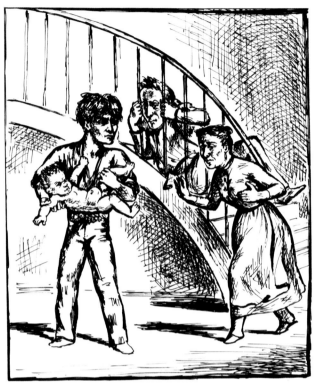

Pl. 61. *"By a natural impulse he arrested his descent."* (*Wuthering Heights*, chapter 9)

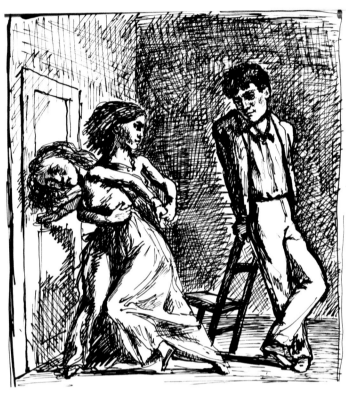

Pl. 63. *"No, no, Isabella, you shan't run off."* (*Wuthering Heights*, chapter 10)

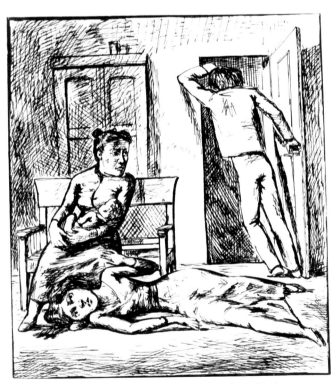

Pl. 62. *"Nelly, do you never dream queer dreams?"* (*Wuthering Heights*, chapter 9)

Fig. 135. Balthus, *Study for "Wuthering Heights,"* 1932–33. Ink on paper, 12½ × 10 in. (32 × 26 cm.). Pierre Matisse Gallery, New York. See fig. 136 for verso of this drawing.

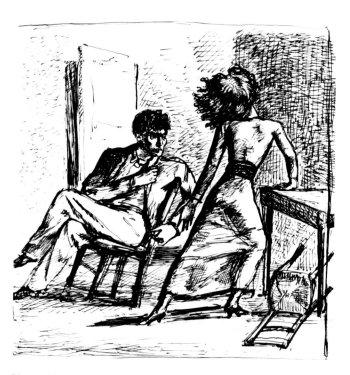

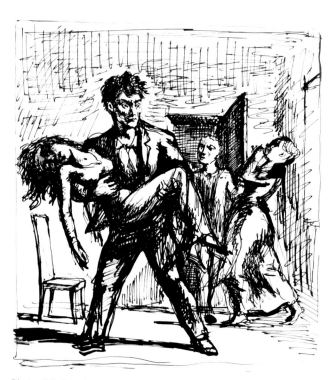

Pl. 64. *"There, you've done with coming here, cried Catherine."* (*Wuthering Heights*, chapter 11)

Pl. 65. *"Catherine's arms had fallen relaxed and her head hung down."* (*Wuthering Heights*, chapter 15)

Fig. 136. Balthus, *Study for "Wuthering Heights,"* 1932–33. Ink on paper, 12½ × 10 in. (32 × 26 cm.). Pierre Matisse Gallery, New York. See fig. 135 for recto of this drawing.

Fig. 137. Balthus, *Study for "Wuthering Heights"* (*"Oh! Nelly, the room is haunted! I'm afraid of being alone,"* chapter 12), 1932–33. Ink on paper, 11⅞ × 11¼ in. (30 × 29 cm.). The Museum of Modern Art, New York, John S. Newberry Collection. See fig. 134 for recto of this drawing.

# CHRONOLOGY

**1908**

Balthasar Klossowski is born on February 29 in Paris. Second son of Erich Klossowski (1875–1946), art historian and painter, and Elisabeth Dorothea (née Spiro; 1886–1969), a painter who later exhibits her works under the name Baladine.

**1914**

At the outbreak of World War I the Klossowskis move to Berlin.

**1916**

For the next three years Erich Klossowski achieves considerable success as a stage designer for Berlin's Lessing Theater.

**1917**

Baladine Klossowski moves with her two sons Pierre and Balthus to Bern and in November to Geneva.

**1919**

From 1919 to 1921 Balthus attends the Lycée Calvin, spending the summer months in Beatenberg, a village above the Lake of Thun. There he meets Margrit Bay, a sculptor, with whom he works as a pupil and assistant for several summers.
In July 1919, Rainer Maria Rilke visits Baladine Klossowski in Geneva. Following his visit in August 1920, they begin a correspondence that continues until the poet's death in 1926.

**1920**

Balthus prepares a series of illustrations for a Chinese novel and sends them to Rilke.

**1921**

Publication of *Mitsou: Quarante Images par Baltusz*, a book containing forty ink drawings with a preface by Rilke. In April Baladine Klossowski moves with her sons to Berlin. Except for most of the summer and autumn months, the Klossowskis remain there until July 1923.

**1922**

Designs stage sets in maquette form and offers them to the Munich Staatstheater for a Chinese play which was not produced. Spends summer in Beatenberg; Rilke, accompanied by Baladine, visits for two weeks at the end of August. Returns to Berlin in November for a second and last winter.

**1924**

Returns to Paris on March 7 at the invitation of André Gide. Joins his brother, Pierre, who has been in Paris since November 1923. Balthus joins the team constructing sets for *Les Soirées de Paris* at the Théâtre de la Cigale during May–June. Attends informal sketching classes in the evening at the Grande Chaumière. In the autumn he shows his paintings to Denis, Marquet, and Bonnard, who advise him to copy Poussin. Balthus is seen from time to time at the Bureau of Surrealist Research, 15 Rue de Grenelle.

**1925**

Rilke spends first five months of the year in Paris; in January he writes the poem *Narcisse*, dedicating it to Balthus. In March Balthus and his brother, Pierre, begin a quiet year of work and study made possible by Rilke, who raised funds for that purpose. That fall Balthus copies Poussin's *Echo and Narcissus* in the Louvre.

**1926**

Balthus spends summer in Florence and Arezzo. Makes small sketches in oil of Piero della Francesca's *The Legend of the True Cross*, a fresco cycle in the chapel of San Francesco. Copies Piero's *Resurrection* in the Pinacoteca at Borgo Sansepolcro. Visits Assisi. Returns to Florence where he copies frescoes by Masolino and Masaccio. Sketches children playing in the Piazza Santa Croce. Spends autumn in Beatenberg, where he offers to decorate the interior of the Protestant church. Works on cartoons for the project.

**1927**

Spends April–June in Beatenberg, where he executes tempera wall paintings, representing the Good Shepherd flanked by the Four Evangelists, in the Protestant church. Works on sketches, in ink and in oil, for a large painting of an episode from the Tobias Legend, a project never realized. Returns to Paris. Paints series devoted to chil-

dren playing in the Luxembourg Garden; also paints Parisian street scenes.

**1928–29**

Paints several portraits, most of which are of friends. Travels to Berlin and Switzerland.

**1930**

In November Balthus begins his fifteen-month military service in Kenitra, Morocco.

**1932**

Stops briefly in Paris in the early spring. Spends the summer in Bern, where he copies several paintings from Joseph Reinhardt's Swiss Peasant Cycle (1787–97) at the Historisches Museum. Returns to Paris in late autumn and stays with his friends Pierre and Betty Leyris. Begins sketching illustrations for Emily Brontë's *Wuthering Heights*, a series completed in 1934–35. Forms friendship with the writer Pierre Jean Jouve; also with André Derain whom Balthus often visits at 5 Rue du Douanier, a house built by August Perret for Georges Braque, who still lived there. At some time between 1932 and 1935, the year Derain moved, Balthus learned about the use of house paint on canvas from Braque.

**1933**

In the spring Balthus executes *The Street*, a painting that initiates a style marked by sharp contours and flat colors. Moves to his first studio at 4 Rue de Furstenberg. Visited there by a delegation of Surrealists: Breton, Éluard, Hugnet, and Giacometti. Enters into a friendship with Giacometti one year later. Wilhelm Uhde and Pierre Loeb, owner of the Galerie Pierre, visit his studio and admire *The Street*. Prepares exhibition at the Galerie Pierre, planned for the coming winter. In September the Beatenberg parish decides to remove his decorations from its church. Forms friendship with Antonin Artaud.

**1934**

First one-man exhibition, held at the Galerie Pierre in Paris (April 13–28), includes five paintings whose erotic and ambiguous character causes a minor scandal: *The Street, Cathy Dressing, The Window, Alice,* and *The Guitar*

*Lesson*. Stops painting for some months. Designs sets and costumes for Shakespeare's *As You Like It* (*Comme il vous plaira*), adapted by Jules Supervielle and directed by Victor Barnowski. Production opens on October 12 at the Théâtre des Champs-Elysées with Jean Pierre Aumont, Annabella, and others.

**1935**

Paints *The King of Cats*. Designs sets and costumes for Artaud's production of *Les Cenci*, which opens on May 6 at the Théâtre aux Folies Wagram with Antonin Artaud, Lady Iya Abdy, Cecile Bressant, and others. *Minotaure*, in its autumn issue, publishes eight of his illustrations for *Wuthering Heights*.

**1936**

Moves to studio at the Cour de Rohan in Paris. Paints portraits of André Derain and the vicomtesse de Noailles. Visits London during the International Surrealist Exhibition, held from June 11 through July 4; unsuccessfully seeks a publisher there for *Wuthering Heights* illustrations. Begins series of works with Thérèse Blanchard as model.

**1937**

Marries Rose Alice Antoinette de Watteville on April 2 in Bern. James Thrall Soby buys *The Street*, the first of many paintings by Balthus to enter an American collection. Paints *Still Life, The Children, The Mountain*.

**1938**

Pierre Matisse, at his New York gallery, gives Balthus his first exhibition outside France (March 21–April 16). Completes portrait of *Joan Miró and His Daughter Dolores* and paints *Thérèse Dreaming*.

**1939**

Called up for army service and sent into battle near Saarbruck in Alsace. Returns to Paris in December after being discharged.

**1940**

During the summer takes refuge with his wife at Champrovent, a farm in the Savoy, remaining there until

late 1941. Begins *Landscape of Champrovent* and *Vernatel (Landscape with Oxen)*. Uses the farmhouse parlor as a subject in two pictures entitled *The Living Room*.

### 1942

Lives in Bern, then moves to Fribourg, Switzerland. Birth of his first son, Stanislas Klossowski.

### 1943

Executes series of portrait commissions in Fribourg. Paints *The Game of Patience*. His first Swiss exhibition is held in November at the Galerie Moos, Geneva.

### 1944

Birth of his second son, Thaddeus Klossowski.

### 1945

Moves to Geneva and lives at the Villa Diodati. Completes *The Golden Days*.

### 1946—47

Returns to Paris. Henriette Gomès organizes his first postwar exhibition, held in Paris at the Galerie "Beaux-Arts" (Wildenstein) (November 25—December 10, 1946). Resumes activity in his studio at the Cour de Rohan.

### 1948

Designs sets and costumes for Albert Camus's *L'État de siège*, a play directed by Jean-Louis Barrault. The production opens on October 15 at the Théâtre Marigny with Madeleine Renaud, Pierre Bertin, Pierre Brasseur, Maria Casarès, Jean-Louis Barrault, and others. Paints series *Georgette Dressing*. Begins *The Game of Cards*.

### 1949

Erich Klossowski dies on January 23 in Sanary-sur-Mer in the south of France. Balthus begins pencil studies for *The Room*. Paints series *The Week with Four "Thursdays."* Designs sets and costumes for Boris Kochno's *Le Peintre et son modèle* (restaged from original choreography by Léonide Massine); ballet opens on November 15 at the Théâtre des Champs-Elysées. Friends now include André Malraux, Paul Éluard, and Jean-Louis Barrault.

### 1950

Designs sets and costumes for a production of Mozart's *Così fan tutte*, performed July 15—August 4 at the Théâtre de la Cour de l'Archevêche during 3ième Festival International de la Musique in Aix-en-Provence. Cast includes Suzanne Danco, Emmy Loose, Eugenia Zareska, and Léopold Simoneau. Balthus's sets remain in Aix until 1961; used at Paris Opéra Comique in 1963.

### 1951

Visits Italy.

### 1952

Begins painting *The Room* and *The Passage du Commerce Saint-André*. First exhibition in England held in January at the Lefevre Gallery, London.

### 1953

Designs sets and costumes for Ugo Betti's play *L'Île des chèvres*, directed by Pierre Valde. The play opens on April 23 at the Théâtre des Noctambules with Alain Cuny, Silvia Monfort, and Laurence Bataille. Balthus moves to the fourteenth-century Château de Chassy in the Morvan (Nièvre). Over a period of several years paints a series of landscapes, all views from Chassy's windows.

### 1954

Begins a series based on Chassy's courtyard viewed in different seasons and from different windows. Begins series entitled *The Three Sisters*. Frédérique Tison, a niece by marriage, moves to Chassy and becomes the artist's favorite model.

### 1956

The Museum of Modern Art in New York holds an exhibition devoted to Balthus's paintings and *Wuthering Heights* drawings (December 9, 1956—February 3, 1957).

### 1960

Designs sets for Shakespeare's *Julius Caesar (Jules César)*. Adapted by Yves Bonnefoy and directed by Jean-Louis Barrault, the play opens on October 27 at the Théâtre de France-Odéon with Barrault, Pierre Blanchard, and others.

**1961**

In February Balthus is named director of the French Academy in Rome. Takes up residence at the Villa Medici, the seat of the academy, and begins its complete restoration.

**1962**

Visits Japan, where he meets Setsuko Ideta, a young Japanese woman who soon joins him in Rome.

**1963**

Begins *The Turkish Room* with Setsuko as model.

**1964**

Continues *The Three Sisters* series.

**1966**

Exhibition of paintings and drawings at the Musée des Arts Décoratifs in Paris (May 17–June 27). Begins *The Card Players*.

**1967**

Marries Setsuko Ideta in Tokyo on October 3. Begins *Japanese Figure with a Black Mirror* and *Japanese Figure with a Red Table*.

**1968**

John Russell organizes a retrospective exhibition of Balthus's work at the Tate Gallery in London (October 4–November 10).

**1969**

Baladine Klossowski dies in Paris.

**1973**

Initiates the restoration of the Villa Medici gardens.

**1977**

Leaves Rome and moves with his wife and young daughter to a village in Switzerland, where he lives and works today.

**1980**

The Venice Biennale exhibits twenty-six of Balthus's paintings at the Scuola Grande di San Giovanni Evangelista.

**1981**

*A New Spirit in Painting*, an exhibition held at London's Royal Academy (January 15–March 18), includes eight of the artist's most recent paintings. Becomes a member of the Royal Academy in London.

**1982**

For the Festival of the Two Worlds in Spoleto, Giovanni Carandente organizes a large retrospective exhibition of Balthus's drawings and watercolors (June 22–July 31).

**1983–84**

Balthus is awarded the Premio Via Condotti by the Italian government. Retrospective exhibition, organized by The Metropolitan Museum of Art and the Musée national d'art moderne, Centre Georges Pompidou, is shown in Paris (November 5, 1983–January 23, 1984) and in New York (February 29–May 13, 1984).

# SELECTED BIBLIOGRAPHY

NOTE: This bibliography does not include catalogues cited in list of exhibitions.

ARTAUD, ANTONIN. "Exposition Balthus à la Galerie Pierre." *La Nouvelle Revue Française*, no. 248 (May 1934), pp. 899–900. Reprinted in *Oeuvres complètes*, 18 vols. to date. Paris: Gallimard, 1961–, vol. 2, pp. 286–87.

————. "La Pintura francesa joven y la tradición." *El Nacional Mexico*, June 17, 1936; translated as "La Jeune Peinture française et la tradition." *Oeuvres complètes*, vol. 8, pp. 248–53.

————. "Balthus." *Art Press*, no. 39 (July–August 1980), p. 4. Text written in February 1947.

BIGGS, LEWIS. "The Literature of Art." Review of *Balthus* by Jean Leymarie. *Burlington Magazine*, April 1980, pp. 270–73.

BONNEFOY, YVES. "L'Invention de Balthus." *L'Improbable et autres essais*, rev. and enl. ed. Paris: Mercure de France, 1980, pp. 39–59.

CARANDENTE, GIOVANNI. *Balthus: Drawings and Watercolors.* Translated by John Mitchell. New York: A New York Graphic Society Book/Little, Brown and Company, 1983.

CHAR, RENÉ. "Balthus, ou le dard dans la fleur." *Cahiers d'Art*, vol. 20–21 (1945–46), p. 199.

CLARK, KENNETH. "A Modern Master." *New York Review of Books*, June 12, 1980, pp. 18–20.

COOPER, DOUGLAS. "The Writings of Blunt and Others." Review of *Balthus* by Jean Leymarie. *Books and Bookmen*, December 1979, pp. 40–44.

ÉLUARD, PAUL. "À Balthus." *Les Cahiers du Sud*, no. 285 (1947), p. 798. Reprinted in *Voir*. Geneva/Paris: Éditions des Trois Collines, 1948, pp. 91–93. Also reprinted in *Oeuvres complètes*. Paris: Gallimard, 1979, vol. 2, p. 181.

HESS, THOMAS B. "Balthus: Private Eye." *Vogue*, January 1974, pp. 104–107.

HYMAN, TIMOTHY. "Balthus: A Puppet Master." *Artscribe*, June 1980, pp. 30–40.

JOUVE, PIERRE JEAN. "Balthus." *La Nef*, September 1944, pp. 138–47.

KLOSSOWSKI, PIERRE. "Balthus: Beyond Realism." *Art News* December 1956, pp. 26–31, 50–51. Reprinted as "Du 'Tableau Vivant' dans la peinture de Balthus." *Monde nouveau*, no. 108–109 (March 1957), pp. 70–80.

KLOSSOWSKI DE ROLA, STANISLAS. *Balthus*. New York: Harper & Row, 1983.

LASSAIGNE, JACQUES. "La Leçon de Balthus." *Revue de la Pensée Française*, June 1956, pp. 55–56.

LEYMARIE, JEAN and FREDERICO FELLINI. *Balthus*. Venice: Edizione La Biennale di Venezia, 1980. Fellini's text was originally published as the introduction to the catalogue of Balthus's exhibition at the Pierre Matisse Gallery, New York, 1977.

LEYMARIE, JEAN. *Balthus*. Translated by James Emmons. 2nd enl. illus. ed. New York: Skira/Rizzoli, 1982.

LEYRIS, PIERRE. "Deux Figures de Balthus." *Signes*, no. 4 (winter 1946–47), pp. 83–87.

LOEB, PIERRE. *Voyages à travers la peinture*. Paris: Bordas, 1946, pp. 137–39.

LORD, JAMES. "Balthus: The Strange Case of the Count de Rola." *The New Criterion*, December 1983, pp. 9–25.

PAULSON, RONALD. "Balthus Between Covers." *Bennington Review*, December 1979, pp. 78–83.

RILKE, RAINER MARIA. "Lettres à un jeune peintre." *Fontaine*, no. 44 (summer 1945), pp. 526–37.

————. *Lettres françaises à Merline 1919–1922*. Paris: Éditions du Seuil, 1950. Translated as *Letters to Merline 1919–1922*. London: Methuen, 1951.

————. *Rainer Maria Rilke et Merline: Correspondance 1920–1926*. Edited by Dieter Bassermann. Zurich: Max Niehans Verlag, 1954.

RUSSELL, JOHN. "Master of the Nubile Adolescent." *Art in America*, November–December 1967, pp. 98–103.

WATT, ALEXANDER. "Balthus." *Occident*, no. 2 (January 1948), pp. 20–26.

# SELECTED LIST OF EXHIBITIONS

*Selected One-Man Exhibitions*

CAMBRIDGE, MASS. 1964. The New Hayden Gallery. Massachusetts Institute of Technology. *Balthus*. Exhibition catalogue.

CHICAGO. 1964. The Arts Club of Chicago. *Balthus*. Exhibition catalogue; introduction by John Rewald.

CHICAGO. 1966. B. C. Holland Gallery. *An Exhibition of Balthus Drawings*. Exhibition catalogue; introduction by Harry Bouras.

CHICAGO. 1980. Museum of Contemporary Art. *Balthus in Chicago*. Exhibition catalogue.

DETROIT. 1969. Donald Morris Gallery. *Balthus*. Exhibition catalogue; foreword by Albert Camus. Camus's text was originally published as the introduction to the catalogue of Balthus's exhibition at the Pierre Matisse Gallery, New York, 1949.

GENEVA. 1943. Galerie Georges Moos. *Exposition Balthus*. Exhibition catalogue.

LONDON. 1968. Tate Gallery. *Balthus: A Retrospective Exhibition*. Exhibition catalogue by John Russell for the Arts Council of Great Britain.

MARSEILLES. 1973. Musée Cantini. *Balthus*. Exhibition catalogue; forewords by Jean Leymarie and Albert Camus. Camus's text was originally published as the introduction to the catalogue of Balthus's exhibition at the Pierre Matisse Gallery, New York, 1949.

NEW YORK. 1938. Pierre Matisse Gallery. *Balthus*. Exhibition catalogue; introduction by James Thrall Soby.

NEW YORK. 1939. Pierre Matisse Gallery. *Balthus: Paintings and Drawings (Illustrations for "Wuthering Heights")*. Exhibition catalogue.

NEW YORK. 1949. Pierre Matisse Gallery. *Balthus*. Exhibition catalogue; introduction by Albert Camus.

NEW YORK. 1956–57. The Museum of Modern Art. *Balthus*. Exhibition catalogue by James Thrall Soby.

NEW YORK. 1957. Pierre Matisse Gallery. *Balthus*. Exhibition catalogue.

NEW YORK. 1962. Pierre Matisse Gallery. *Balthus: Paintings 1929–1961*. Exhibition catalogue; foreword by Jacques Lassaigne. Lassaigne's text was originally published in the exhibition catalogue *7ième Biennal—Peintres d'aujourd'hui: France-Italie*, Galleria Civica d'Arte Moderna, Turin, 1961.

NEW YORK. 1963. E. V. Thaw & Co. *Drawings by Balthus*. Exhibition catalogue; introduction by John Rewald.

NEW YORK. 1967. Pierre Matisse Gallery. *Balthus: "La Chambre turque"; "Les Trois Soeurs"; Drawings and Water Colors 1933–1966*. Exhibition catalogue; foreword by Patrick Waldberg.

NEW YORK. 1977. Pierre Matisse Gallery. *Balthus: Paintings and Drawings 1934 to 1977*. Exhibition catalogue; introduction by Frederico Fellini.

PARIS. 1934. Galerie Pierre. *Balthus*.

PARIS. 1946. Galerie "Beaux-Arts" (Wildenstein). *Balthus: Peintures de 1936 à 1946*.

PARIS. 1956. Gazette des Beaux-Arts (Wildenstein). *Balthus*.

PARIS. 1966. Musée des Arts Décoratifs. *Balthus*. Exhibition catalogue; introduction by Gaëtan Picon. Also shown in Knokke-le-Zoute. 1966. Casino Communal. XIX Festival Belge d'Été.

PARIS. 1966. Galerie Henriette Gomès. *Peintures, aquarelles, et dessins de Balthus*.

PARIS. 1971. Galerie Claude Bernard. *Balthus: Dessins et aquarelles*. Exhibition catalogue; introduction by Jean Leymarie.

PARIS. 1983. Musée national d'art moderne, Centre Georges Pompidou. *Balthus*. Exhibition catalogue by Dominique Bozo, Gérard Régnier, et al.

SPOLETO. 1982. Twenty-fifth Festival of the Two Worlds. Palazzo Racani-Arroni. *Balthus: Disegni e acquarelli*. Exhibition catalogue by Giovanni Carandente.

TURIN. 1958. Galleria d'Arte Galatea. *Balthus*. Exhibition catalogue; introduction by Luigi Carluccio.

VENICE. 1980. Thirty-ninth Biennale. Scuola Grande di San Giovanni Evangelista. *Balthus*. Introduction by Jean Leymarie in the biennale's catalogue, *Arte Visive '80*, pp. 210–16.

*Selected Group Exhibitions*

BRUSSELS. 1934. Palais des Beaux Arts. *Exposition Minotaure*. Organized by Éditions Albert Skira, Paris. Exhibition catalogue.

LONDON. 1952. The Lefevre Gallery. *Balthus and a Selection of French Paintings*. Exhibition catalogue; foreword by Cyril Connolly.

LONDON. 1981. Royal Academy of Arts. *A New Spirit in Painting*. Exhibition catalogue by Christos Joachimides, Norman Rosenthal, and Nicholas Serota.

NEW YORK. 1975. The International Council of The Museum of Modern Art. *Modern Masters: Manet to Matisse*. Exhibition catalogue edited by William S. Lieberman.

PARIS. 1979. Musée d'Art Moderne de la Ville de Paris. *L'Aventure de Pierre Loeb: La Galerie Pierre, Paris 1924–1964*. Exhibition catalogue by Bernadette Contensou, Jean Coquelet, et al. Also shown in Brussels. 1979. Musée d'Ixelles.

PARIS. 1980–81. Musée national d'art moderne, Centre Georges Pompidou. *Les Réalismes: 1919–1939*. Exhibition catalogue by Pontus Hulton, Gérard Régnier, et al.

PARIS. 1981. Musée national d'art moderne, Centre Georges Pompidou. *Paris-Paris: 1937–1957*. Exhibition catalogue by Pontus Hulton, Germain Viatte, et al.

PARIS. 1982–83. Musée national d'art moderne, Centre Georges Pompidou. *Paul Éluard et ses amis peintres, 1895–1952*. Exhibition catalogue by Dominique Bozo, Germain Viatte, et al.

TURIN. 1961. Galleria Civica d'Arte Moderna. *7ième Biennal— Peintres d'aujourd'hui: France-Italie*. Exhibition catalogue; introduction by Jacques Lassaigne.

# LIST OF COLORPLATES

## PHOTOGRAPH CREDITS

All credits for black-and-white illustrations are given in the captions. Color photography for pls. 4, 9, 30, and 36 was done by The Metropolitan Museum of Art Photograph Studio; the owners of the works supplied all other color transparencies.